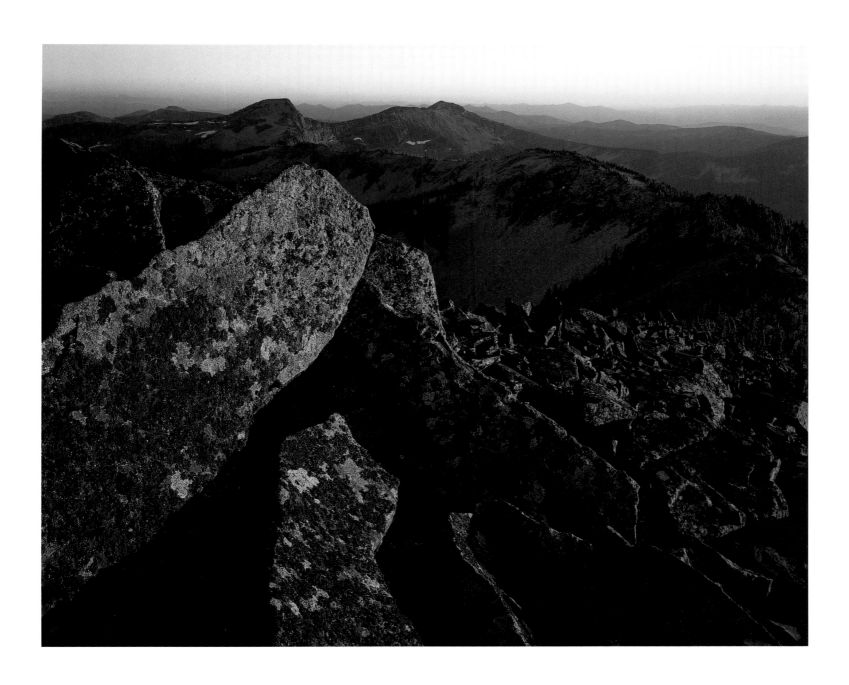

As we passed on it seemed as if
those seens of visionary inchantment
would never have and [an] end . . .

—Meriwether Lewis
as it appeared in his journal entry of May 31, 1805,
writing of the land that is now Montana

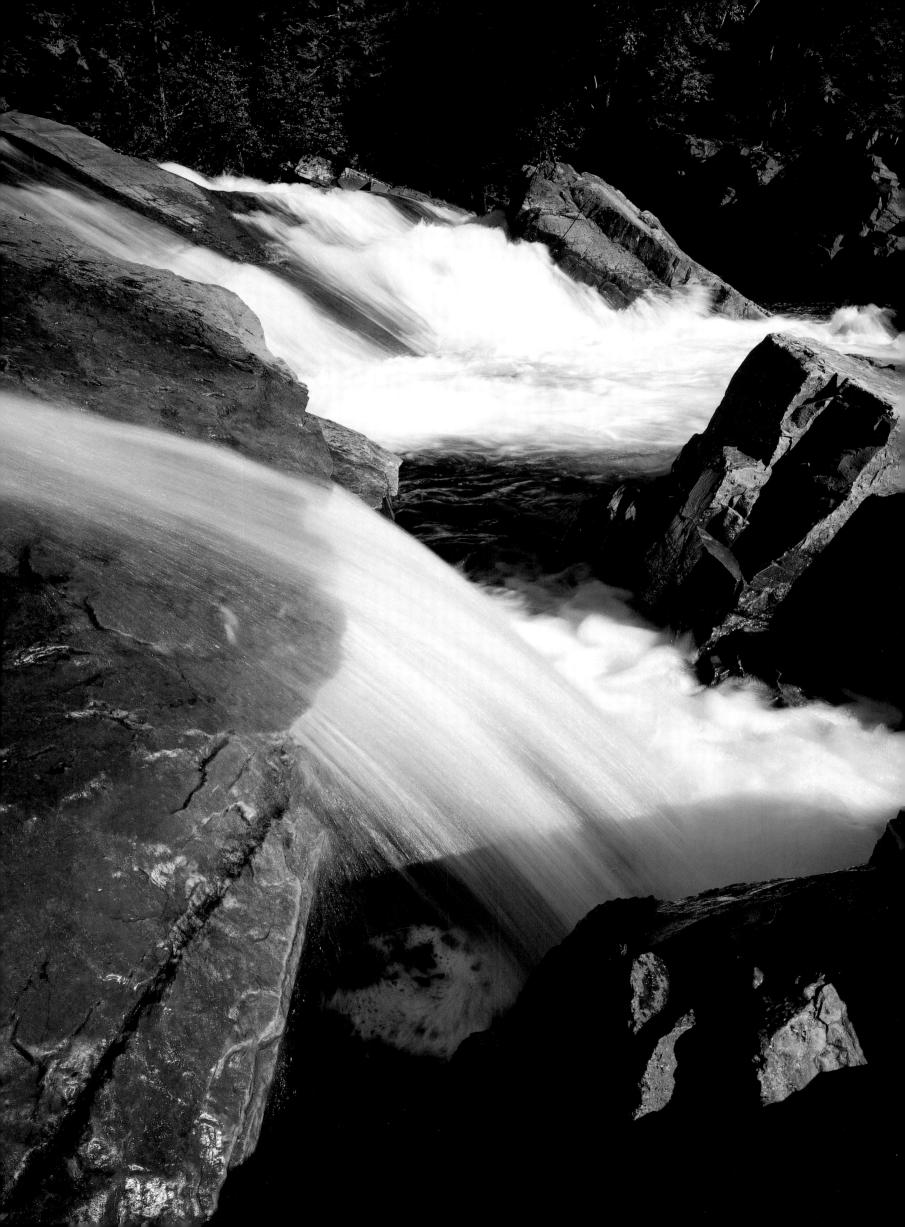

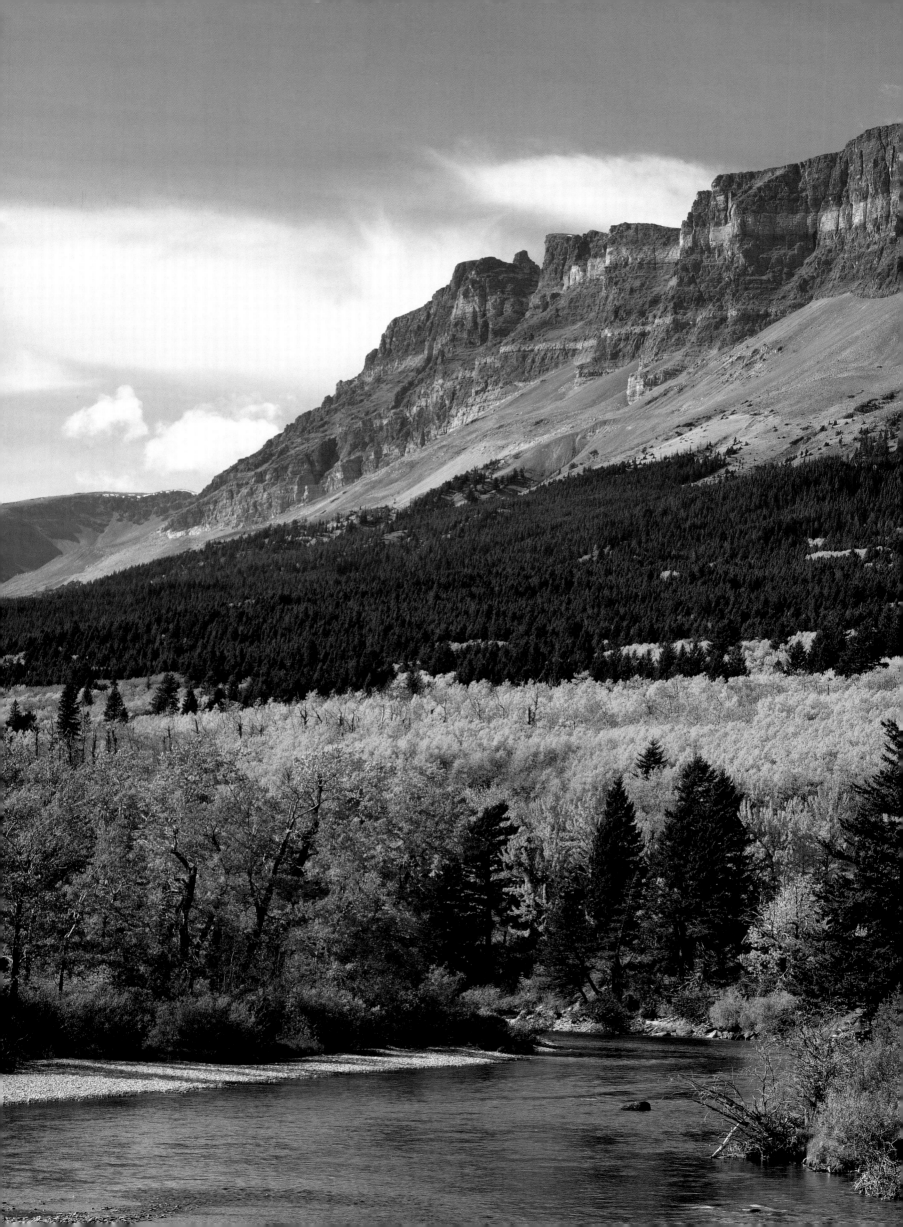

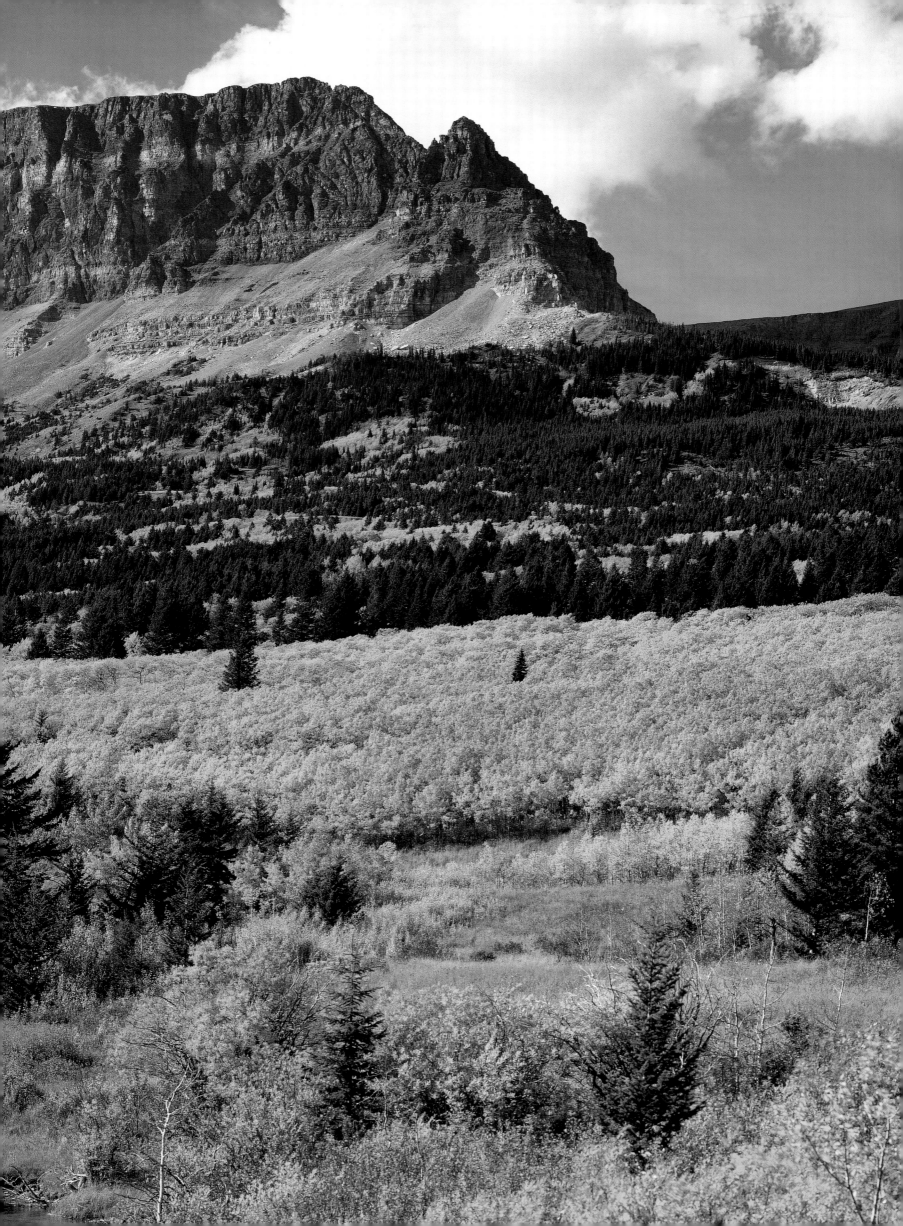

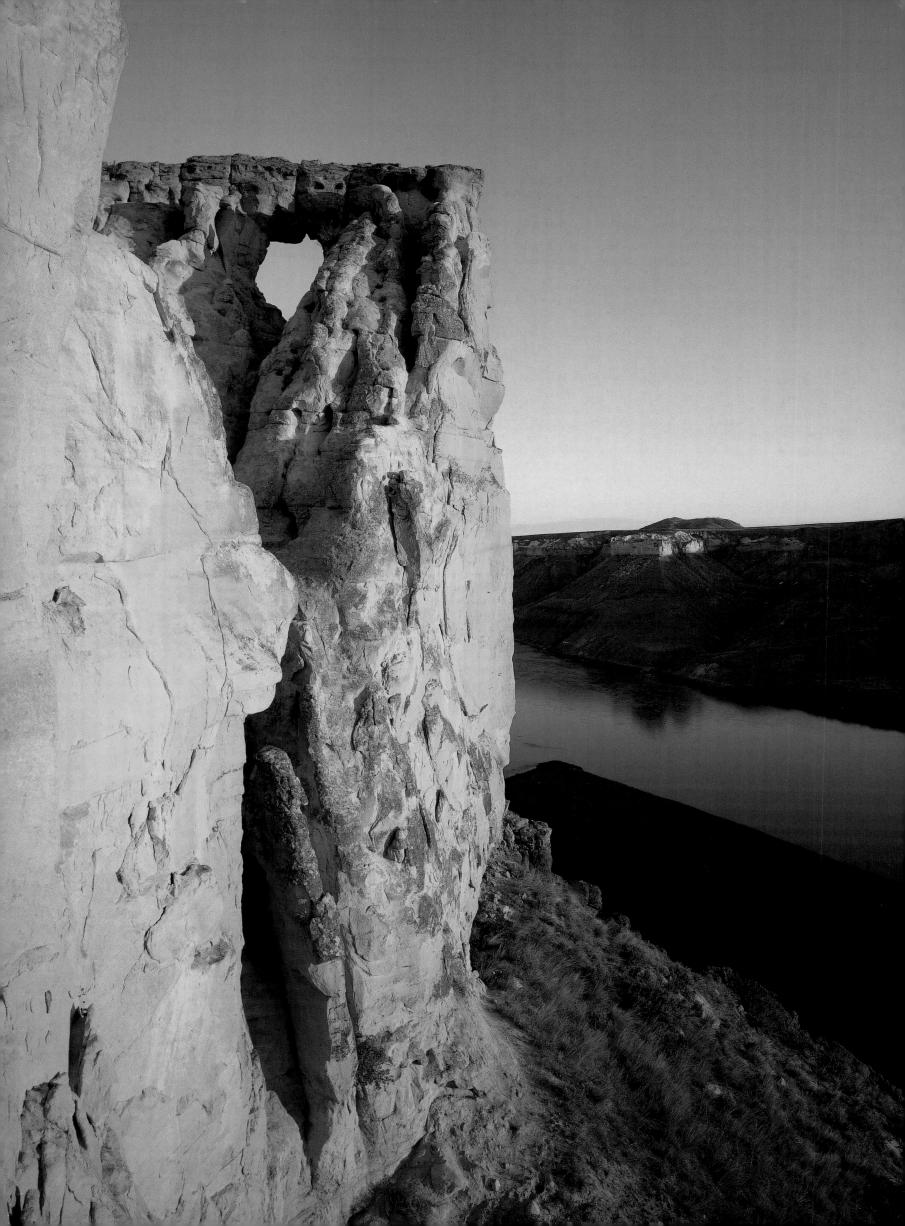

MONTANA

Photography by Salvatore Vasapolli

Essay by Pat Williams

Graphic Arts Center Publishing®

*To those that dream. No, not the wishful thinker who dreams
but never accomplishes anything, but those whose goals
seem unattainable at first, but slowly work hard
to achieve them, for this world was made for you.*

—SALVATORE VASAPOLLI

≈

Photographs © MMIII by Salvatore Vasapolli
Essay © MMIII by Pat Williams
Book compilation © MMIII by Graphic Arts Center Publishing®

Library of Congress Cataloging-in-Publication Data

Vasapolli, Salvatore, 1955-
 Montana / photography by Salvatore Vasapolli ; essay by Pat
Williams.
 p. cm.
 ISBN 1-55868-696-7 (hardbound : alk. paper)
 1. Montana—Pictorial works. 2. Montana—Description and
travel. 3. Montana—Miscellanea. 4. Natural history—Montana.
I. Williams, Pat, 1937- II. Title.
 F732 .W55 2003
 978.6'0022'2—dc21 2002013275

To see more images of Montana or to request custom prints,
visit photographer's Web site at www.vasapolliphotography.com

Graphic Arts Center Publishing®
An imprint of Graphic Arts Center Publishing Company
P.O. Box 10306, Portland, Oregon 97296-0306
503-226-2402; www.gacpc.com

President: Charles M. Hopkins
Associate Publisher: Douglas A. Pfeiffer
Editorial Staff: Timothy W. Frew, Tricia Brown, Kathy Howard, Jean Bond-Slaughter
Designer: Reynolds-Wulf Design; Jean Andrews
Production Staff: Richard L. Owsiany, Heather Doornink
Printed in the United States of America

False Title: Boulders adorn 7,705-foot Northwest Peak, Purcell Mountains.
Page iii: The upper Yaak Falls are a jewel situated in northwestern
Montana's Kootenai National Forest. *Yaak* is an Indian word for "arrow."
Pages iv–v: Billion-year-old rocks can be seen spanning Singleshot
Mountain. The St. Mary's River waters the golden carpet of Aspen trees.
Page vi (frontispiece): The White Cliffs, here showing Sunrise Hole in the Wall
above the Missouri, were described by Meriwether Lewis, "The hills and
river Clifts which we passed today exhibit a most romantic appearance. The
water . . . has trickled down the soft clifts . . . and worn it into a thousand
grotesque figures . . ." His ability to describe surpassed his spelling precision.

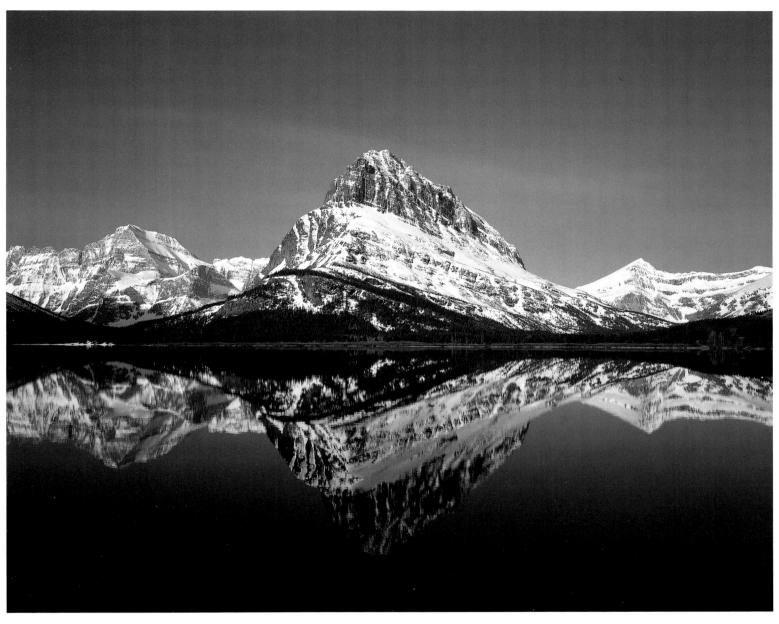

△ On the east side of Glacier Park the clear waters of Swiftcurrent Lake reflect the majesty of Grinnell Point. Here, as throughout the park, we see the results of hundreds of millions of years of nature's relentless carving. The park's name reflects how the mountains were shaped—but does not indicate that this is a place of many remaining ancient glaciers.

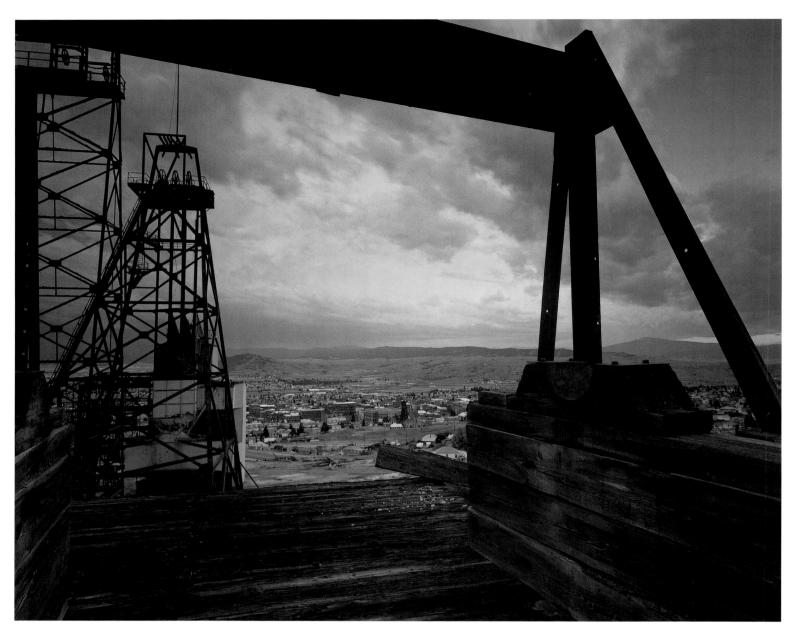

△ A gallows frame, one of the hoisting head frames that top shafts, many reaching a mile deep, stands sentinel above a century of the mining past of Butte—once famous as the the Richest Hill on Earth. ▷ ▷ A storm develops near Square Butte in the Judith Basin. The area was named by explorer William Clark to honor a lady friend in Virginia. Clark and Judith Hancock were married following his return.

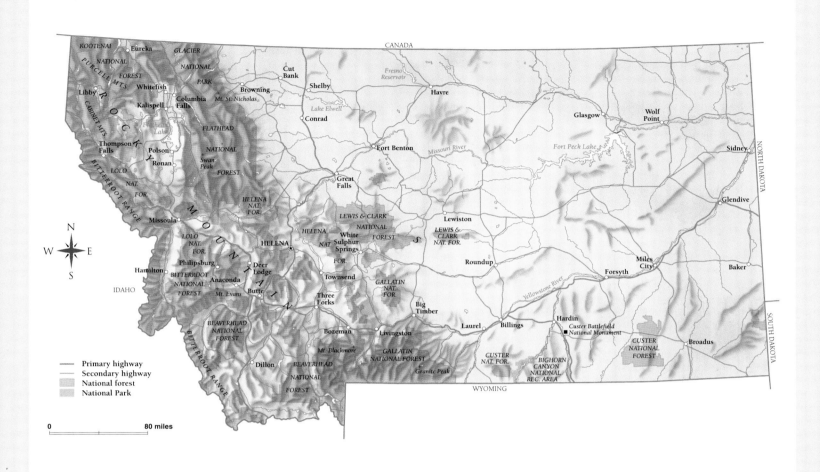

Granted statehood: November 9, 1889

State capital: Helena

Nicknames: The Treasure State

& Big Sky Country

Population: 902,195 (census 2000)

Total land area: 147,138 square miles

Elevation: highest point at Granite Peak,

12,799 feet; lowest point along the

Kootenai River in Lincoln County,

1,820 feet

State motto: *Oro y Plata* ("Gold and Silver")

State song: "Montana"

State flower: bitterroot

State grass: bluebunch wheatgrass

State tree: ponderosa pine

State bird: western meadowlark

State animal: grizzly bear

State fish: blackspotted cutthroat trout

State gemstones: sapphire and agate

State fossil: duck-billed dinosaur

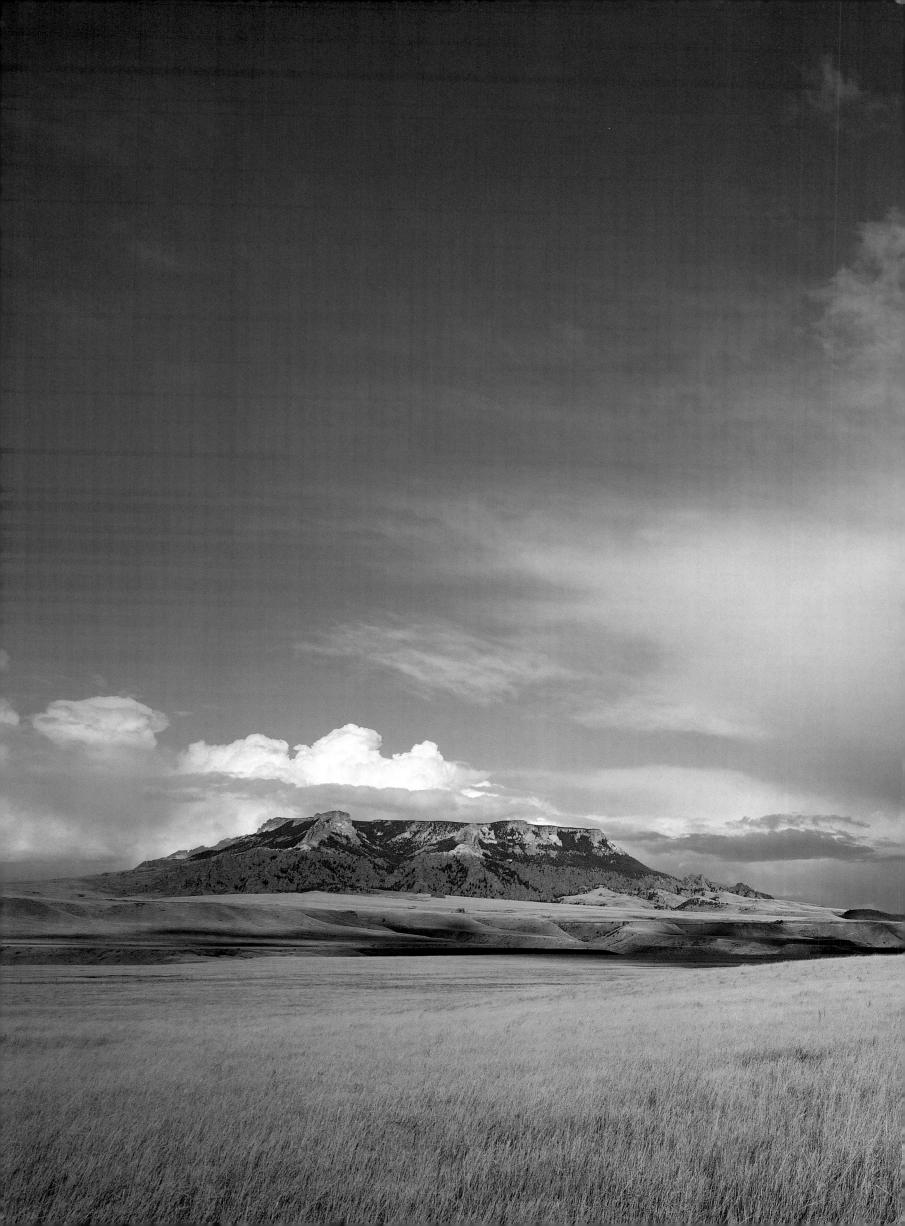

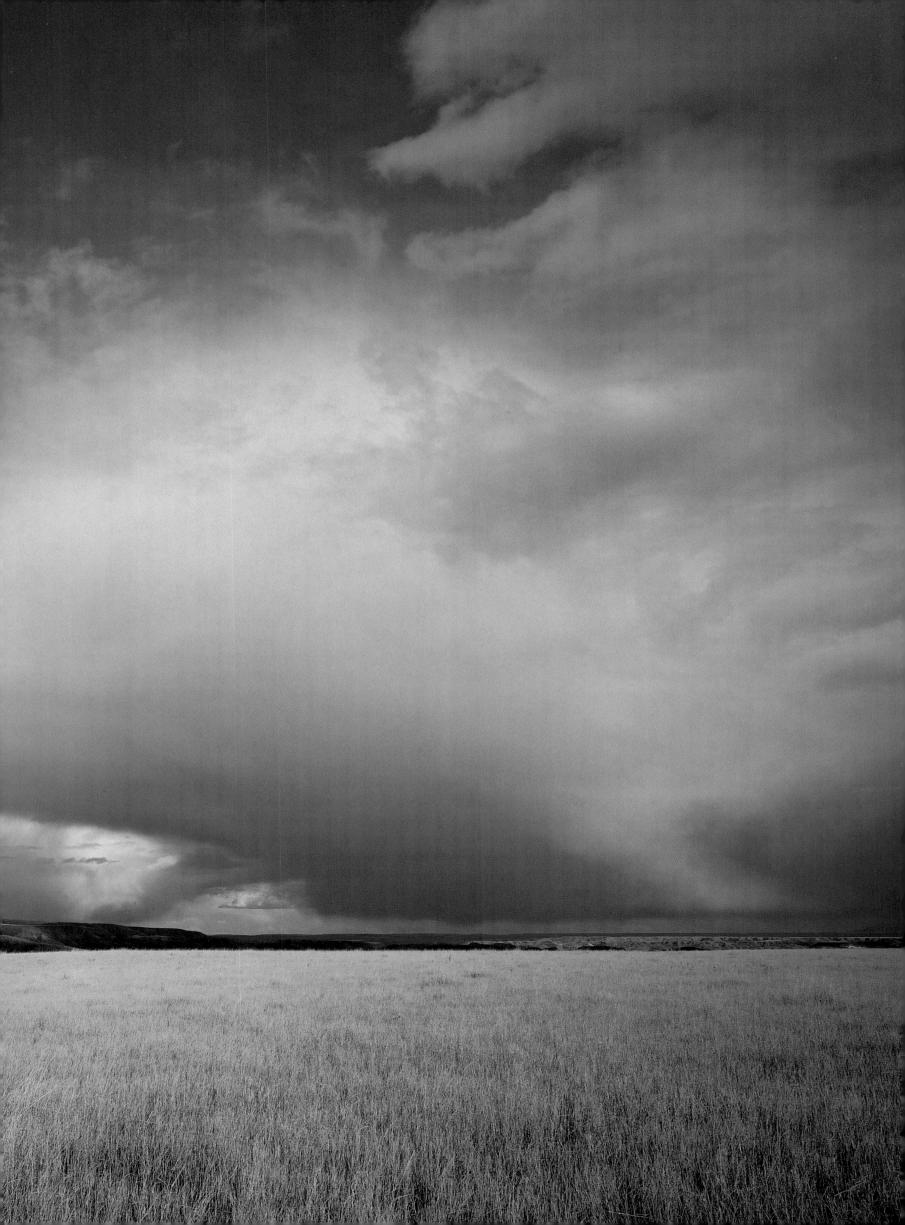

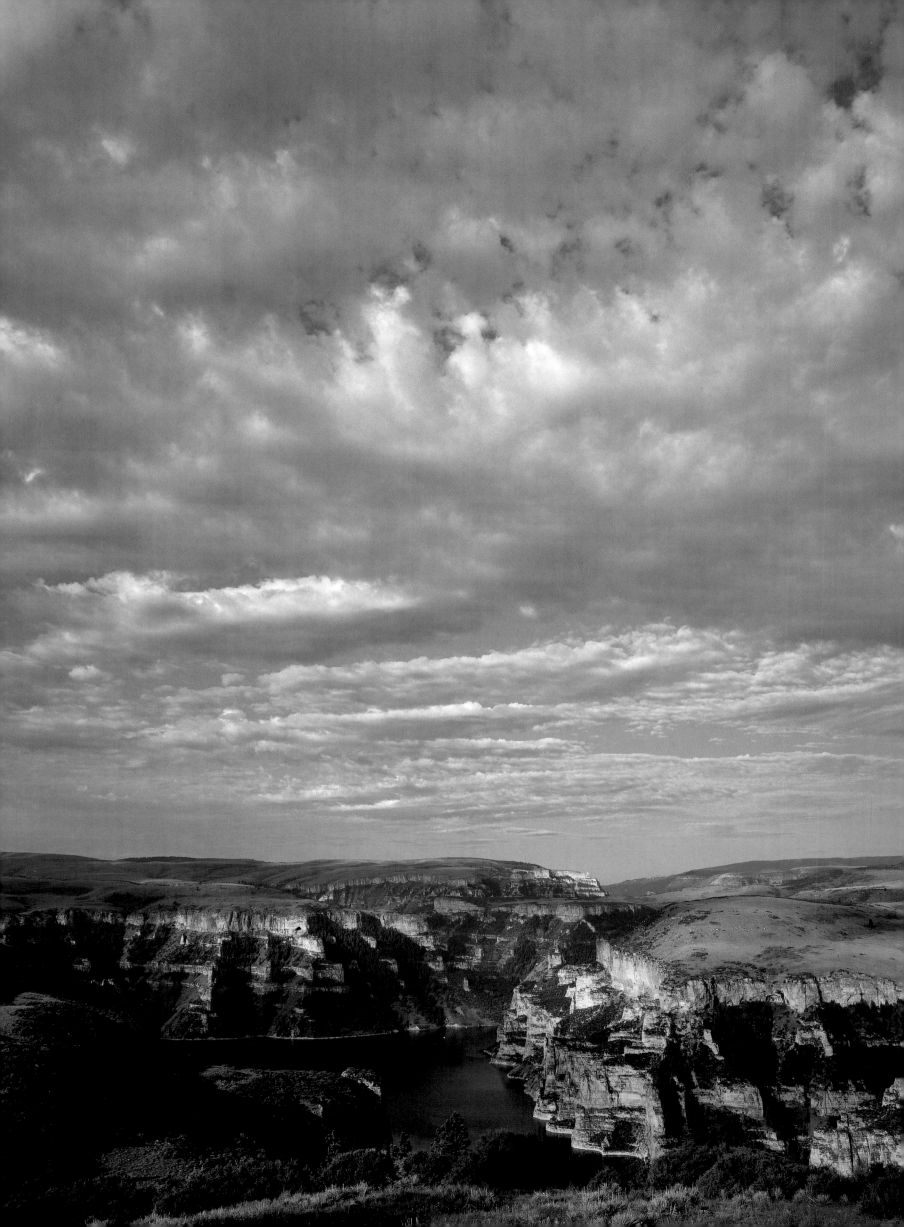

INTRODUCTION

Montana! The word is a showstopper.

The Spanish word for mountain, it conjures images of wild and wonder and West. The mere utterance of the word implies the story of the American frontier with its promise and myth.

During my eighteen years representing Montana in the United States Congress, I repeatedly heard people reverentially mention the name of our state, as in, "Oh, that's Pat Williams, the congressman from Montana. . . ." For a moment, silence, and then people would approach me. "Montana? My parents took us there almost every summer when I was a kid . . . Montana's wonderful!"

"Hey, Congressman, I drove across Montana once, thought it was going to take forever. I got a flat tire outside of Great Falls and three cars stopped to help."

"I suppose you've been to Butte. Gosh but I had a good time that night," followed by a hearty laugh.

"Hey, Congressman, when I was in college a couple of friends and I spent four days in Miles City at the bucking horse sales. Man, was that a hoot or what!"

The stories flowed constantly throughout my almost twenty years in Congress. People were eager to talk with me about their travels in Montana. Our national parks—Glacier and Yellowstone—enthralled them. The state's hunting and fishing opportunities, they said, were unlike anywhere else. They recounted being mesmerized by the setting sun casting its crimson glow across the Big Sky. To many, the mountaintops seemed unapproachably beautiful, while the lower big-shouldered ranges beckoned them to climb and romp on the pine-shadowed slopes.

Many who had visited the state told of pulling their cars off the highways onto stretches of dirt roads, then sitting on the banks of rivers listening to the gurgling of water and the light rattling of August leaves, until they felt transported in time.

Almost everyone spoke enviously about the pace of life in our cities and towns. "Neighborhoods not hives," commented the part-time Montanan and New Yorker, television's Charles Kuralt. Life in such places is easier. Although the pace of life is accelerating, even in the more populated cities of Billings, Missoula, Kalispell, Bozeman, and Great Falls, most people can still drive from home to work within fifteen minutes, and many others simply walk. In small cities, rush hour is replaced by rush minutes, and traffic jams are so rare that when they occur they often appear as features on the nightly television news. In Montana, a car's honking signals "Hello," not "Get out of my way!"

It may be that latitude affects attitude, but the friendliness of Montanans is more likely the product of our population. There is virtually no anonymity in our smaller towns, and a warm hello is not only good manners but is, in fact, obligatory.

Perhaps, as our population nears one million, we notice some changes in the pace of our daily living; however, the logistics of living in Montana remain relatively simple. Compared to the hurried pace suffered by most Americans, in Montana each day is a delight.

During all of the time I served in the U.S. Congress, I missed Montana—the hum of the land, the unhurried conversations of its people. I was homesick, longing for the sight of big-shouldered mountains, the starkness of the state's high plains and rugged breaks.

I understand, of course, that natural beauty abounds throughout the planet, and I know, too, that we are all subject to our own parochial biases; however, many of us truly believe that Montana is extraordinary. We take comfort in that bias, knowing many people—including residents of other states—who readily agree with our assessment.

There is a cure for homesickness: go home. Thus, in mid-career, I left Congress to return to Montana. I left a job I loved for a state I couldn't do without. Perhaps it was a selfish act, substituting trails and tributaries for trials and tribulations.

WALK TO THE FISHING HOLE OR TRAIL

Many Montanans are only a short drive, a bike ride, or a walk away from a fishing hole, a hiking trail, or a ski slope. The late historian K. Ross Toole once said to me, "Out here wilderness is never far from the windowpane."

In my case, just beyond our front door begins an "open space" boundary—land purchased by the citizenry to preserve valuable habitat for birds, elk, deer, and other mammals. Surrounded by ponderosa pine, Douglas fir, bluebells, and lupine, these many miles of hiking trails are used daily by people from throughout the area. After living for two decades in urban Washington, D.C., it is an indescribable joy to step off my front porch and onto a hiking trail.

This open space is composed of two mountains that define the eastern boundaries of the city of Missoula. Mount Sentinel and Mount Jumbo comprise more than three thousand acres of wildlife habitat and trails, much of which is closed to human traffic from December to March in order to protect the winter habitat of elk herds that travel down from the adjacent high country to graze.

During the three seasons when people are allowed on these slopes, thousands of Missoulians and their visitors enjoy leisurely strolls or energetic climbs. The open space is home to one hundred bird and thirty-five mammal species, including mule deer and an occasional black bear. The resilient magpie is a year-round resident, and the sounds and sights of soaring red-tailed hawks, golden eagles, and bald eagles remind one to look up into the arching expanse of Big Sky.

Mounts Sentinel and Jumbo are crisscrossed with many miles of hiking trails, similar to many other areas in Montana. Throughout the state, Montanans often take the time on languid summer afternoons to hop in their cars and drive to their favorite fishing holes, where they catch a few native rainbow trout and are home in time for dinner, which is often those very fish. Montanans pass many hours surrounded by such luxuries. The downhill skiing is world-class. Our mountains offer both hiking and technical climbing. Big game hunting is extraordinary throughout the state. Golf, backpacking, floating and canoeing, snowmobiling, and cross-country skiing are enjoyed year-round—each in its own season.

WILDERNESS

Strange that so few ever come to the woods to see how the pine lives and grows and spires, lifting its evergreen arms to the light to see its perfect success. Henry David Thoreau, 1858

Today, almost 150 years after Thoreau penned those words, many of Montana's mountain valleys and high plains remain

◁ *Bighorn Canyon with Yellowtail Lake, Crow Tribal Vision Quest Site, Bighorn Canyon National Recreation Area*

wild and seldom explored, but that is changing as new residents and tourists by the hundreds of thousands come "to the woods to see how the pine lives. . . ."

Montana contains some of America's last wild places. Ten million acres of land remain roadless, providing spawning grounds and habitat for many of the nation's threatened or endangered species. However, these wildlands are not contiguous but lie as islands surrounded by roads and towns, clear-cuts and tilled fields.

A relatively small portion of the state's most pristine and critical public lands have been designated Wilderness. The 1964 Wilderness Act was passed "to secure for the American people of present and future generations the benefits of an enduring resource of wilderness." This act defined statutory Wilderness as areas "where the earth and its community of life are untrammeled by man, where man himself is a visitor who does not remain."

Although most of Montana has been developed to one degree or another, a few extraordinary wild places remain. Three million acres of those lands—which are owned by all Americans—have been declared Wilderness by the U.S. Congress. The first and perhaps most renowned is the Bob Marshall Wilderness, just over a million acres that Montanans have struggled to protect and preserve. The overthrust mountains that make up the unique geology of the area contain, in full view, rocks from the basement of time. Larger than the state of Delaware, "the Bob" is south of Glacier National Park and is a critical part of a vast ecosystem that extends through America's Northern Rocky Mountains and across Canada's Waterton National Park. Comprised of soaring peaks, scattered glaciers, timbered valleys, and sparkling meadows, this expansive region is home—one of the last homes—to the grizzly bear, *Ursus arctos horribilis*.

The Bob wilderness complex comprises half of all the statutorily protected wilderness in Montana. The rest are important but are relatively tiny islands of sanctuary, each isolated from the other. Increasing numbers of ecologists believe that such islands of wilderness cannot provide the necessary habitat for the last remaining great mammals. For twenty-five years efforts have been made in the U.S. Congress to increase wilderness designation in Montana. However, those efforts have had limited success. One exception was a congressional effort in the mid-1980s that passed legislation to protect approximately three million additional acres of federal public land in Montana; however, that bill was vetoed by President Reagan.

That presidential action, the only veto of a wilderness bill in American history, reflected the very deep disagreements about the appropriate management of Montana's remaining wild places. Our state, like others in the Northern Rocky Mountains, is in a historic transition. The economic, political, and cultural changes have created deep divisions among our state's citizens. Montana is the brow of America's last hill, a watershed of the Missouri and Mississippi Rivers on the east and the Columbia River on the west, as well as the migration and calving ground for the last of America's great herds of land animals. It is America's wild playground—the final frontier of the Lower 48. But it is also the land of corporate prosperity. There is "gold in them thar hills," as well as timber, gas, oil, and always land speculators. Montana

is the nexus of American values, the Gettysburg of the West's two economies: extraction versus preservation.

However, no one should be misled: We Montanans respect the land with a visceral understanding that our last, best wild places are not only weather-makers, watersheds, and home for the great creatures of the continent, but also part of each of us. That includes those of us who live here as well as those who visit or dream of visiting. These wild places belong to all Americans through federal ownership, and the public must demand their protection. In the words of President John F. Kennedy, "Each generation must deal anew with the 'raiders,' with the scramble to use public resources for private profit and with the tendency to prefer short run profits to long-run necessities. We must develop new instruments of foresight, and protection and nurture in order to recover the relationship between man and nature and to make sure that the national estate we pass on to our multiplying descendants is green and flourishing."

THE MOUNTAINS ON THE HIGH PLAINS
Isolated mountains rise from the great arid basins of the Yellowstone and Missouri Rivers just as the plains emerge with the eastern front of the Rocky Mountains. They break the level horizon like mirages of huge ships or islands in the ocean giving measure to the ephemeral blue of distance.

Mark Meloy, *Islands on the Prairie*

Perhaps among the most unexpected of these mirages are the Bull Mountains and the Big Snowies of central Montana, and the Sweetgrass Hills of north-central Montana. The Bull Mountains lie between the basins of the Missouri and Yellowstone Rivers, fifty miles of big-shouldered uplifts rising above sandstone terraces. North and west lie the Snowies, a one-hundred-thousand-acre island range. Unusually flat on top, the Snowies offer wonderful hiking with marvelous views across three hundred miles of grassy plains and farmland. The northern ridges of the Snowies reach three thousand feet above the surrounding land.

One of the most incongruous mountain ranges in America is the Sweetgrass Hills. Located along northern Montana's highline, the "Hills" are primarily composed of three cones of igneous rock, buttes resulting from volcanic activity and millions of years of erosion.

The Hills—whose coverings include limber pine, lodgepole pine, ponderosa pine, and fir—are said to contain gold, and decades ago oil was found nearby. But the Sweetgrass Hills are also a critical source of the West's liquid gold—water. The Hills are also important to Native Americans as a religious site. Conflicts arise between those who insist that the Hills remain just as they are and those who prefer the economic potential of mining and drilling. Although the Hills were temporarily protected by the Clinton administration, their eventual fate remains undecided.

There are other island ranges rising from the prairies of eastern Montana. Near the Yellowstone River and its feeder streams and rivers are three stunning highland features: the Pryors, the Bighorns, and the Rosebud. To the northeast lie the Sheep ranges. Nearer to the Missouri Basin are the Belts, the Highwood, the Little Rockies, and the Bearpaw. Several of these ranges hold spiritual significance to Native Americans, including the Bighorns,

▷ *Natural Bridge Falls, Boulder River, Gallatin National Forest*

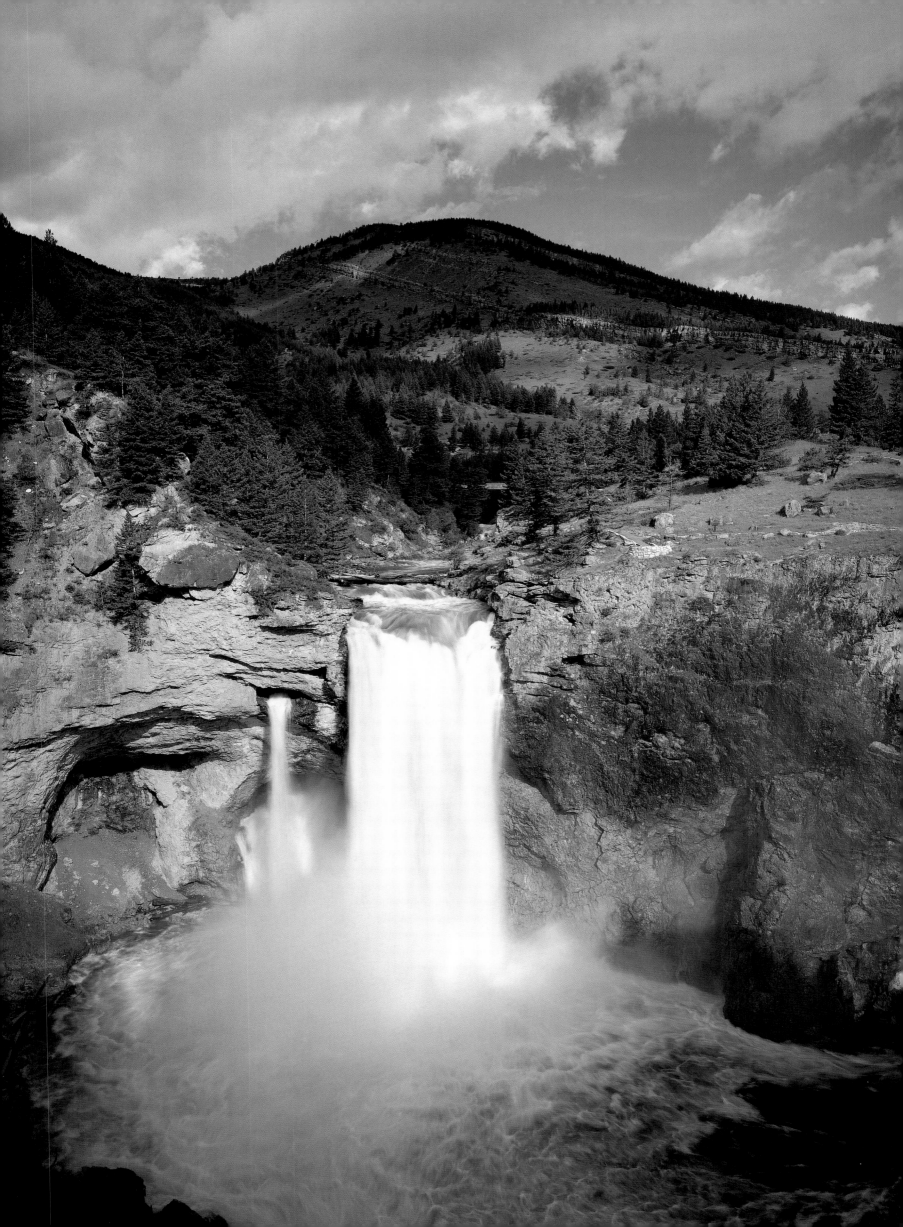

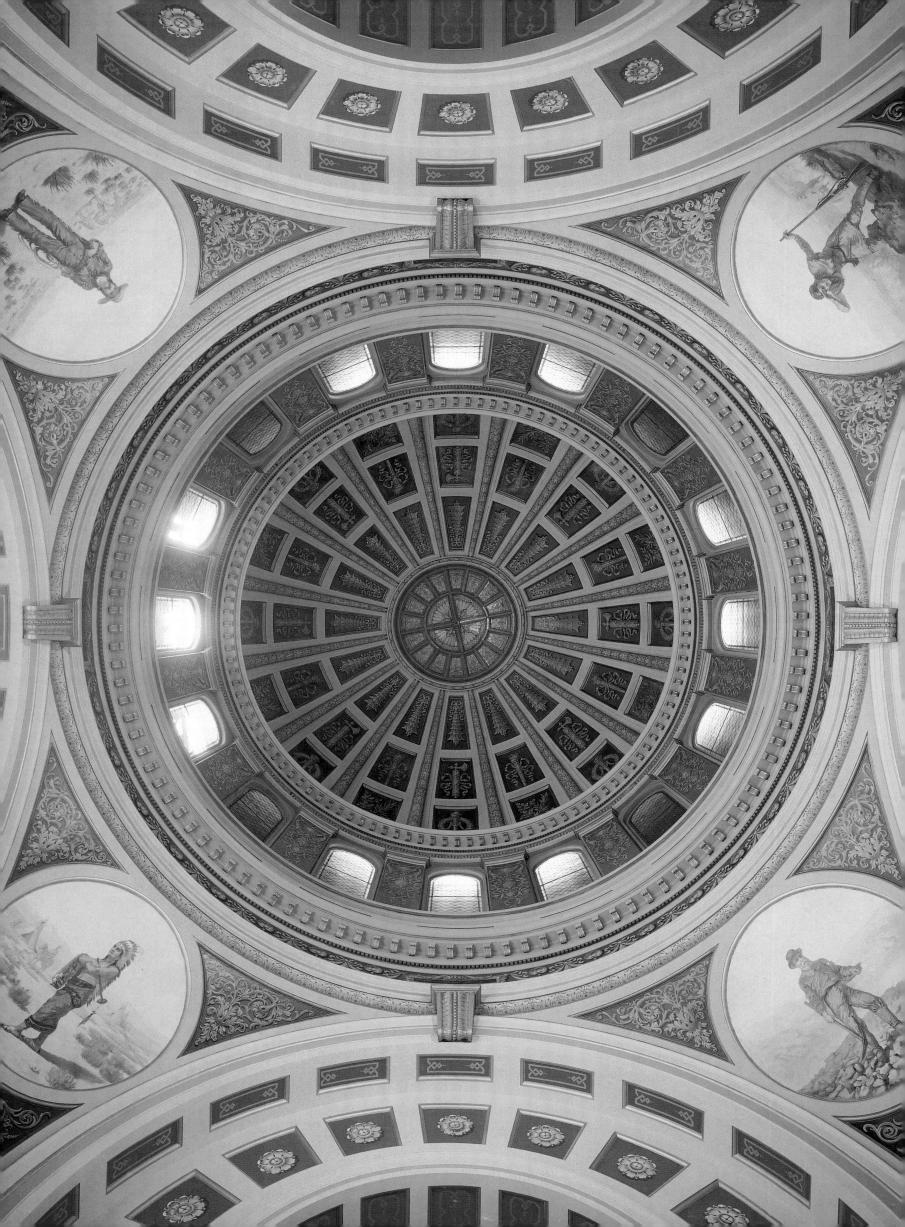

which are sacred to the people of the Crow Nation. Each of these island ranges supports a great variety of flora and fauna, including birds of prey, songbirds, elk, mountain goats, fox, deer, and, as always, that most resilient of predators, coyote.

THE ROCKIES IN MONTANA'S WEST

In his book *Montana: Land of Contrasts,* University of Montana history professor Harry Fritz wrote, "When on May 26, 1864, President Abraham Lincoln signed the act of Congress that established Montana Territory, he created as well a permanent land of contrast. The legislation, which fixed Montana boundaries in their permanent configuration forever locked contrast and even contradiction into the land."

Those contradictions are found throughout Montana—in our economy, people, weather, and landforms. Perhaps it is in the latter, our state's geography, that the stark contradictions are most noticeable. Elevations range from 1,820 feet to 12,799 feet. Except for the island mountain ranges, the eastern plains are essentially dry, rolling grasslands; whereas, the western one-third of Montana—from the Canadian border and Glacier National Park in the north to Yellowstone National Park and the Wyoming border in the south, and from the eastern front of the Rockies to the western border with Idaho—comprises the Rocky Mountains and America's spine—the Continental Divide.

During my years representing Montanans in the U.S. Congress, I often traveled from city to city by small plane. Flying a few miles above the Rockies, particularly west to east, I was struck by the manner in which the western ranges lie in great north-south folds, each divided by long U-shaped valleys.

Near Yellowstone National Park the Absaroka Mountains stand sentinel on one side of the gorgeous Paradise Valley, with the Gallatin Range to its west. Farther west is the Gallatin River and Valley, which in turn is flanked by the Madison Range. Beyond the Madison Mountains is the Madison Valley with its nationally renowned, blue-ribbon river of the same name. That valley is flanked on its other side by yet more stunning mountains—in this instance the Gravelly Range and the Tobacco Root Mountains.

This natural arrangement of bookend mountain ranges paralleling rivers and grassland valleys is found again and again: the Little and Big Belt Ranges divided by the rushing waters of the Smith River; the East and West Pioneers guarding the Wise River; the Bitterroot Valley bounded on its east by the low-slung Sapphire Mountains and on its west by the craggy Bitterroot Range.

These Bitterroots, bordering Idaho, were shaped by glaciers, the last of which receded ten thousand years ago, and thus contain many cirques and hanging valleys. Its forests are coniferous: ponderosa, spruce, Douglas fir. Its peaks range from 4,000 to 10,100 feet, and it contains 170 miles of hiking trails, many of which were constructed for fire control during and following the nation's Great Depression. No doubt, the young Americans who labored to create those trails recognized the value of hiking them, but I wonder if any of them considered the possibility that one day the trails would be used primarily for recreation.

THE BREAKS AND BADLANDS

The best known of the state's dry steppe provinces is the Missouri Breaks, a complex of 407,000 acres characterized by dissected slopes and faces, most of it too steep to support vegetation—160 miles of river walls following the Missouri River from Glasgow in the east to Fort Benton in the west. The Breaks consist of surreal formations carved by wind and water: myriad sandstone towers, landslides, clay bluffs, narrow canyons—all home to coyotes, deer, elk, prairie dogs, bear, and raptors.

Ten million years of geological history await the relatively few visitors to this seemingly inaccessible land. Its thousand-foot-deep gorge, bizarre rock formations, colorful cliffs, and expansive prairies present a virtually undisturbed landscape that is not only an ecological gem, but is also an important crossroads of American history.

Meriwether Lewis and William Clark walked and floated through the Breaks in 1805, and of the region Clark wrote in his diaries, "I do not think it can ever be developed."

It had, of course, already been lived in long before Clark wrote those words. The Blackfeet, Crow, and the Assiniboine hunted, fished, and made camp throughout the Breaks and the adjoining prairie. The teepee rings from those encampments are still visible today.

In their efforts to find freedom in Canada, the Nez Perce and their many chiefs, including Joseph, crossed the Missouri at Cow Island just days before many of them were slaughtered and the remainder captured only thirty miles from the Canadian border and peace.

Outlaws, including Butch Cassidy and the Sundance Kid, found refuge in the Breaks. Train robbers, cattle rustlers, and traders in bootleg whiskey all headed for the Breaks with posses in full pursuit.

Some hearty pioneers saw this country as home, coming here up the Missouri on steamboats or across the land on wagon and horseback. Most found the country unbelievably harsh with a constant unforgiving wind and a soil that turned into six inches of gumbo with the first good rain. The scant remains of their homesteads are scattered throughout the area as testament to a landscape that not only beleaguers humans but also spits them out.

WEATHER

When people in other places think of Montana, they often focus on the state's weather, particularly our winters. America's news media often report, as they should, unusual national occurrences, such as temperatures in Texas reaching more than 105 degrees for two long, scorching weeks. That's news, as are tornadoes and hurricanes. In Montana, the occasional winter reading of minus thirty degrees accompanied by a foot of snow is widely reported. However, Montana weather is relatively moderate, influenced primarily by the Pacific Ocean and the Gulf of Alaska. Our slim spring is countered by the long luxury of fall; the occasional harsh winter says "I'm sorry" by giving way to glorious summer, with its sun-soaked high skies and restful evenings washed by cool, dry breezes that flow down the mountainsides into the valleys and across the plains.

Montana is home to the weather phenomenon known as the Chinook—an Indian word for "snow eater." Chinooks occur when air pressure causes a warm, westerly flow of air from the southwest of the state to the western slope of the mountains,

◁ *Capitol Rotunda, State Capitol (dedicated in 1902), Helena*

during which the temperature of a winter day often rises from well below zero to thirty degrees above within only a few hours. The National Weather Service has noted a forty-three-degree rise in temperature in only fifteen minutes. University of Montana geology professor Jeff Gritzner notes that Fairfield, west of Great Falls, holds the twelve-hour record with a decrease of eighty-four degrees. In January 1916, a one-hundred-degree drop in temperature occurred in twenty-four hours—still a national record.

Despite its relatively moderate year-round temperatures, Montana is nonetheless a state of extremes. In the northwest corner of the state, temperatures will drop each winter to minus forty degrees. On the morning of January 20, 1954, the coldest temperature ever recorded in the Lower 48 occurred near the state's capital—Helena—on Rogers Pass: seventy degrees below zero. During July and August many areas in Montana reach ninety degrees for most of those two months; temperatures over one hundred degrees are not uncommon.

A notorious Montana winter occurred in 1886, made famous by human suffering and loss of livestock. That year, following a dry summer and fall, a November arctic front dumped six inches of snow followed by plunging temperatures. By mid-February the snow was three feet deep and the temperature had reached minus fifty-five. Cattle and sheep perished by the thousands, with some "spreads" losing 90 percent of their herds. It was the end of the open range in Montana, forever changing both grazing methods and absentee-ownership patterns. The artist Charles Russell created a two-by-four-inch masterpiece titled "Waiting for a Chinook," a stark depiction of a starving, freezing cow. With that one tiny painting, which Russell also called "The Last of the 5000," he portrayed the disastrous cattle winterkill of '86.

Montana's elevation and latitude create weather that has determined much of our history. As an element of our economy and culture, it does more than shape our landscape; it shapes us as well.

THE STATE'S SYMBOLS

Montanans, like residents of other states, chose flora and fauna to represent our state. Our state flower is the bitterroot, our bird the meadowlark, and our tree the ponderosa pine. From our many fish we chose the blackspotted cutthroat trout, which is often eaten by Montana's most potent symbol, the grizzly bear.

Some of these symbols found their way into the journals of Lewis and Clark. That great American expedition traveled eight thousand miles through eleven states: up the Missouri to the Rockies, over the mountains, and down the Columbia to the Pacific, where they spent a winter before returning to St. Louis twenty-eight months after having set off. In Montana the expedition walked, floated, rode, climbed, and paddled more miles than they traveled in any other state.

On their return through Montana, the explorers divided their commands and separated, thus broadening their explorations. The only violence toward Native Americans—resulting in the death of a Blackfeet Indian at the hands of one of the expedition's members—occurred in Montana. And in Montana, the Shoshone Indian girl Sacagawea guided the expedition, pointing out which river to follow once they had reached the three forks of the Missouri. The only known physical imprint remaining

from the journey is Clark's inscription carved into the walls of Pompey's Pillar, a geological formation near the Yellowstone River that was named to honor Sacagawea's infant son, born during the westward trek.

In Montana's Bitterroot Valley the expedition got a close look at "the most terrible mountains," which seemingly blocked their passage to the ocean. In early September of 1805 on a creek-side plateau that they named Travelers' Rest, they rested before attempting the arduous climb. Montana is inexorably linked to Meriwether Lewis and William Clark, and to "their perilous service that endear them to every American heart."

Bitterroot Flower

The state flower was known and prized by the Native people long before it was seen by the members of the Lewis and Clark Expedition. Lewis tasted the root of the plant in the fall of 1805 and noted a taste too bitter for his liking but wrote that the Natives "eat them heartily." During the return trip Lewis described the flower in detail after finding it near the junction of Travelers' Rest Creek (now Lolo Creek) and Clark's River (now the Bitterroot). The Indians who knew these valleys and waterways as home—the Snake, Kootenai, Shoshoni, Salish, Kalispell, Nez Perce, and Spokane—prized the root for its starch and sugar content.

The bitterroot blossoms are approximately two inches in diameter, with color variations from white to reddish purple, the most common being rose red or pink. These tiny, cup-shaped flowers hug the ground, often blooming profusely in seemingly dry, subalpine soil.

In 1950, U.S. Supreme Court Justice William O. Douglas wrote, "I never see the Bitterroot blooming among the sage without feeing that I should take off my hat and stand in adoration of the wondrous skill of the creator." (*Bitterroot*, Jerry DeSanto)

The Meadowlark

Captain Lewis commented on the meadowlark in his journal, dated June 22, 1805.

The meadowlark is often found in open, grassy areas reciting its distinctive, variable song, which begins with a low, short whistle and ends with a musical rattle. The bird summers in the northern tier of the States and into Canada's northern provinces. Commonly seen on treetops, bushes, and fence posts, it is a small bird with a golden throat and underside, limited white tail, brown back and upper wings.

Montana's schoolchildren chose the meadowlark as our state's bird in 1930, and our legislature made the official declaration soon thereafter.

The Ponderosa Pine

In Montana, we have more conifers than deciduous trees—that is, more fir, juniper, hemlock, larch, pine, cedar, and spruce than we have aspen, birch, maple, and other leaf-shedding shade trees. Most of the western third of Montana is forested, and, as noted in the Lewis and Clark journals, the stately ponderosa pine is dominant throughout the Rocky Mountains. The tree can live for a century and a half, reaching heights of two hundred feet. Its seed cones are three to five inches long, and the luxuriant pine needles often reach ten inches in length.

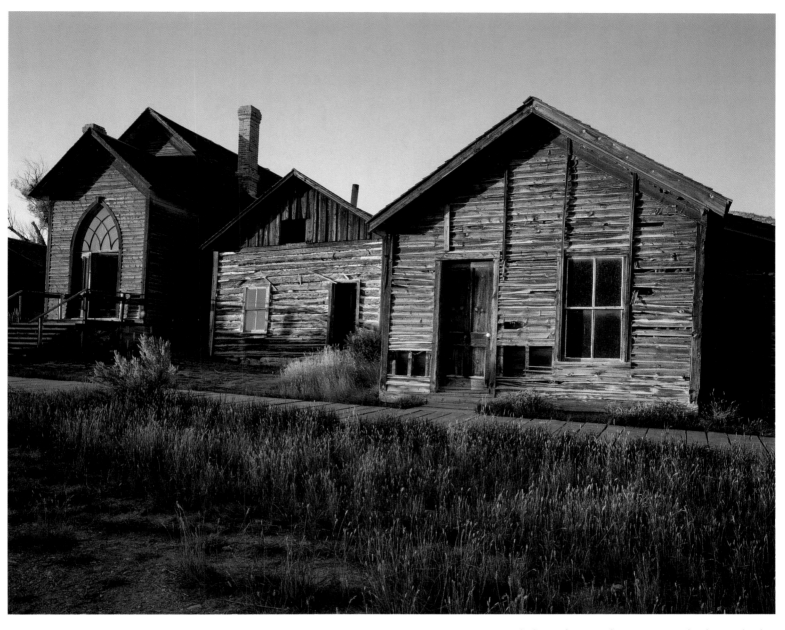

△ In 1954, Montana dedicated Bannack as a state park. The Methodist church, left, had been built in 1877. A year after gold was discovered at Grasshopper Creek, Bannack's population had grown to three thousand.

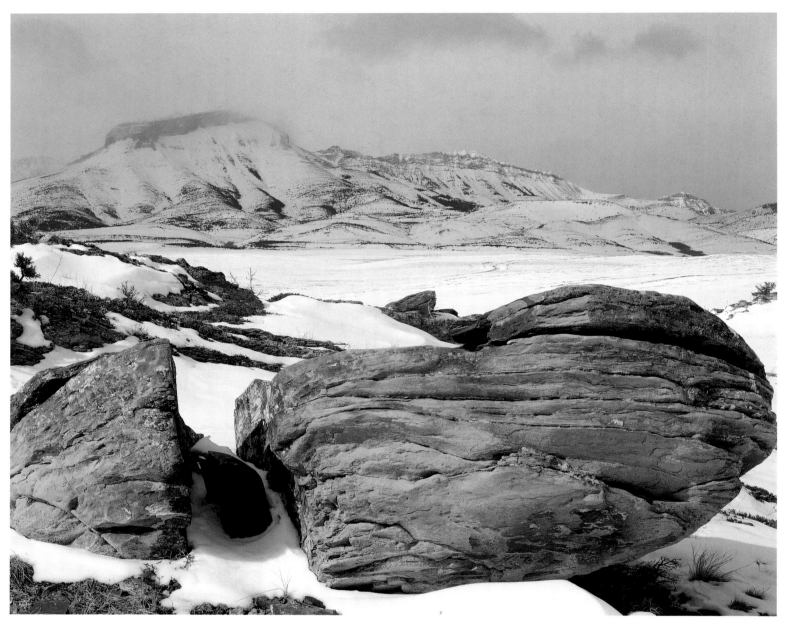

△ Deep winter arrives early, stays late, and, through an ongoing process of freezing and thawing that has continued for centuries, shapes the rocks of Ear Mountain near the Bob Marshall Wilderness.

In 1908 schoolchildren chose this conifer as Montana's tree; however, it was not officially designated until forty-one years later by our legislature.

The Cutthroat Trout

The members of the Lewis and Clark expedition noted a "sumptuous" meal of these trout, which were caught near the site of what is today the city of Great Falls. Two hundred years later, with populations dropping, the state fish is in trouble, particularly in the upper drainages of the Missouri system. They are particularly vulnerable to competition from other artificially introduced fish species; anglers and other environmentalists are making efforts to protect the fish from further depletion.

The Grizzly Bear

No other animal, including the state's ubiquitous horses and cattle, represents Montana as the grizzly does.

"We were now about to penetrate a country at least two thousand miles in length . . . the good or evil it had in store for us was for experiment yet to be determined." (Journal of Meriwether Lewis, April 1806.)

The Mandans and Hidatsas warned Lewis and Clark that they would likely encounter a fierce animal, so large and ferocious it was difficult to kill. At the end of April, Lewis and another man came upon and killed a grizzly with ease, noting that ". . . in the hands of a skillful rifleman they are by no means as formidable or dangerous as they have been represented." His bragging was premature. The great bear, *Ursus arctos horribilis,* presented constant peril for the next two months, chasing the explorers in and out of rivers, across the land, up trees, seemingly immune to the rifle balls fired into their bodies.

> [But the bear] took after them and chased 2 mean in to a cannoe. He pursued two of them . . . so close they were obliged to throw aside their guns and pouches and throw themselves into the river . . . so enraged was this animal that he plunged into the river only a few feet behind.

Lewis's early swagger was replaced with this final entry about the griz:

"I find that the curiosity of our party is pretty well satisfied with rispect to this animal."

The grizzly, originally a plains and foothills wanderer, is today, essentially, relegated to the mountains. With the steady and inevitable encroachment of people into these highlands, each year of the past thirty has seen increasing numbers of confrontations and deaths between grizzlies and people who get too close. The remaining sanctuaries for the grizzly in the Lower 48 are the Greater Yellowstone in southern Montana, and the Bob Marshall Wilderness and Glacier National Park complex near the Canadian border.

The great bear was voted our state animal in 1982 by fifty-five thousand students in 425 schools throughout the state. Despite its popularity as the state's official animal, the bear—as well as its protection, habitat needs, and the concern it causes the state's ranchers and timber harvesters—represents Montana's ongoing battle between extractive industries and the imperative to protect what is left of the state's wilderness. The bear, despite its aura of invincibility, is fragile: it depends on the complex, little-understood ecosystem, that functional interplay of animals, vegetation, and abiotic resources. In this age of diminishing wild habitat, the grizzly is the nation's miners' canary.

MONTANA'S GEMSTONES

Along with our five state symbols—the ponderosa pine, the meadowlark, the cutthroat trout, and the grizzly bear—we also celebrate as our state's gemstones both the moss agate and the yogo sapphire.

Perhaps because of Montana's colorful and important mining past, our citizens show significant interest in gemstones, particularly in the exquisitely fine-grained variety of quartz fiber and colored crystals of the moss agate, which is most commonly found along the banks and floodplain of the Yellowstone River. Along with the agate, we are fond of the yogo sapphire, which, unlike most sapphires, reflects rather than absorbs artificial light, thus retaining their brilliant colors.

THE BISON

Despite the reputation of the grizzly, the bison is the largest animal in North America. Mature bulls are often six feet high, ten feet from nose to tail, and weigh up to twenty-five hundred pounds. A herd animal, the bison once roamed two-thirds of the continent, covering much of what is now the United States and the Canadian provinces of Alberta, Saskatchewan, and Manitoba. At one time their numbers may have reached seventy million, providing the Native people with abundant sustenance.

However, in the 1870s the slaughter of the bison by commercial hunters began. Their hides had become valuable, and within fifty years the bison faced extinction. By 1900 the bison had been eliminated on the Great Plains. Following the railroad west into Montana, the hide merchants established shipping points, and by 1890 the animal had been virtually exterminated. Rapacious greed had reduced the abundant herds to eighty-five free-roaming buffalo.

To their everlasting credit, two Indians—Michael Pablo and Charles Allard—decided to nurture and expand a bison herd in Montana. By 1910, their herd had reached two hundred bison, the largest in America. In 1908, Montana's U.S. Senator Joe Dixon had introduced legislation to create a National Bison Range and to purchase land from the Salish, Kootenai, and Pend d'Oreille Indians. The eighteen-thousand-acre National Bison Range lies on the Flathead Reservation in northwestern Montana, home to not only bison but to bighorn sheep, deer, bobcats, antelope, elk, birds, prairie grasses, and plants. The herd is maintained at about 350 animals in order to match the carrying capacity of the range. A few forward-thinking Indians and the National Bison Range have rescued a magnificent animal at the last moment.

CITIES AND TOWNS

During my eighteen years of service in the U.S. House of Representatives, my wife, Carol, and I lived in two places: the old Civil War town of Manassas, Virginia, and Chevy Chase-Kensington, Maryland.

Manassas is a southern town in northern Virginia—southern though by virtue of its two Civil War battles and the preferences of its older residents. Chevy Chase is a neighborhood just outside of the D.C. city limits and bordered by Connecticut Avenue. We lived in Manassas for seven years and in Chevy Chase-Kensington for eleven. They were fine places, nice people, good neighborhoods—but somehow the people seemed disconnected from place. I suppose the pace, logistics, and demands of today's big-city living have created a separation of people from neighborhoods, from communities, and from one another. During my time in those surroundings I found myself missing the feeling that comes from knowing a place and its people well. Upon our return to Montana, we found it easier to be citizens—and good neighbors.

People adapt to their physical and natural surroundings. In the more populated cities, families are required to juggle a complex series of time-consuming daily chores: waking early, getting the children off to school, dropping the youngest at daycare, finding the quickest traffic routes, and continually practicing patience in the ever-present snarl of traffic. In D.C., my wife, children, and I negotiated such logistics every day.

On many weekends, however, I flew home to Montana on congressional business: individual constituent meetings, convention or conference appearances, town meetings, and other state duties. After a couple of years of that transient existence, it became wonderfully apparent that not only is America a big place with great diversity, but that people in Montana live very differently than those who live in the heavily populated cities. I came to understand that the reason for those differences is more than the crush of population; it is also a function of place and space.

The vistas of the high grassland plains expand one's imagination, while at the same moment offering assurance of one's place in that great expanse. Montanans—gazing up at the timelessness of mountains—are reminded of their own mortality.

More than anything else, though, I was struck by how Montana requires—insists—that one slow down. Despite the nationwide renown that the state once had no speed limit, the truth is that Montanans, for the most part, drive automobiles just as they do most things—without haste. The pace of daily life in this place—and I'm sure in others like it—is very comfortable; one seldom sees anyone in a hurry, no one pushes ahead in the grocery lines (lines which seldom contain more than a half dozen people), and there is no weaving and passing of cars intent on rushing through traffic lights changing from yellow to red. Montanans will hold the door for an oncoming stranger and do it, seemingly, not out of an artificial politeness. Montanans do it because of the unhurried nature of their communities, and perhaps with an understanding that such politeness is necessary for community to flourish.

The claim is sometimes made that the independence of Montanans makes us chafe under the regulatory restrictions of too much government. A visitor gazing at a political map of our state's jurisdictions would likely doubt that claim. Within our 146,000 square miles are fifty-six counties and approximately three hundred cities and towns, although not all of them are incorporated. We have, in fact, created a lot of government and a lot of communities, and we have insisted upon doing so despite—or perhaps because of—a small population. Although our population has increased each decade since statehood—with the exception of the Depression decade of the 1930s—there are still fewer than a million of us at the turn of this twenty-first century. In 1880 we numbered 39,000. By the end of the Roaring Twenties we were 550,000. Seventy years later, the 2000 census counted 902,195 of us. From our beginnings as a territory, however, we have seemed intent on establishing and applying the order and restraint inherent in many governmental entities.

The earliest "towns"—rendezvous points, trading and hunting villages—were, of course, settled and populated by the Native people of the high plains and Rocky Mountains. During the winter of 1804–5, Lewis and Clark found shelter in the Indian villages near what is now the Montana–North Dakota border. Those villages were more populated than the city of St. Louis, from where the expedition had been launched.

Those early Montana villages were inhabited by Indians who moved in rhythm with the seasons and the wandering bison, leaving little trace in any single location. That, along with the terrible reality of forced relocation of Native people, has led many people to mistakenly believe that the first Montana settlements were established in the early 1800s.

Indeed, the beginnings of those "second generation" villages began with mountain men, fur trappers, and traders such as Jim Bridger and Manual Lisa, who owed much of their understanding of the waterways and mountain passes to explorers such as George Drouillard and John Colter, both members of the Lewis and Clark Expedition. The British-owned Hudson's Bay Company and the St. Louis company of Henry-Ashley—which competed for the fur trade in the Rocky Mountains in the early and mid-1800s—employed trappers and traders who set up winter encampments and trading forts, often at river junctions. A few of those early, crude establishments have evolved into today's towns and cities throughout the Northern Rockies: Fort Laramie, Riverton, and Dubois in Wyoming; Salmon and Rexburg in Idaho; and Livingston in Montana.

Fur and gold fueled these settlements, which provide us with some of America's most colorful, raucous history. The author Joseph Kinsey Howard, in his 1943 book *Montana: High, Wide and Handsome,* wrote, "A little more than fifty years ago [Montana's] first exploiters were slaughtering 150,000 buffalo a season on its plains, brawling in its frontier bars, robbing its gold-laden stages, and swinging from vigilante gallows."

Another renowned Montana historian, K. Ross Toole, in *Montana: An Uncommon Land,* wrote about the early miners who found their way to Montana following the gold and silver discoveries in California, Colorado, and Nevada: "It was they who contributed most of the knowledge and most of the techniques. It was they who set the form for the laws and the courts."

"The rich placer deposits, fabulous as some were, were quickly gone. The camps and towns (or cities, as their residents called them) became ghost towns. Most of them had a brief and fitful existence. They were located, quite naturally, only with reference to gold. But superficial as placer mining was, the miner, unlike the trapper, was more than a shadow. It was the miner that merchants came to sell to, that thieves came to steal from, and that farmers came to feed. And after every stream had

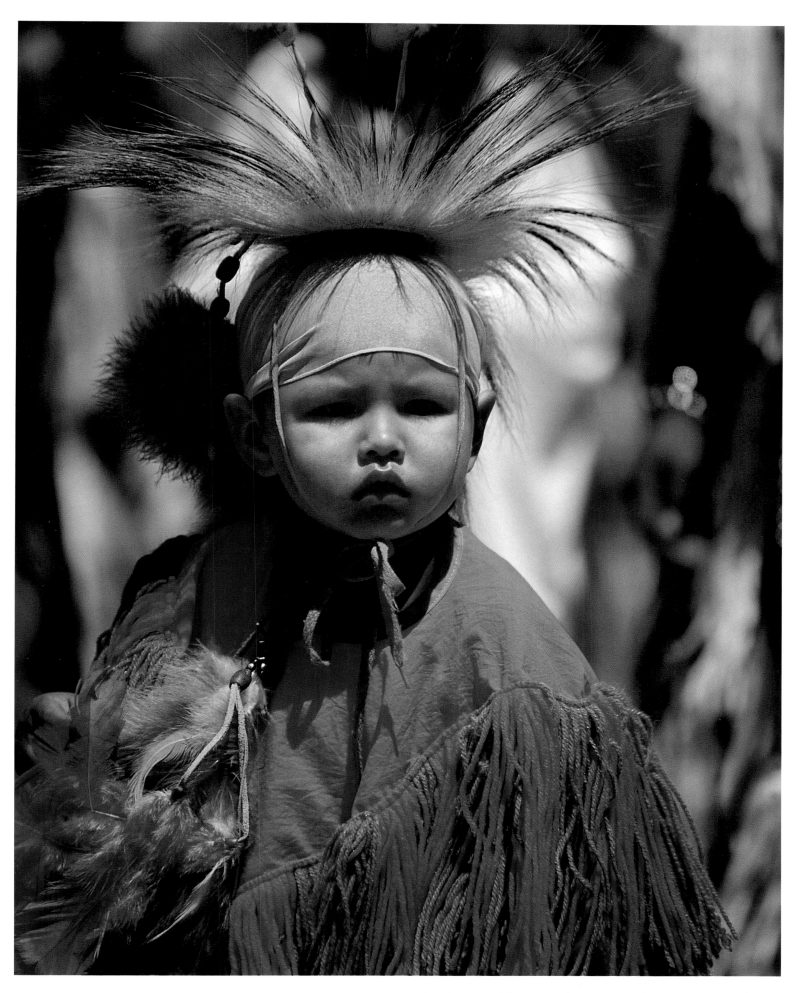

△ A native son celebrates North American Indian Days, an annual event hosted by the Blackfeet Tribe. Indian dress with its bright beading and plumage would receive accolades on any Paris fashion show runway.

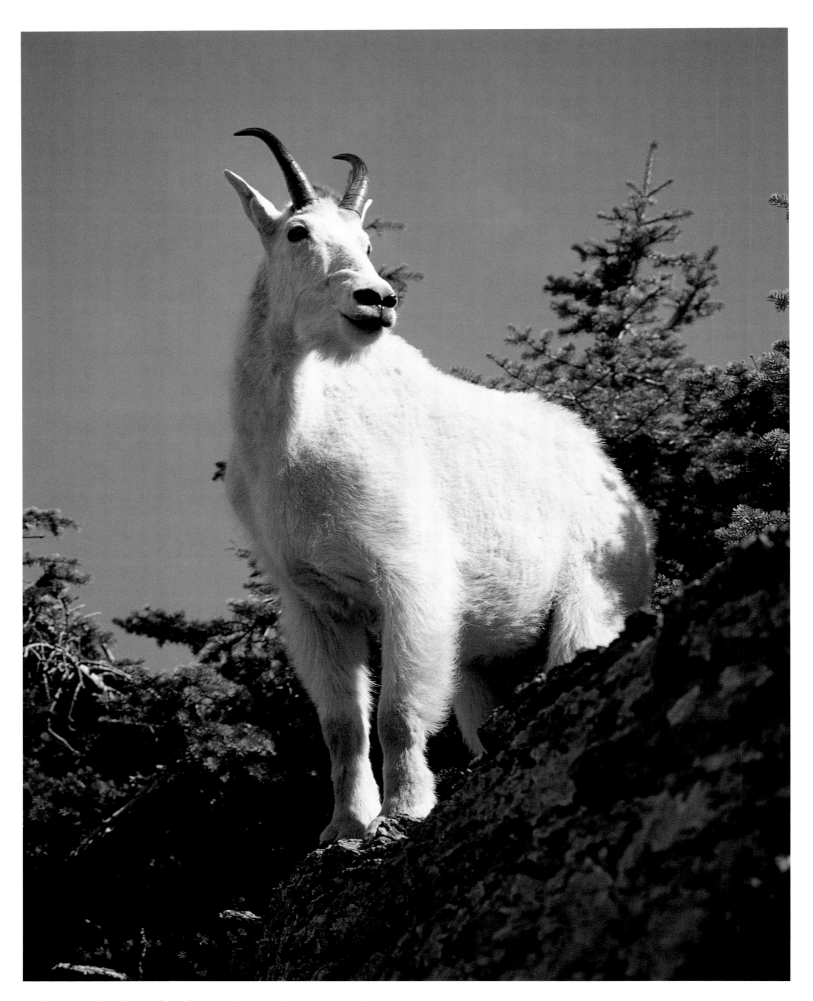

△ The extraordinarily surefooted mountain goat *(Oreamnos americanus)* flourishes in many of the state's still-wild high places. As winter arrives, the goats will congregate in the lower valleys.

been scoured of its dust and nuggets and the prospector had moved on, civilization kept a toehold, however tenuous."

A precious few of those early toeholds of civilization have evolved into today's cities: Helena, Montana's capital; Philipsburg, in the beautiful Flint Creek Valley of southwestern Montana; and Cooke City, more town than city, still enduring near the northeastern entrance to Yellowstone National Park.

Hundreds of Montanans live in neither towns nor cities, and yet their contributions to the state's economy and diversity are very significant. They live out there on the range. They are our farmers and, of course, our livestock producers—Montana's cattlemen.

Cattle were first driven to the area in the early 1830s, arriving as a part of the earlier Green River rendezvous to our south. The upper Missouri had cattle in 1846, as did the St. Mary's Mission in western Montana.

Early day miners wanted to eat beef, and the cattle business boomed, spreading from the western valleys across the broad grasslands of the eastern plains. Both the cattle and sheep industries in Montana have experienced boom and bust. Weather, freight costs, distance, foreign markets, fluctuating demand, overstocking, absentee ownership, wolves, rustlers, and grizzly bears have combined to make ranching a difficult enterprise. However, those who engage in the cattle industry have provided the state with a critically important element of our economy. Although the cattle frontier ended with the closing of the open range more than a century ago, Montana's livestock producers persist and prevail, but are no longer in the image of the nomadic, rowdy cowboy. Today, Montana's cattlemen are part scientist, part businessman—an integral piece of our culture and economy.

The state's crop producers, farmers, are vitally important to the state's economic well-being. The early farmers in the area were called honyockers, and they arrived by the tens of thousands between 1909 and 1918. Most of them were driven from the land by weather and their own inexperience. Those who remained and whose descendants are still farming the land have planted many millions of acres, most often in wheat. As it is throughout the nation's breadbasket, economics and federal laws have virtually assured the loss of small farmers and the creation of ever-larger landholdings.

Some farmers could sell their property for its real estate development value and retire handsomely. A few have—but most persevere, clinging to the remoteness and the hard work. Whatever it is—stubbornness, loyalty, or the intense need to work the land—the many farmers of Montana are a vital part of our yesterdays and our tomorrows.

Each of our cities and towns, including those populated only by ghosts, has a colorful past. They were built by a people who, in the words of former U.S. Senator and Ambassador Mike Mansfield, ". . . drove, tumbled, and stumbled into the twentieth century. Our history is of a people drawn from many sources, headed toward the glowing promise of a western frontier. The history of Montana is the song of a people who, repeatedly shattered, have held together, persevered, and, at last, taken enduring root."

For the most part, we have put those roots down in cities and towns. The names of many of those towns reflect a people "drawn from many sources." The names of some of our towns represented "back home" to early settlers: Amsterdam, Belgrade, Dunkirk, Florence, Glasgow, Kremlin, Lima, Malta, Manchester, Sumatra, Verona, and Zurich.

Although there are only about seven of us per square mile, we do tend to bunch up. My old friend K. Ross Toole put it this way: "Montanans have a strong sense of belonging—a sense which grows perhaps, out of their common necessities. They live, after all, in a place where nature can turn a face of cold inhospitality upon them in an hour's time. Without kindness, friendship, and cooperation, they could not stand up in the face of it."

Ross, in making that case, left out a few obvious personality traits of some Montanans. While friendliness abounds in Montana, the hard times that are part and parcel of the landscape require a determination and persistence that manifest as the tight-lipped, steely-eyed attitude so common here. Many westerners want to be left alone, and they bristle at intruders. Changing economies have caused frustration, denial, and anger, which make fertile ground for extremism. Be it the far-right militia or the far-left Unabomber, political demagoguery and dangerous discontent have occasionally found root in the remoteness of Montana.

Butte

Butte is the city of my youth. A bawdy, boisterous, ethnically diverse city heralded for sitting on the slopes of The Richest Hill on Earth, Butte was the nation's greatest mining camp.

The author Bill Bevis says this about Butte and its place in Montana: "Unlike neighboring agriculture states, we had an international center. Butte was tied into the world and its politics. It was a city of strong individuals, of thinking intellectuals. In a state of wheat and cows, Butte was the exception—a center of excitement and ferment."

I came of age there in the 1940s and 1950s. The city, despite a population of only fifty thousand, had a distinctive metropolitan feel. Its architecture, its multiple languages, and its ethnic neighborhoods (Dublin Gulch, Chinatown, Finn Town, and others) resembled those of the nation's great cities. Presidents (Theodore Roosevelt, Franklin Roosevelt, Truman, Taft, Harding, Kennedy, Eisenhower, Lyndon Johnson) courted the voters in Montana's once most populous and politically savvy city, and celebrities such as Charles Lindbergh, Will Rogers, Mark Twain, W. C. Fields, and many others came to see Butte and be seen by its residents.

As a young man, I often danced the night away at the Columbia Gardens Pavilion. The Gardens, on the outskirts of Butte, was a beautiful, magical recreation site with hundreds of acres of gardens, lawns, and thrill rides. The dance floor occupied fifteen thousand square feet. A night of dancing in the elaborate pavilion—its many windows facing the surrounding flower gardens—was a delight. People danced to the live music of Glenn Miller, Duke Ellington, Guy Lombardo, Benny Goodman, Tommy Dorsey, and Harry James. The music is gone now, as is the entire Columbia Gardens, replaced by an open-pit mine.

Butte's mining history is divided into three eras. The first began shortly after the Civil War when two prospectors—G. O. Humphrey and William Allison—dug a shallow hole and hit

gold. Within two years the town had five hundred people. The boom lasted for a few years until the placer deposits were worked out. The next era, of silver, ended with the price crash in 1893. By then the town had approximately thirty thousand people, served by twelve churches, nine schools, seven theaters and 250 saloons.

The third era saw copper as king. The War of the Copper Kings lasted from 1889 to 1906, during which the mining millionaires W. A. Clark, Marcus Daly, and Augustus Heinz battled for control of the world's richest veins of copper, gold, and silver. The Copper Kings were held in check by Butte's workers, who organized America's first miners union and whose determination and solidarity made them the best-paid industrial workers in the world. However, they paid a great price: Butte's miners were often the victims of terrible mining accidents—cave-ins and underground explosions—such as the 1917 disaster at the Speculator Mine, which killed 164 workers.

From those years to the early 1980s, the dust never settled. As its population neared one hundred thousand, Butte was a wide-open, unpredictable paradox, referred to alternately as "merciful mother of the mountains" and "perch of the devil." The city was charitable but ruthless, cruel but kind, joyous but tragic. It was like a lady without makeup who was tender during hard times, but aloof and fickle when times were good.

The authors Dan Baum and Margaret Knox have written that "Butte, Montana, is a place where the wild west met the industrial revolution. . . . Over the years, Butte literally consumed itself in its frenetic gouging of the earth's riches. Hundreds of miles of shaft and tunnel snake beneath this mile-high city, some plunging down to sea level. . . . When the underground mines lost their competitive edge in the 1950s, the Anaconda Company began carving out one of the biggest open-pit mines on earth."

That cavernous hole, the Berkeley Pit, ceased operation in the early 1980s and ever since has been slowly filling with acidic, metal-laced groundwater that flows from the abandoned shafts under the adjacent hills. The lake, now a thousand feet deep, is the largest body of toxic water in the nation, composing the uppermost portion of the longest superfund site in the nation, with streams, rivers, and waste dumps slicing dangerously along the length of the Clark Fork River basin across western Montana. Butte may well be considered the template of America's industrial revolution: high times followed by high costs, boom followed by bust.

The price for that century of mining is now being paid. Butte, when the big operation closed in the early 1980s, understood that its economic future lay elsewhere. In the Northern Rockies, copper, gold, and timber were no longer king. Decreased productivity, plunging world prices, and diminishing supply had assured the end of those eras of high employment and easy profit. Astonishingly, Butte and its sister city of Anaconda (the Smelter City) let the past go and with only an occasional nostalgic backward look have moved aggressively to diversify their economies. With the public's financial help, applied technology companies were started. Light manufacturing and recreation jobs were created. The city of Anaconda sealed a waste area with a world-class golf course, attracting thousands of visitors and players each year.

Butte's past and its promise make it a unique American city. Those of us who know it as our hometown recognize the old girl's blemishes, but we can't help agreeing with the final stanza from a poem written by Berton Braley early in the last century:

Butte

Ugly and bleak? Well maybe,
But my eyes have learned to find
The beauty of truth not substance.
The beauty that lies behind.
Her faults and sins are many
To injure her fair repute,
But her heart and soul are cleanly.
And she's beautiful dear old Butte.

Lewistown

Not far from the geographic center of Montana lies the lovely Judith Valley. The Judith River, which helped carve the valley, was named in 1805 by William Clark in honor of a young woman back home in Virginia. Clark and Judith Hancock were married immediately following his return from the expedition. In the Judith Valley is the small, friendly city of Lewistown, which by its official founding in 1884 already consisted of two hotels, a school, four saloons, and a new jail that was being constructed at the cost of $1,295.

Lewistown's early services to the surrounding farm families included a roller mill, which produced flour from locally grown wheat. The citizens of Lewistown have always shown strong interest in civic improvements, be it the construction of a town drainage system in the 1890s, the turn-of-the-century theater, or the ever-improving school system.

Lewistown has witnessed both high times and depression. Winter storms and summer droughts have been all too common for people living on these high plains, where weather is a great determiner, "counting coups" on both success and failure.

A good sense of a community can be found by thumbing through a few stories in any local newspaper. A collection of Lewistown's stories have been assembled in a book, *The First 100 Years*. Randomly flipping through its pages, I came upon these items from 1959:

• *A baby girl born New Year's Day to Mr. and Mrs. Warren Folda . . . claimed the honor of being the first baby in 1959.*
• *Lewistown police raided a teenage drinking party and, in the process, captured several youth involved in a string of burglaries . . . much of the loot taken in the break-ins was stashed in a small cave on the outskirts of town.*
• *Joe C. Wicks, who farmed with his father near the South Moccasin Mountains, was named Montana's "Outstanding Young Farmer of the Year."*
• *The recent fires that destroyed Lewistown's two major hotels fueled the enthusiasm of local civic leaders to build a new hotel.*
• *The first problem facing the City Council after it reorganized under the new mayor was the perennial one of what to do about dogs running loose in town.*

▷ *A small alpine lake, or tarn, with 12,500-foot-high Silver Run Peak, Absaroka-Beartooth Wilderness*

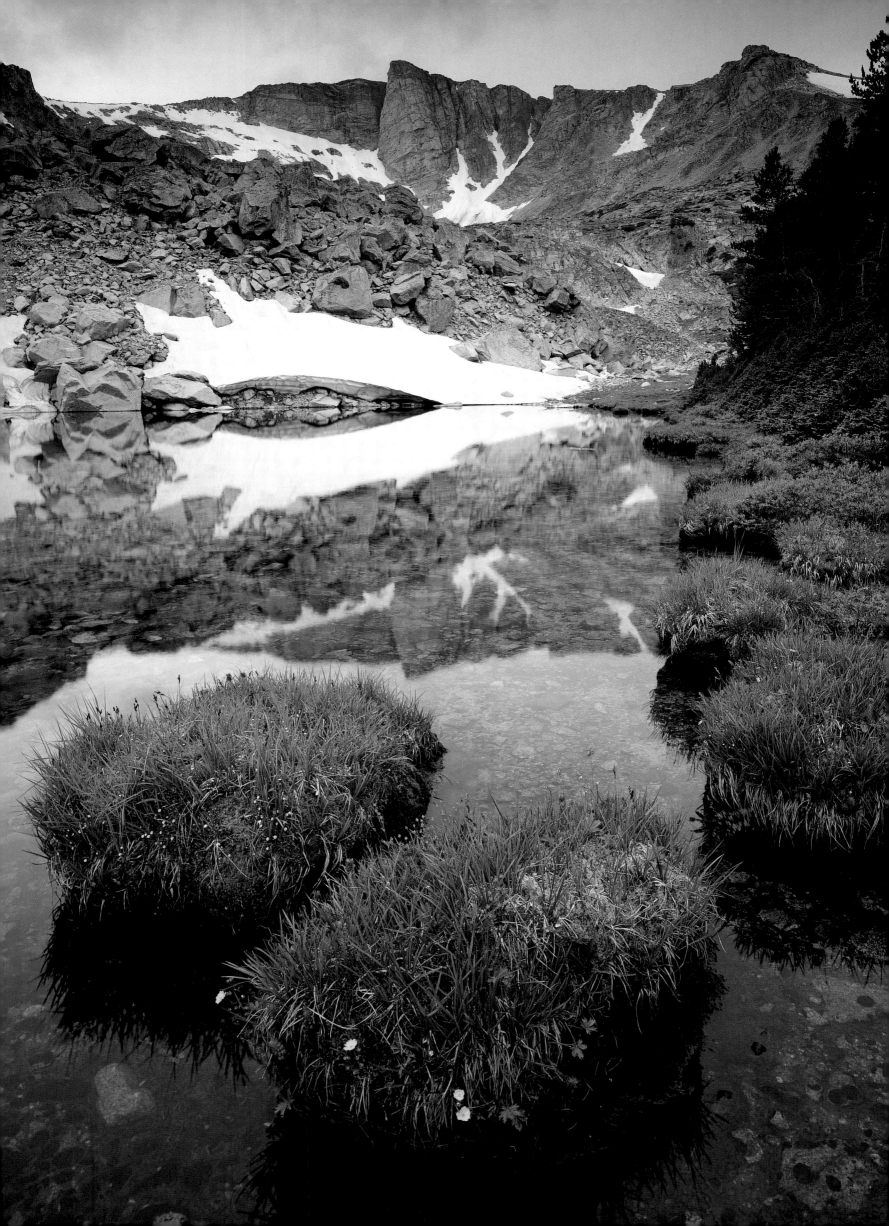

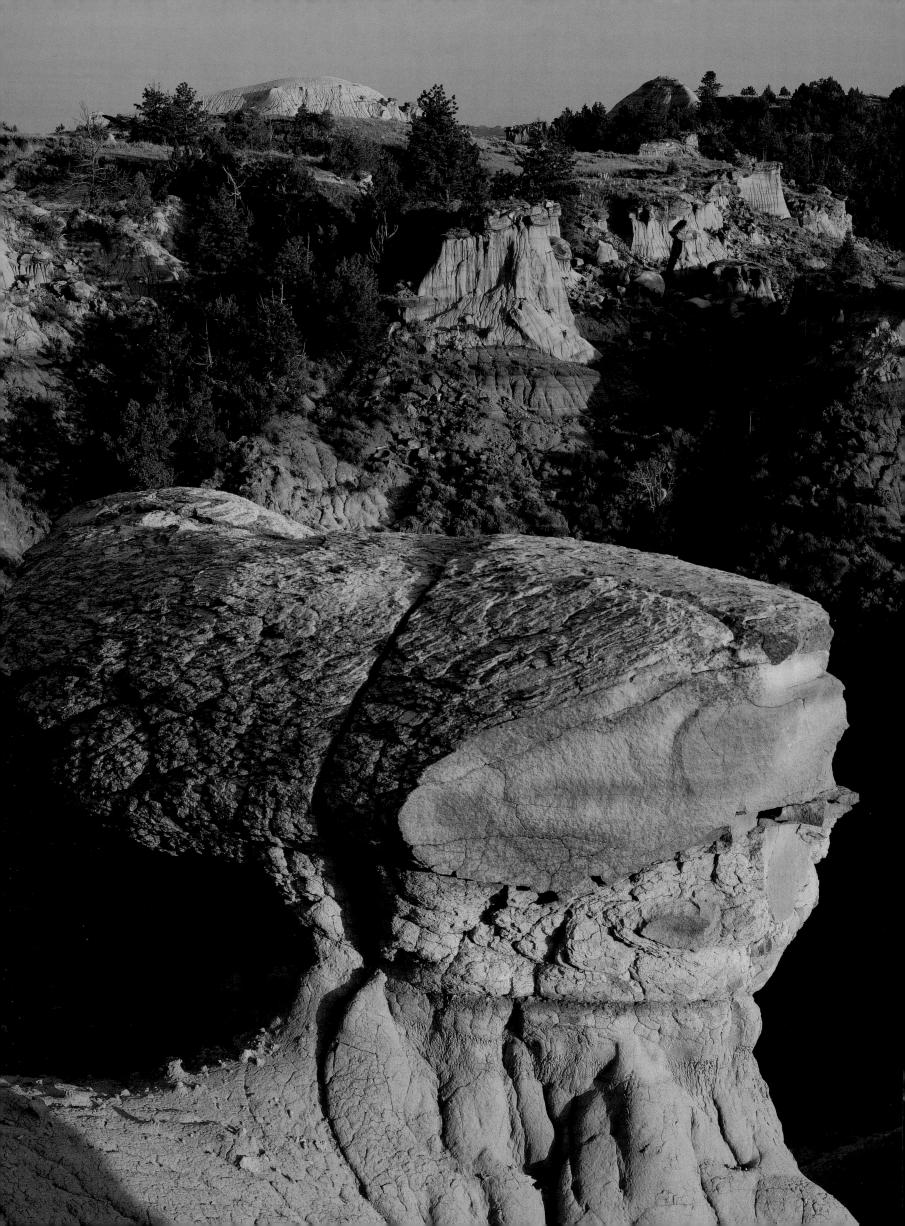

That year's news ended with this:

Three Air Force jets from Malmstrom Air Force Base crashed into a hillside west of Lewistown during a snowstorm. Four airmen were killed in the accident, while two others managed to parachute to safety. The two that ejected landed on the King's Colony Hutterite Ranch.

In cities like Lewistown the ordinary seems extraordinary and the extraordinary becomes ordinary.

Missoula

Missoula is a lovely, low city extending from the banks of a river to mountains on every side. Lying in the Rockies of western Montana at three thousand feet above sea level, the city borders wilderness in every direction: to the east the 1,500,000-acre Bob Marshall complex; to the west the 1,300,000-acre Selway-Bitterroot; and to the north the 70,000-acre Mission Mountain Wilderness—the first land ever to be formally designated wilderness by Indian tribal government, the Salish-Kootenai. In addition, a few miles south of Missoula is the 28,000-acre Welcome Creek Wilderness, and just on the edge of town is the 60,000-acre Rattlesnake Wilderness and National Recreation and Education Area, every Missoulian's favorite retreat on hot summer days. I was pleased to sponsor the legislation that created that wilderness designation.

Both historically and geographically, Missoula is somewhat different from the rest of the state. Never a cowboy or farming town, the city was barely affected by the early prospectors' rush to find precious metals. It was, however, a center for western Montana's early logging and milling operations. The city is also home to the University of Montana, the flagship school of our state's system of public colleges and universities.

Missoula is located on the bed of what was once an enormous prehistoric lake, whose waters at one time reached a depth of 950 feet in the Missoula Valley and 2,000 feet north of the city. Impounded by glacial ice, the waters of Glacial Lake Missoula would slowly rise until they eroded the ice, releasing an enormous flood of water. The "world's great flood," as it was referred to by Norman MacLean, the author of *A River Runs Through It,* happened several dozen times over millions of years, scouring what is now Washington State as it raced toward the Pacific Ocean. The lake level varied, and rill marks of its differing shorelines are timelessly etched into the hillsides above the city.

It is often said that living in Missoula is addictive, and this may be true. Certainly, like many college towns, it is a pleasant, progressive place, high on controversies—particularly those of a political nature. In such places, especially those in beautiful, bountiful settings, the living is vigorous but easy.

Miles City

While Missoula lies near Montana's western border with Idaho, on a line almost directly across the state to our eastern border with North and South Dakota is one of Montana's most colorful and historic towns: Miles City.

The city and its nearby army encampment, Fort Keough, were founded in the aftermath of the Battle of the Little Bighorn—Custer's Last Stand. The fort was constructed during the fall and winter of 1876 under the command of Colonel Nelson Miles. The town, named for the colonel, was a few miles away. Its permanence was guaranteed five years later with the arrival of the railroad.

Miles City may well be the nation's Cowboy Capital. Although it has become the area's medical, economic, and academic center, it is better known for its annual Bucking Horse Sale—a several-day auction and celebration of the West's cowboy culture.

THESE MONTANANS

My Irish immigrant grandmother Lizzie Keough often gave me this advice: "Remember, sonny, people are just people wherever you go." I've never understood all the meaningful facets of that simple declaration; however, I have realized that, in part, she was referring to the traits that are shared by all of us. Despite our ethnic, religious, and cultural differences, we are bound together in our common humanity.

Each state is populated by generous, friendly, wise, colorful members of the human family, and the people of any given state should not expect the rest of us to believe that they are superior simply because of where they live.

There is, nonetheless, an identifying characteristic about Montanans that I believe was best described by the author Norma Tirrell in her 1988 book *We Montanans:* "The Montana neighborhood is peopled with a surprising diversity of characters whose common bond is their attachment to their state. If there is something truly different about Montana—something that won't let go—it is the people who won't let go of Montana."

From the first residents, the Indians, to the mountain men, fur trappers, and river traders, the state has attracted characters—people confident in their own ability to live and flourish on the edge.

Montana is one of the few remaining western states with cowboys and Indians—real live ones—conducting their daily lives in pursuits unlike those practiced by almost any other people. Of all the people who enrich Montana's experiences, the sheepherders, linemen, farmers, carpenters, loggers, and all the rest—those who have captured my attention during these past two decades are the artists and writers.

Oh what a treasure they are—enlivening our understanding of place and deepening our appreciation of purpose. I believe Montana has more dancers, poets, writers, singers, painters, and sculptors per capita than does any other state. They are everywhere, enriching our state through the constant reflection of truth.

Montana is a good place for reflection. Our artists help us know who we are, where we live, and our connection to each other and to place. We know why, underfoot, the fawn sits tight and overhead the eagle dives. In part because our artists uncover truth, we Montanans know that we can stop trying to change the course of determined rivers. We nod our understanding of a June snow. Because of artists and their spinning we have moved toward understanding.

Montana is rich with artists and enriched by them.

NATIVE PEOPLE

A colleague at the University of Montana's Center for the Rocky Mountain West, Professor Bill Farr, defines the Northern Rockies as "a place where Indians live." As with the cities

described in a previous section, the Indian tribes also have sovereign governments.

In Montana there are more than sixty thousand Indian people, a diverse group of individuals distinct in their various languages and cultures, belonging as they do to separate tribes that are very different from one another. At least a dozen unique groups of Native people lived within or traveled through the area now known as Montana. The largest of these groups, commonly thought of as tribes, were the Assiniboine, the Blackfeet, the Cheyenne, the Chippewa, the Cree, the Crow, the Gros Ventre, the Kootenai, the Little Shell, the Salish, the Sioux, and the Nez Perce. Many of the tribes' leaders are well known to most Americans: Sitting Bull, Crazy Horse, Plenty Coups, Dull Knife, Charlo, Heavy Runner, Rocky Boy, Little Bear, Stone Child, Little Wolf, and Chief Joseph.

Although many Americans tend to stereotype Indian people, most of us have come to understand that the history of Native Americans during the past two hundred years is scarred with atrocities inflicted by the white majority. When European settlers arrived in North America, it is estimated that ten million people were already here. Within 150 years, those Native people had been reduced to approximately 248,000. The spiritual leader Tatanka Yotanka—Sitting Bull—said of whites, "These people have made many rules that the rich may break but the poor may not. They claim this mother of ours, the earth, for their own and fence their neighbors away. Their nation is like a spring that overruns its banks and destroys all who are in its path."

Early Sites

Throughout Montana there is ample evidence of early civilization. Tipi rings, cooking pits, pictographs, vision quest sites, hunting and butchering grounds, and dancing grounds prove that the ancestors of Montana's Indians—the Kootenai, Salish, and Pend d'Oreille in the northwest, and the Shoshone in the state's southwest—lived here at least five hundred years ago. It is also likely that Native people occupied large parts of the continent fifteen thousand years ago.

Today's Indian Citizens

Most Indians living in Montana call their reservation home. There are seven reservations; the land within them—8,300,000 acres, or 9 percent of the state—is owned by Indians, a small portion of what they once owned (although the concept of land ownership is not comfortable for many Native people).

The reservation system that was started in the mid- to late-1800s has culminated in tracts of land reserved for Indian tribes. These reservations—Fort Peck, Fort Belknap, Rocky Boy, Blackfeet, Flathead, Crow, and Northern Cheyenne—are located throughout the state, with five in the east and two in the west. The people living on them are as different from neighboring Indians as the German are from the Swiss or the French are from the English.

Some reservations are home to Indians from several tribes. For example, Fort Peck in northeastern Montana is home to both Assiniboine and Sioux. In north-central Montana, Rocky Boy's citizens are from two distinct tribes: the Chippewa, largest of the tribes from the Great Lakes area, and the Cree, who lived to the north in what is now Canada. Near Glacier National Park is the Blackfeet Reservation, Montana's largest tribe, whose international confederation includes the Blood, Piegan, and Sikista people who live in the Canadian province of Alberta.

Native Americans are a significant, vital part of today's Montana. They are emphatically not relics of a past, museum pieces, or antiquities. Like all citizens, they are important to the state's economy and culture. Their significant contributions to education, to the arts, and to commerce have enriched our past, informed our present, and given promise to our future. It remains true that we all have much more to learn from each other; that, too, is our assurance of a better future.

RIVERS

They begin in the high country, a collection of snowflakes, raindrops, and trickles merging into meandering rivulets, joining with streams rushing to find their lower channels, carved millions of years ago by ice and water. Montanans know the names of these waters as well as they know the names of their own relatives: the Yellowstone, the Missouri, the Big Blackfoot, the Madison, and the Big Hole.

These and many other rivers throughout the state were vital in the development of our commerce. The early steamboats, flatboats, canoes, and pirogues carried the explorers, sodbusters, miners, and those who followed them. Lewis and Clark found these rivers "quite practicable and by no means dangerous."

In Montana's high plains the river corridors are broad, carrying the lifeblood of water to areas that, without these rivers, would be sagebrush deserts. Eastern Montana's rivers, including the Yellowstone and Missouri, are usually calm, languid stretches dotted with occasional campsites and offering a paradise to recreational floaters and fishermen.

In western Montana, where the majority of the rivers flow, the steeper terrain forces white water through narrow gorges, over waterfalls, and into broad valleys between mountain ranges. Along the banks and slopes live abundant wildlife: bear, deer, elk, bighorn sheep, waterfowl; above soar the osprey and the eagle.

These rivers and the Continental Divide that births them are the prime feeders for the Missouri and Mississippi Rivers to our east and the Columbia River to our west. The protection of Montana's watersheds and rivers should be an American imperative.

I hesitate to write about only a few of Montana's splendid waterways, for every one is crucial to thousands of species, including humans, who count on water to sustain them. However, let's "dip our line" into a few fine rivers.

The Madison

Probably America's most renowned fishing river, the Madison flows 133 miles through forested slopes and open valleys to create—along with the Jefferson and Gallatin Rivers—the great Missouri. It begins in Yellowstone National Park, and in its upper reaches creates Hebgen and Quake Lakes before gliding through the Madison Valley, with its ranches, farms, small towns, and picnic areas dotting the river's banks. Containing thousands of native fish per mile, the Madison is unique: no hatchery fish are released into the river. During the salmon-fly

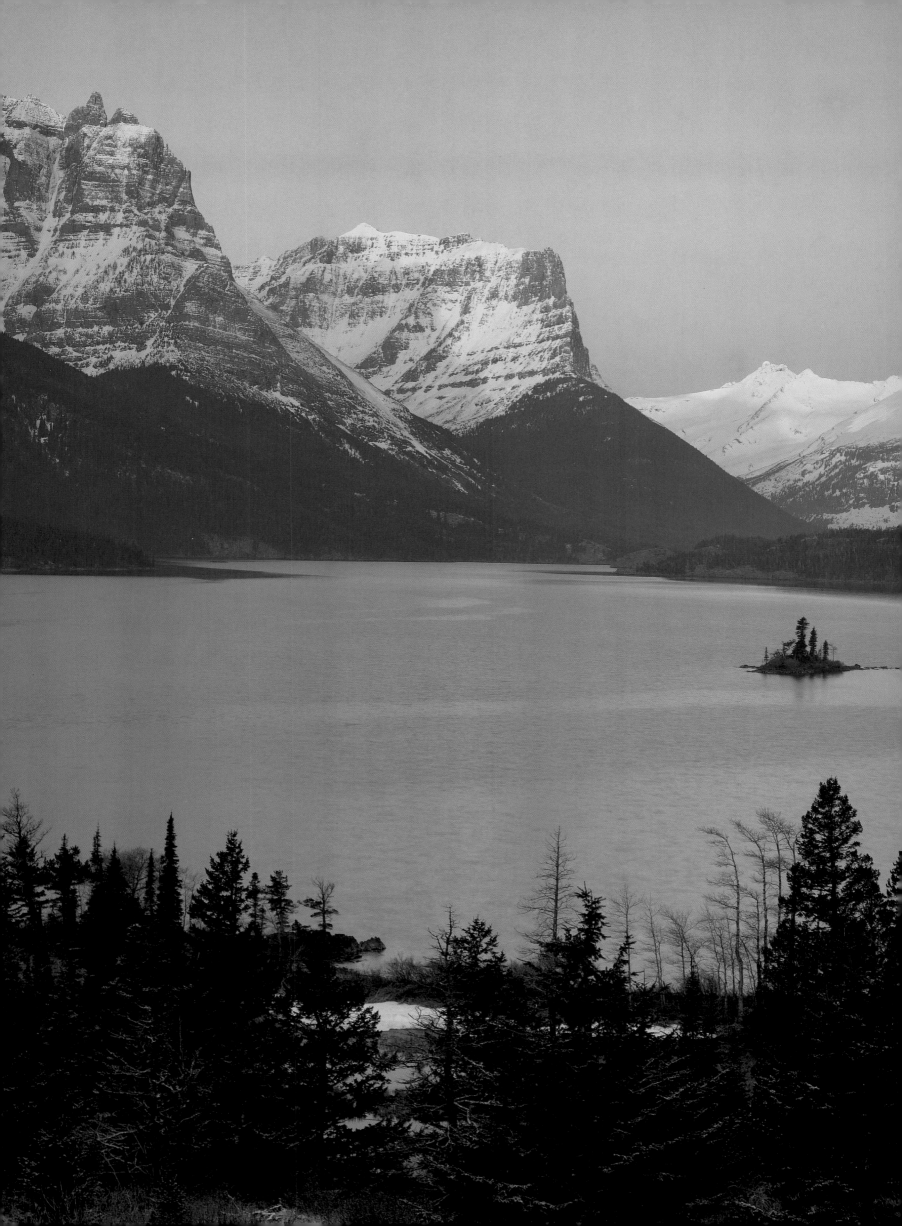

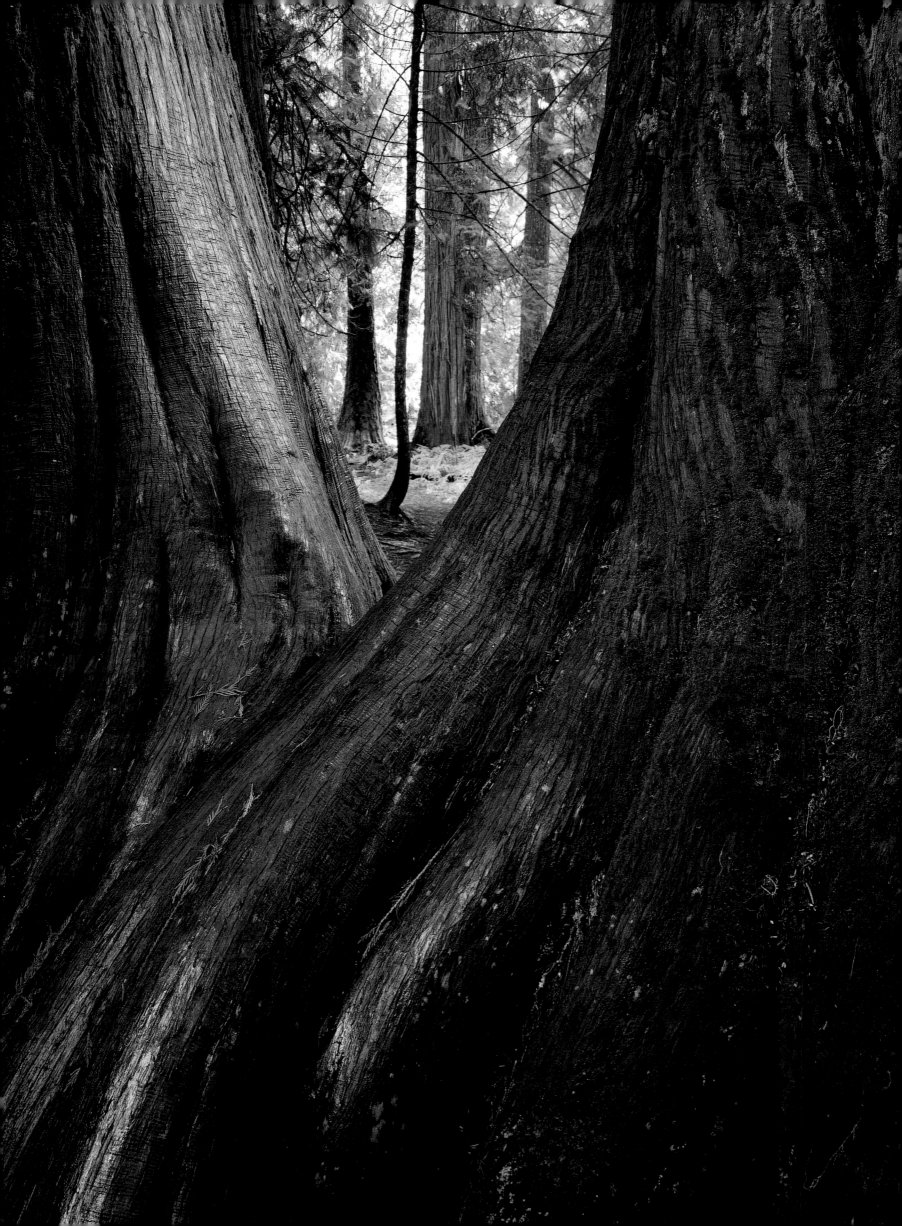

hatch, the trout go into a feeding frenzy, and even those of us who make no claim to being great fly-casters can do well by drifting imitations toward the hungry rainbows and browns. This blue-ribbon trout stream is threatened by whirling disease, over crowding by sportsmen, occasional drought, and dewatering.

The Clark Fork

The Clark Fork of the Columbia could serve as a template for abused American rivers that are now in the process of recovery.

The Clark Fork begins its three-hundred-mile journey in the hills above Butte and ends in Idaho's glittering Lake Pend Oreille. Near the river's head is the mile-wide, thousand-foot-deep Berkeley Pit, the remnant of one of the world's largest open-pit mines, abandoned now and filled with thirty billion gallons of toxic soup that continually leach in from the ten thousand miles of abandoned mine shafts, stopes, and tunnels of Butte Hill. Just downriver is the reclaimed land of the long-gone Anaconda Smelter, with its 585-foot-high smokestack still standing as testament to the area's halcyon days of industrial production.

The days when the Clark Fork and many other American rivers ran red from misuse have ended. Beginning in the 1960s, a determined public encouraged the enactment of landmark environmental laws. Slowly, people have begun to see rivers as a critical part of our ecosystem. The days of pouring heavy metals and municipal waste into the Clark Fork are over, and a time of renewal and restoration has begun.

The Clark Fork is fed by a few fish-laden tributaries, including the famous Blackfoot River and Rock Creek, which are also recovering from past sins. Both the Nine Mile and Fish Creeks are major spawning tributaries for rainbow and brown trout.

The Bighorn

The Bighorn River is born in the towering Wind River Range of northwestern Wyoming. Fed by the Shoshone, Wind, and Little Bighorn Rivers, it is as big as the Yellowstone when they join in eastern Montana.

Slicing through the Montana-Wyoming border, the river carves its channel deep into the fifty-mile-long limestone gorge of Bighorn Canyon. Today, the 535-foot-high wall of the Yellowtail Dam backs the river into the canyon and has transformed the white water into a languid, flat-water float.

The Bighorn offers some of the nation's greatest fishing. The record catch is a sixteen-pound, twenty-nine-inch rainbow, just one of the estimated six thousand fish per mile that average more than one foot in length.

The upper Bighorn flows through the Crow Reservation, and a warm-water fishery is found below the town of Hardin, where much of the river's course is through private land. This great fishing river is a valuable resource for eastern Montana. Larger than the Madison and full of trout, it is a river known to keep both its secrets and its fish.

The Yellowstone

The Yellowstone River is the exclamation point to the description of Montana as "The Last Best Place!" Of all our nation's great rivers, only the Yellowstone flows free, unhampered by even a single dam.

At twelve thousand feet on the slopes of the nation's rocky spine in Wyoming, America's last free-flowing waters began their course of 670 miles to the Missouri River. The Yellowstone's course across Montana is joined along the way by feeder rivers, many of them with their own renown: the Boulder, the Stillwater, the Rosebud, the Shields, the Bighorn, the Tongue, and the Powder Rivers.

The upper Yellowstone is a small mountain stream passing within sight of the Continental Divide, its waters near freezing even in the summer. It empties into Yellowstone Lake as a stream, and pours out as a river. It gushes over the Yellowstone Caldera, a remnant of an enormous explosion six hundred thousand years ago that was ten times more powerful than the eruption of Mount St. Helens in 1980.

Flowing out of Yellowstone National Park, the river enters the aptly named Paradise Valley, where the Yellowstone River is best known for its fishing, scenery, and ferocious wind. Over the one hundred miles of its middle course, the river transforms from its cold mountain birth to a warm prairie river, drifting deep and slow across the state's eastern plains to its marriage with the great Missouri.

The Big Hole

Montanans, I suppose, have a parochial pride in their favorite rivers or streams. For me it is the Big Hole, about which I wrote the following for the jacket of the book *Montana's Last Best River.*

The Big Hole is the river of my youth. Walking its banks and casting into its waters from Wise River to Glen, it taught me that a very fine river can exalt even a very poor fisherman. The Big Hole channels through our history from the early Salish and Nez Perce to today's fifth generation ranchers. Yesterday's Honyockers, miners, and ranchers needed the river. Now, under pressure, the river needs us, today's conservationists with our care and nurturing.

The Big Hole River flows through southwestern Montana from the mountains near Jackson, 150 miles to the Jefferson River near Twin Bridges. This is a trout stream, flowing through hayfields and grazing lands that have changed very little in the past century. Cutthroat trout, whitefish, rainbows, browns, brookies, and grayling offer the angler ample thrills.

This stream forces one to gear down, relax, and let the waters inform the senses. This is an important landscape; one can feel it. After walking its banks and wading its waters, it returns to my thoughts again and again.

The Big Hole may indeed be the Last Best River.

≈

So . . . slow down, breathe it in; let Montana and the Big Sky surround you. Through the windows of an automobile plowing ahead at sixty miles per hour, you can barely glimpse the glories of this great splash of grandeur. I urge you to stop! Take a walk, grab some air, wet a line, stand and stare, say "hello." Listen to the rhythms of Montana's harmonious natural symphony.

◁ *Old-growth cedar trees in the Ross Creek Cedar Grove*

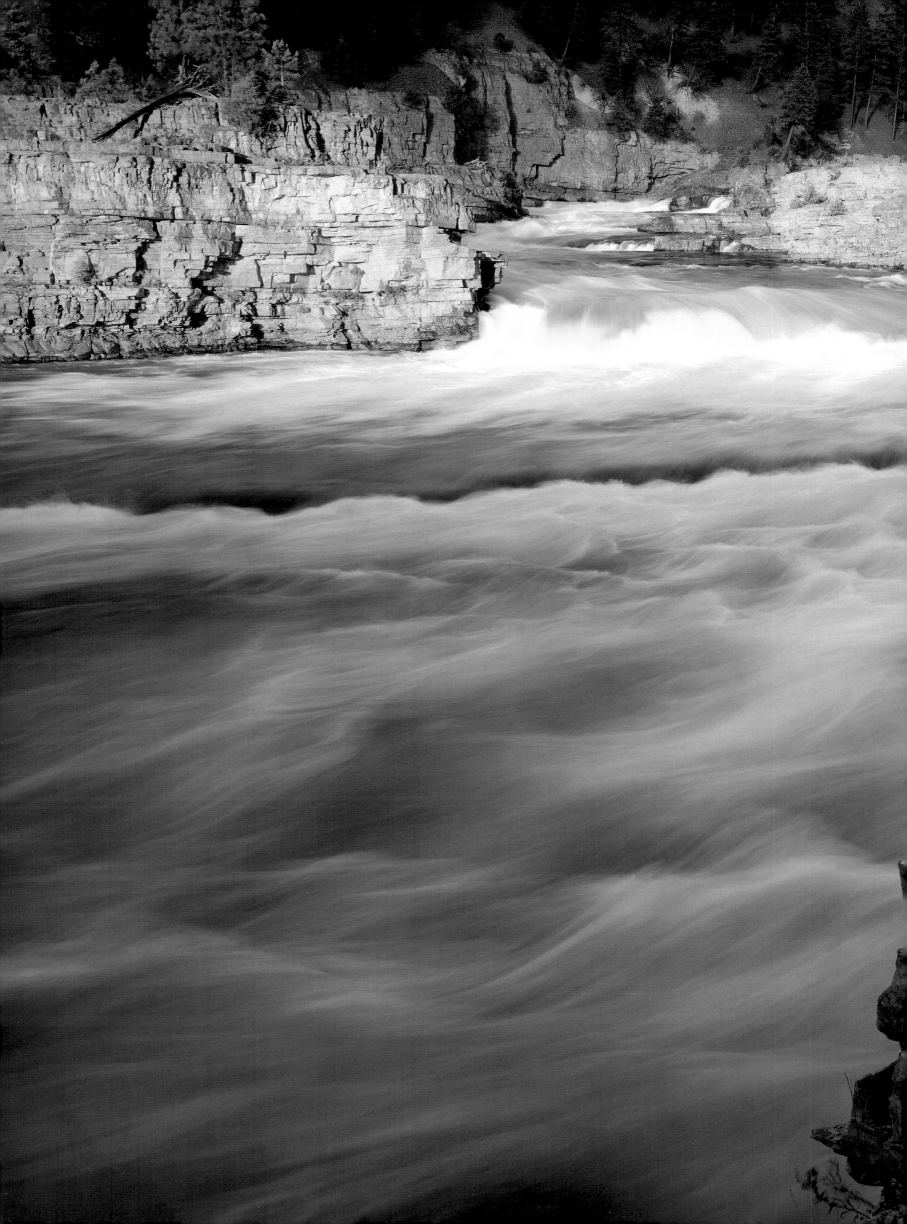

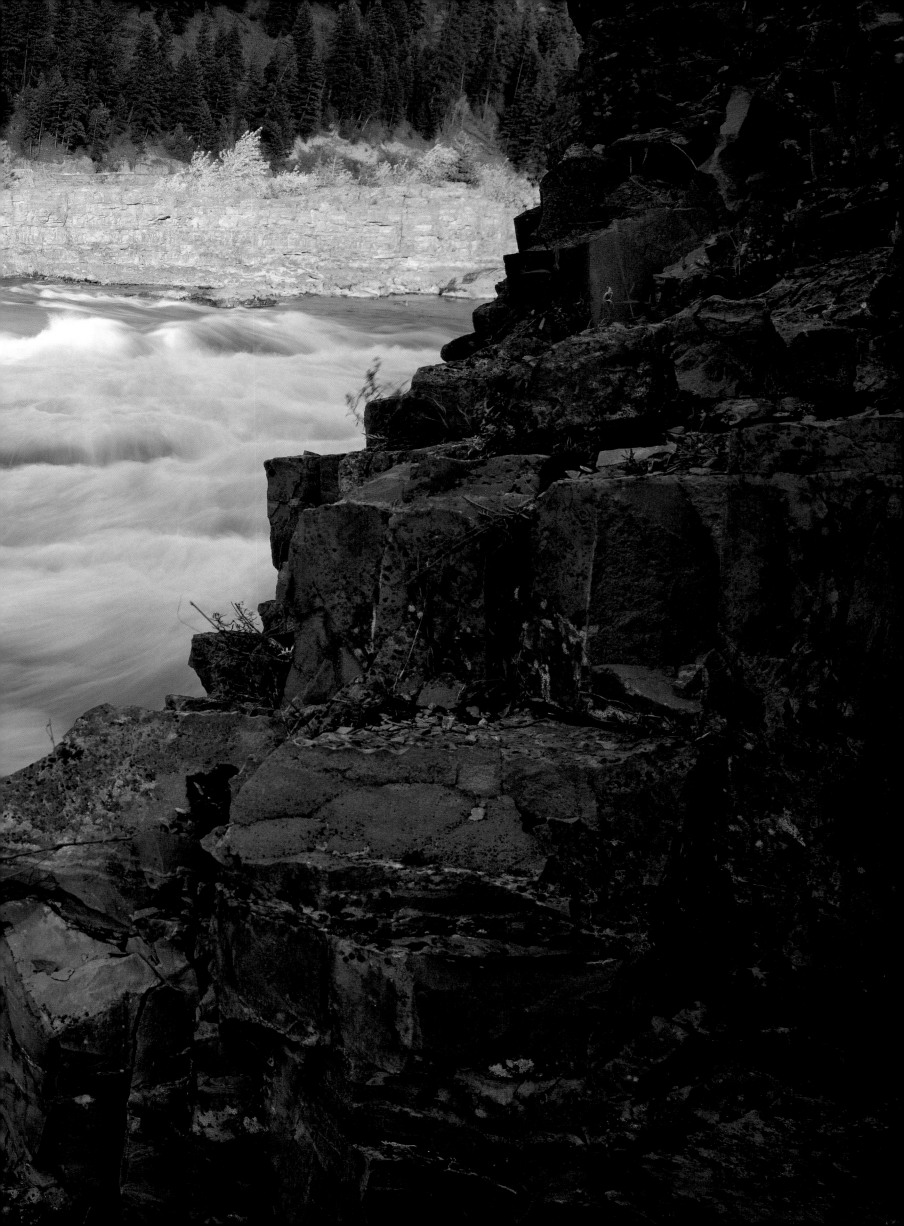

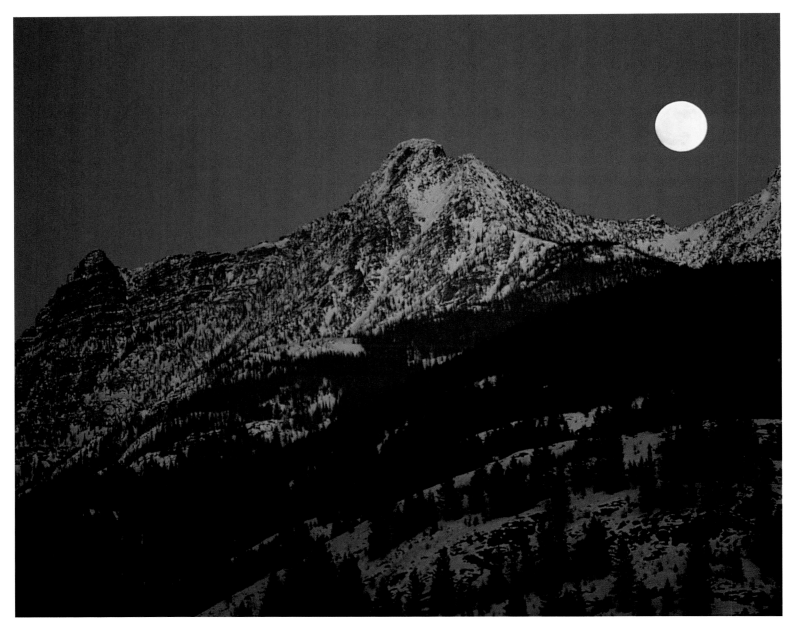

◁ ◁ Named for the Native people who once lived in the area, Kootenai Falls boom through the cracked and colorful rocks of Kootenai Gorge. The roar of these waters is heard long before their cascading plumes can be seen.
△ The Cabinet Mountains were granted protection within the National Wilderness System in 1964, the year that the U.S. Congress began the legislative process of providing the ultimate protective designations to portions of the country's wildest and most critical public lands.
▷ Mountain rocks are largely sedimentary formations, laid down slowly on sea bottoms. This boulder lies near the confluence of Bear Creek and the Middle Fork of the Flathead River in the state's scenic northwest.

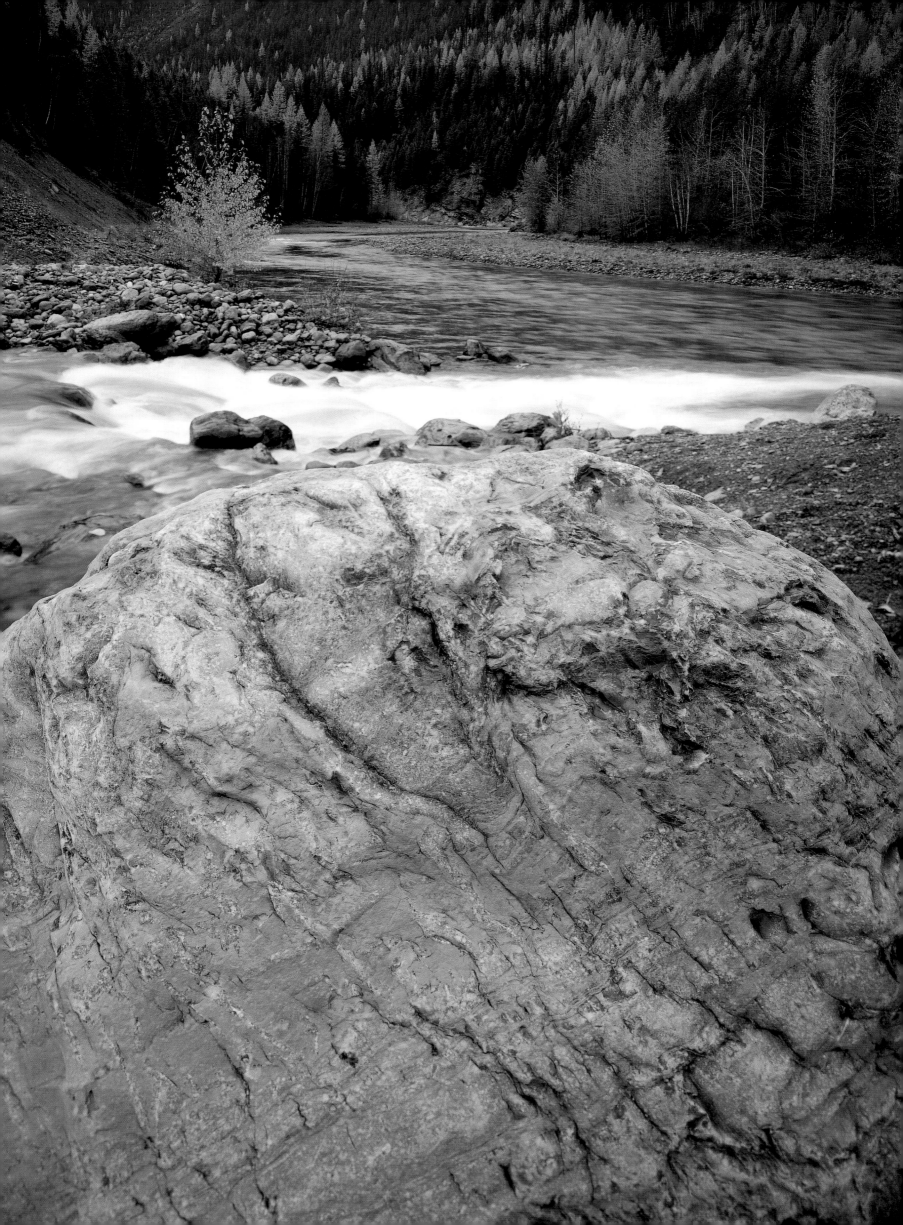

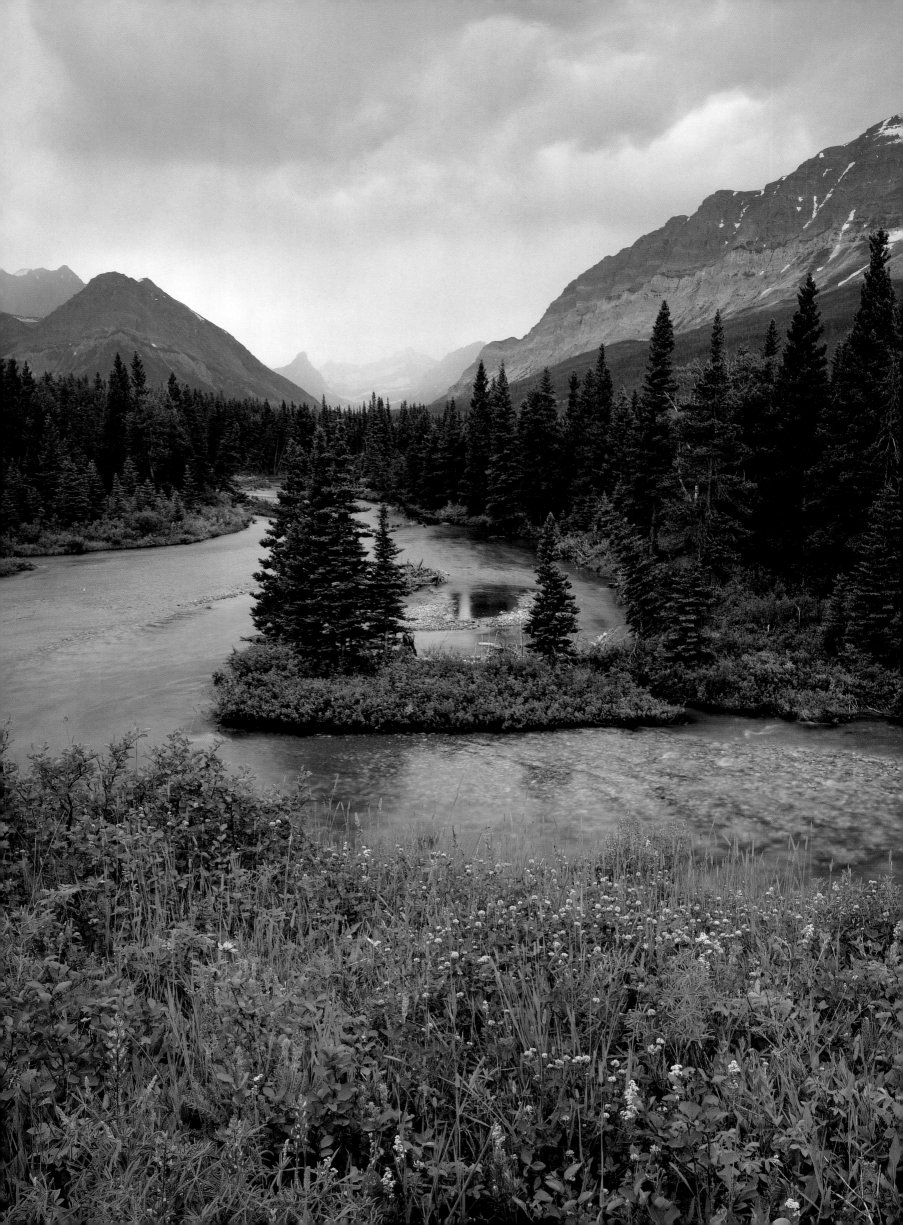

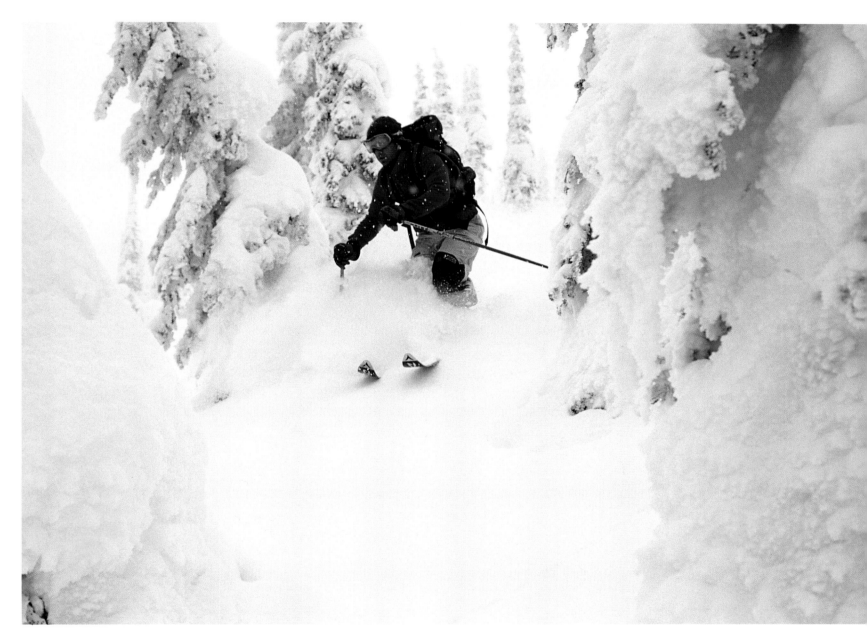

◁ Storm clouds approach the Belly River Valley in Glacier National Park. The park officially became part of the National Park System on May 11, 1910, just twenty-one years following Montana's statehood.
△ Winter provides the sublime conditions of deep powder and snow ghosts for those skiing under the Big Sky. Here, John "Disco" Derby enjoys the powder in back country access at Big Mountain Winter Resort.

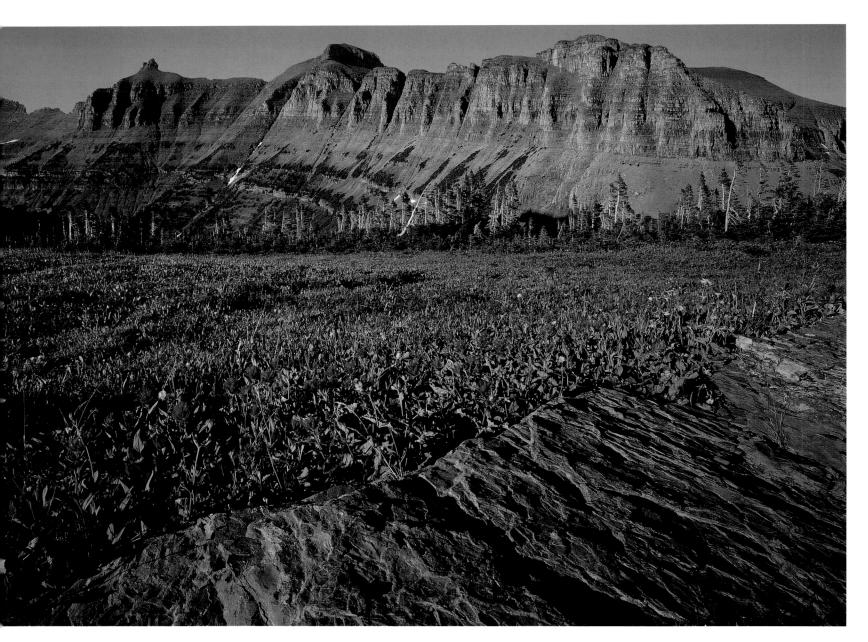

△ Ripple marks of red mudstone create the foreground for paintbrush and the Garden Wall, whose jagged cliffs were formed by glaciers cutting into the ridge. The Bishop's Cap crowns the Wall on the left.
▷ Avalanche Creek tumbles from its beginning high in Avalanche Lake until it reaches the Trail of the Cedars, becoming a small tranquil creek.
▷ ▷ The nation's most scenic highway, Going-to-the-Sun, peeks out at Logan Pass on the spine of the continental divide. Nearby are fields of bear grass, an evergreen herb of the lily family.

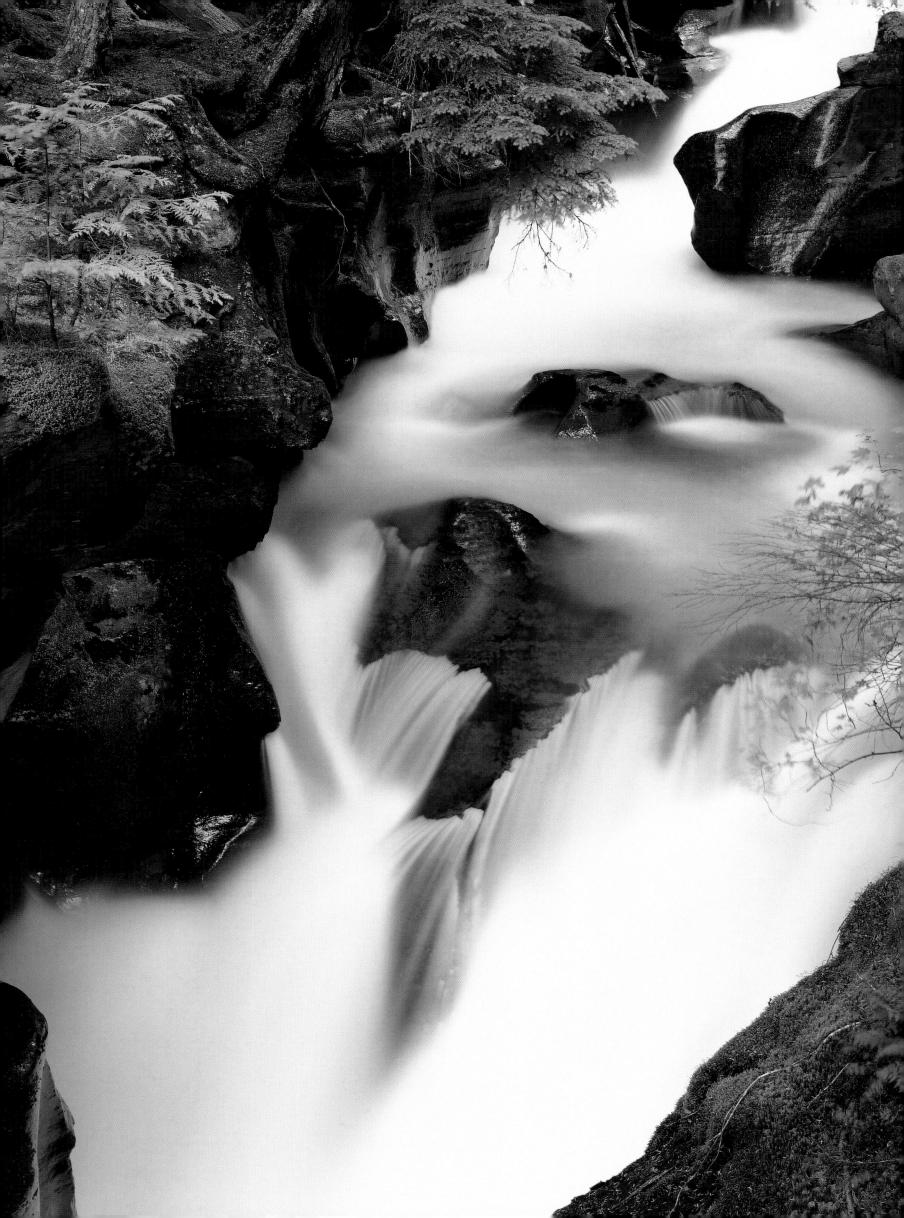

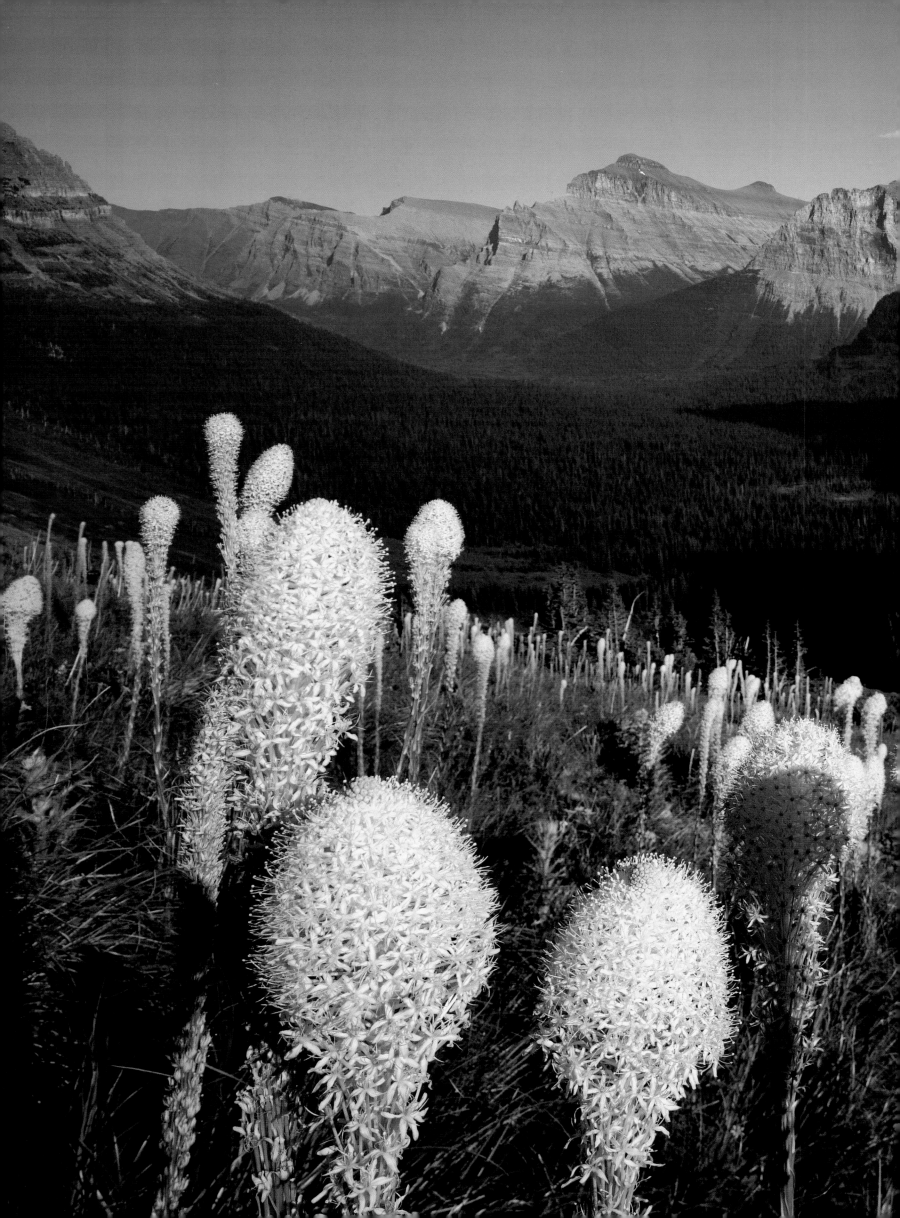

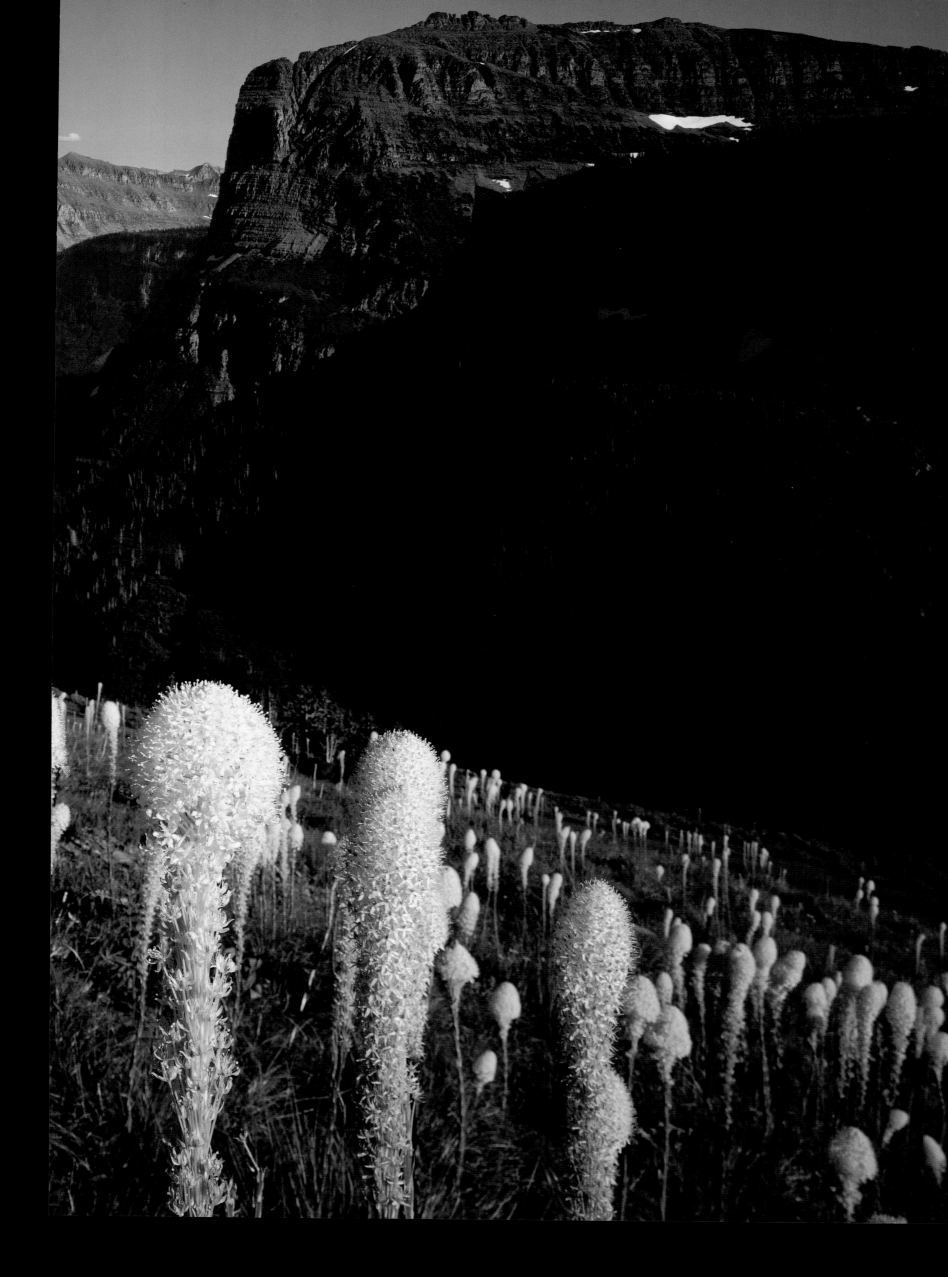

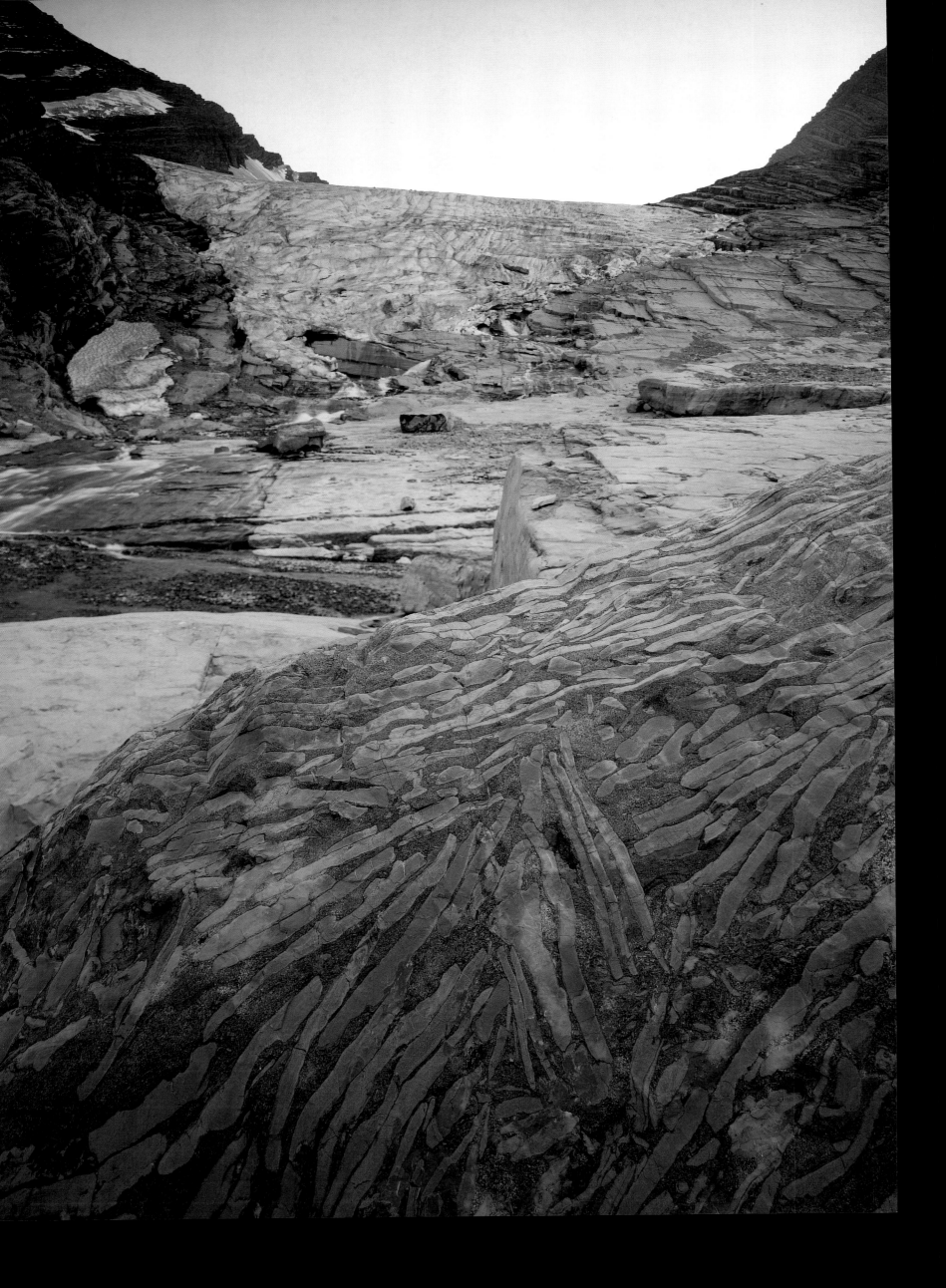

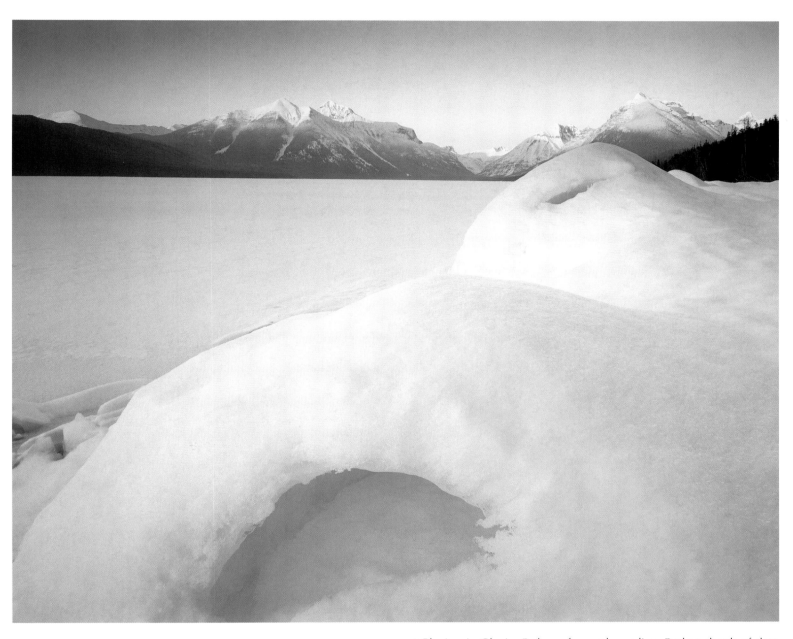

◁ Glaciers in Glacier Park are few and receding. Broken shards of slate are signs of Jackson Glacier's passing. U-shaped, hanging valleys are also evidence of glacier action that resulted in the park's astonishing geology.
△ Snow pillows—pockets of air lifting the snow ice into intriguing forms—line the south shore of Lake McDonald, in Glacier National Park.

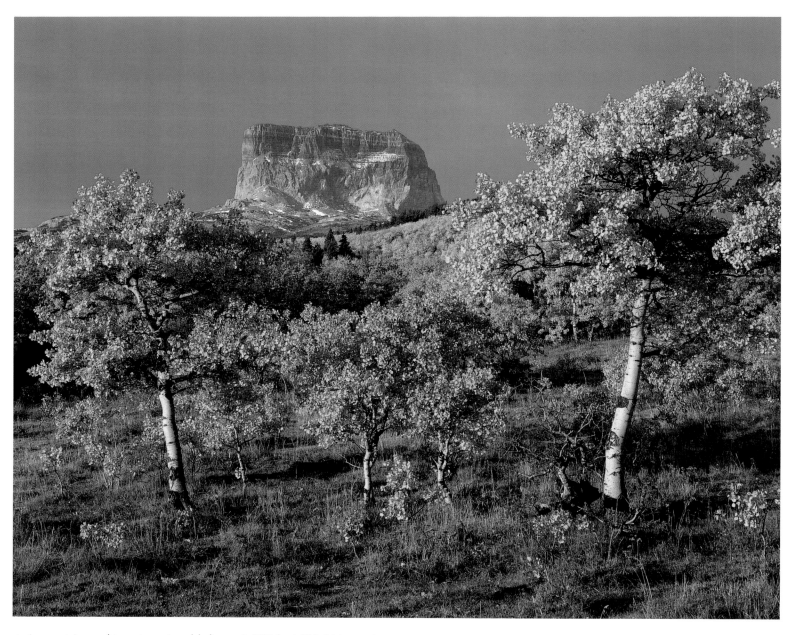

△ Aspen, trimmed in autumn's gold, frame 9,080-foot Chief Mountain. Seventy million years ago the entire Northern Rockies were covered with the waters of a shallow sea. For a hundred thousand centuries an uplift has continued to raise this and the other mountains of the region.
▷ Glacier National Park's Mokowanis River flows over Gros Ventre Falls.

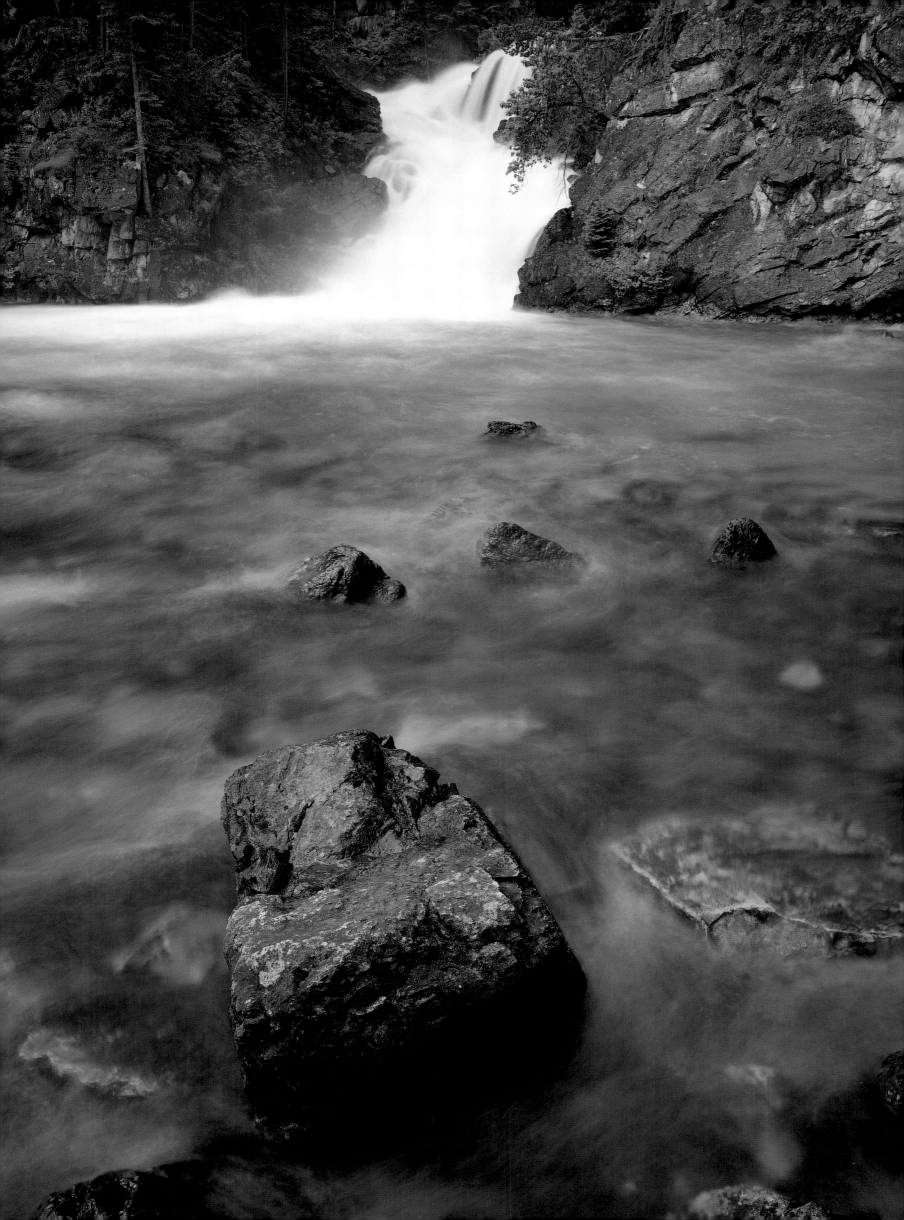

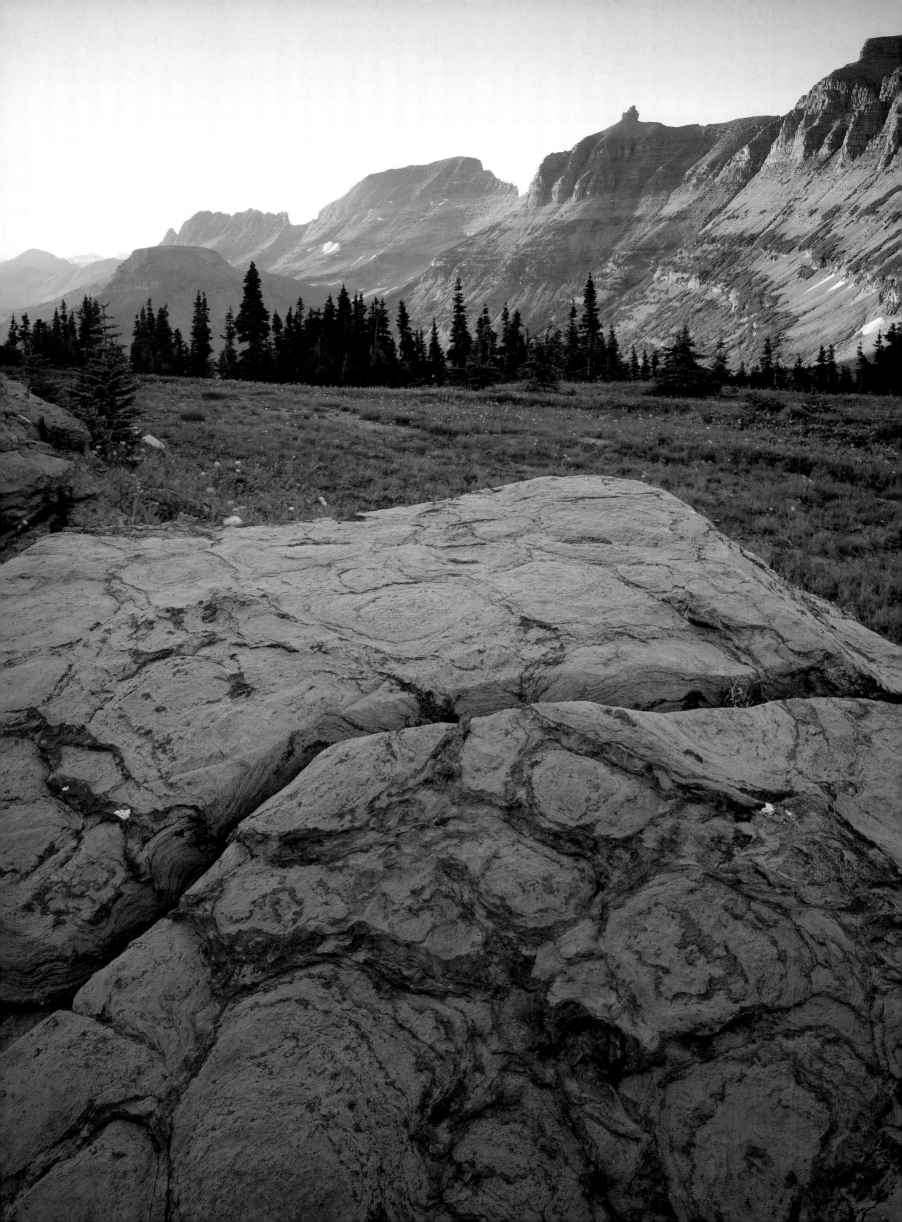

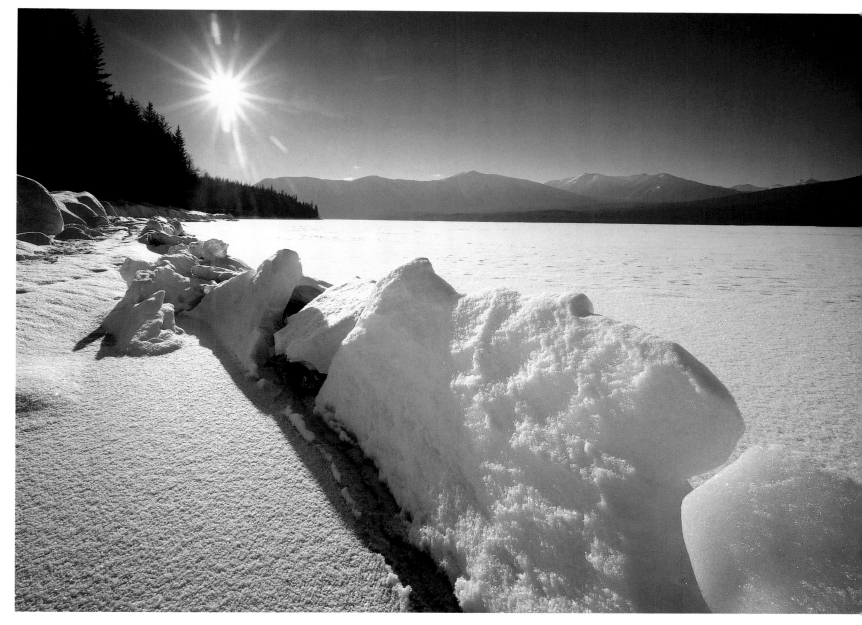

◁ The trapping and binding of sediments by minute organisms formed this stromatolite boulder beneath Glacier Park's ancient Garden Wall. △ The moving water beneath the winter cover of Lake McDonald creates ice heaves near Apgar Village. Apgar Mountain rises in the distance. ▷ ▷ Fall leaves bathe in sunset light on the shore of Lake McDonald in Glacier National Park. The 472-foot lake depression was gouged by a two-thousand-foot-high glacier about twenty thousand years ago.

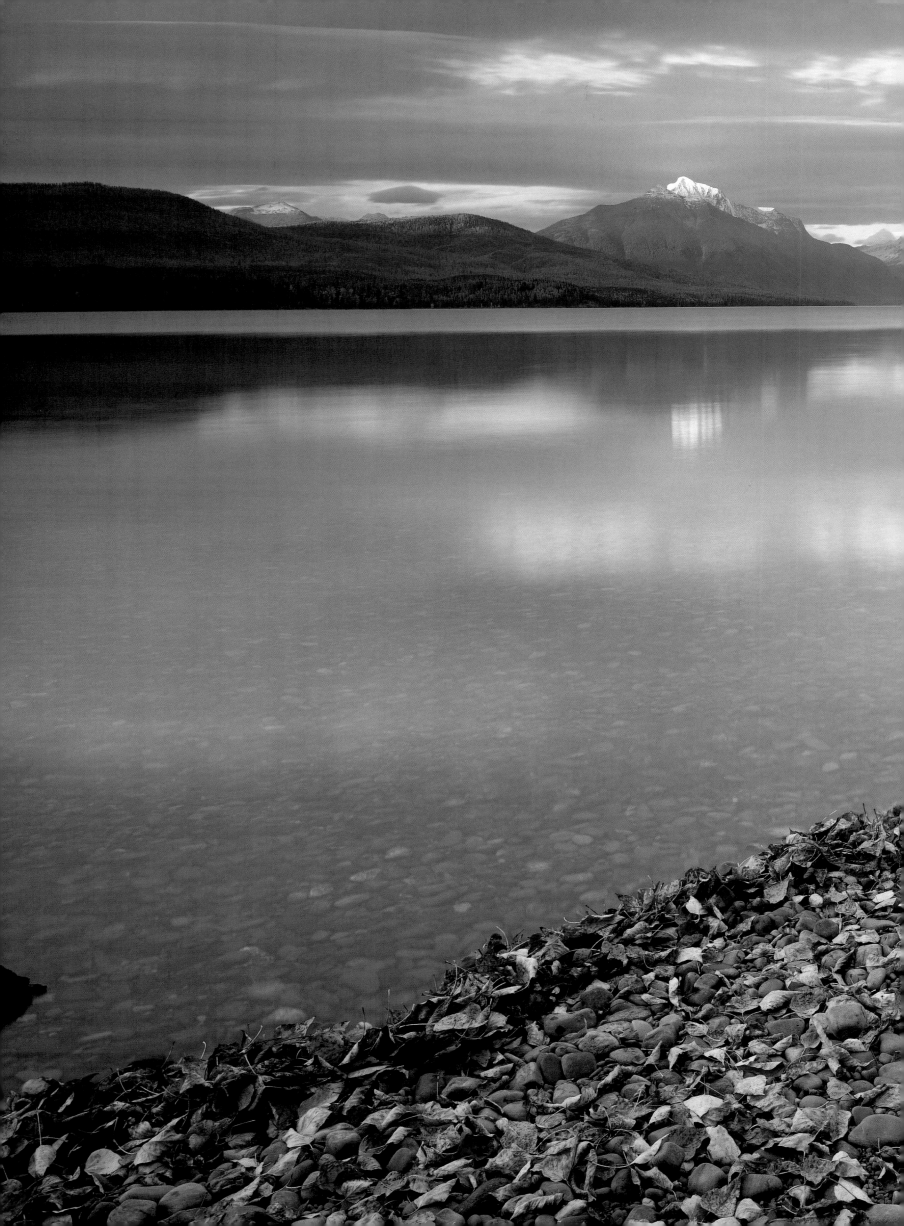

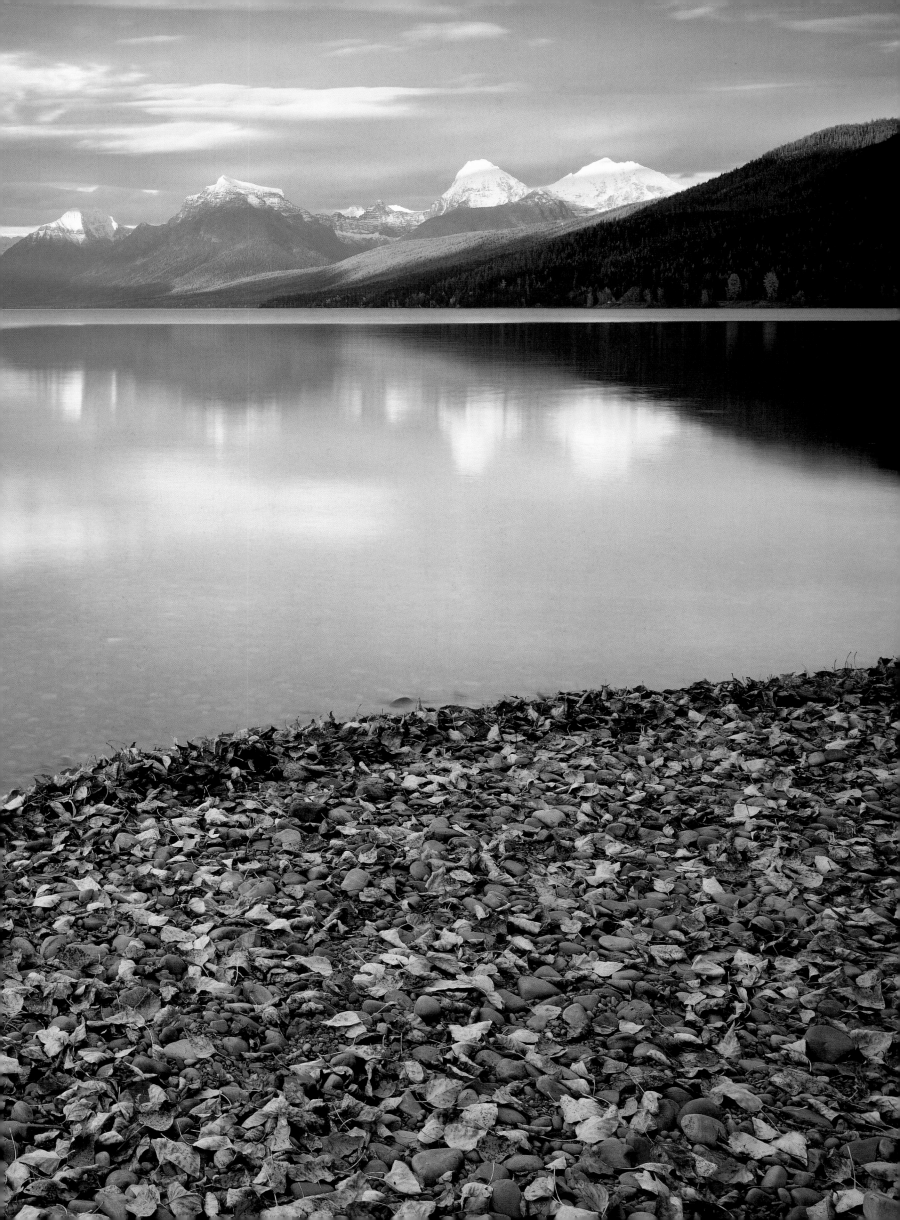

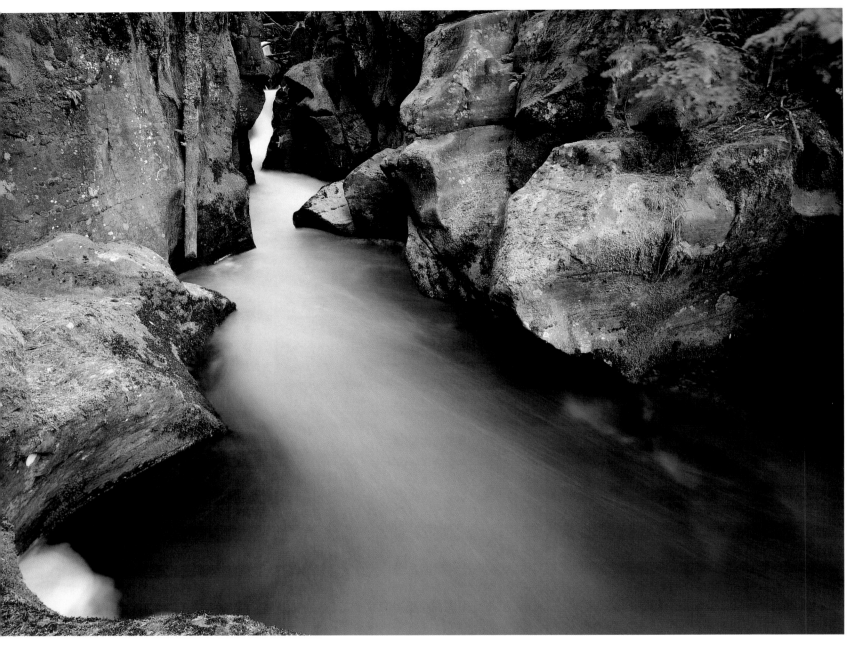

△ In a display of the power of water, tiny Avalanche Creek, flowing from
Avalanche Lake, cut through massive rocks to create the gorge, whose
rock walls confine the creek as it tumbles toward the Trail of the Cedars.
▷ Rocks from the Garden Wall lie among paintbrush, arnica, and rock vine.

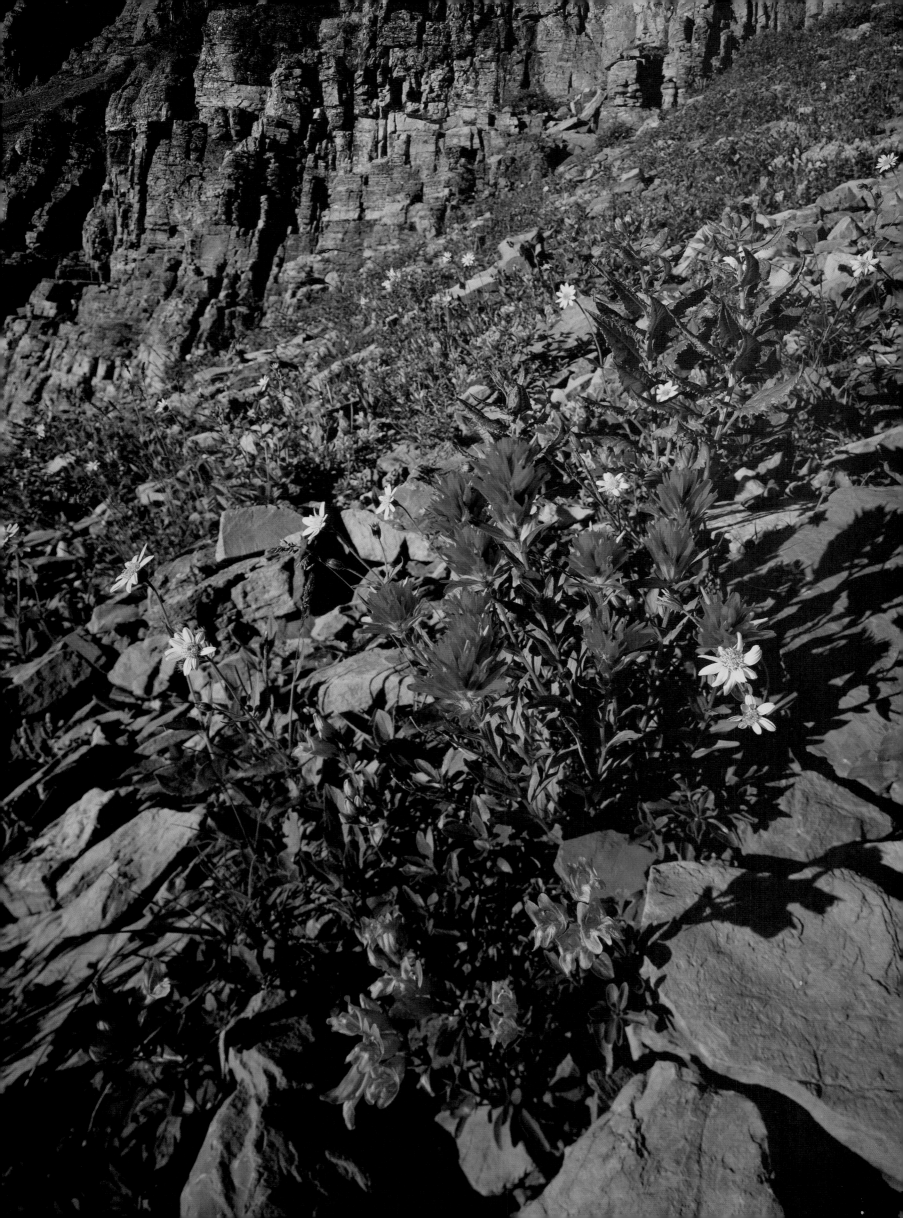

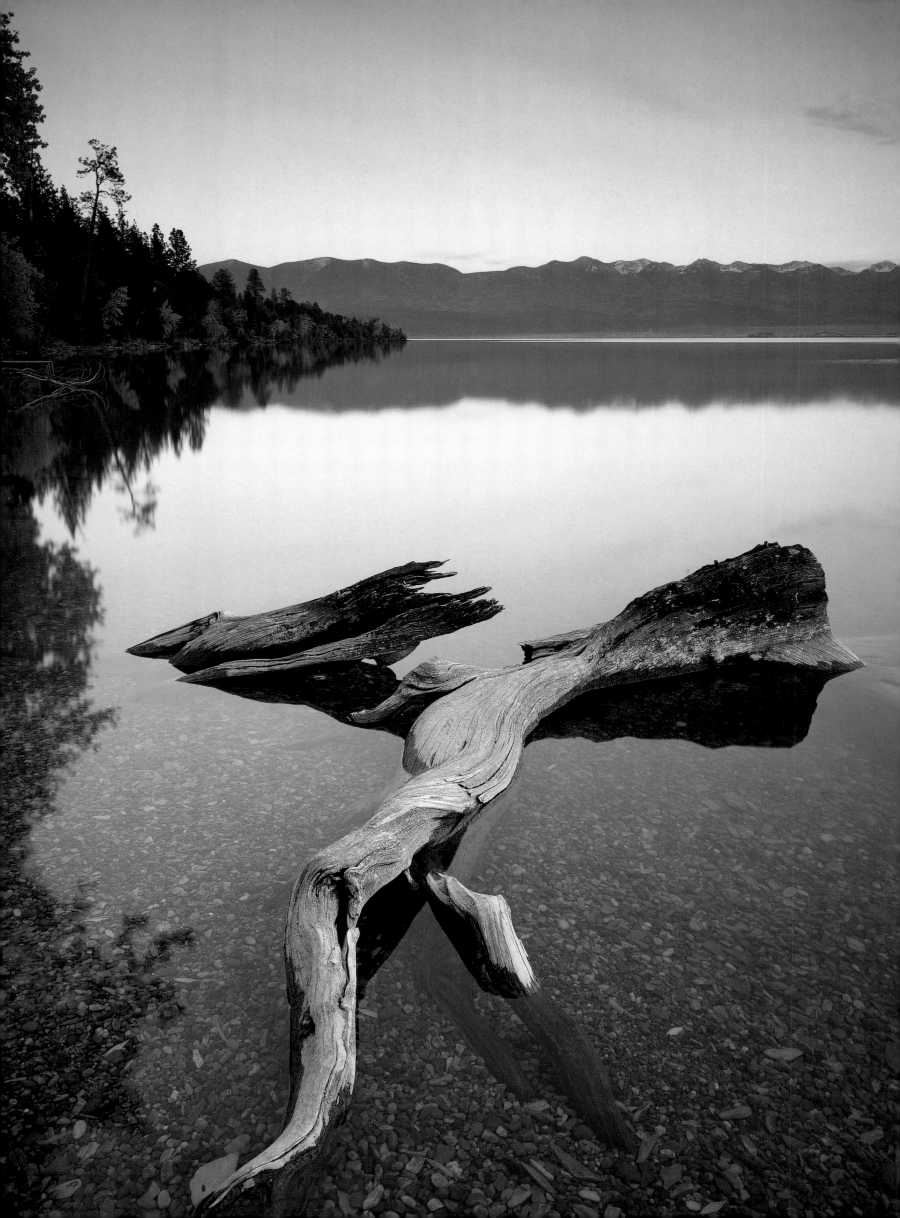

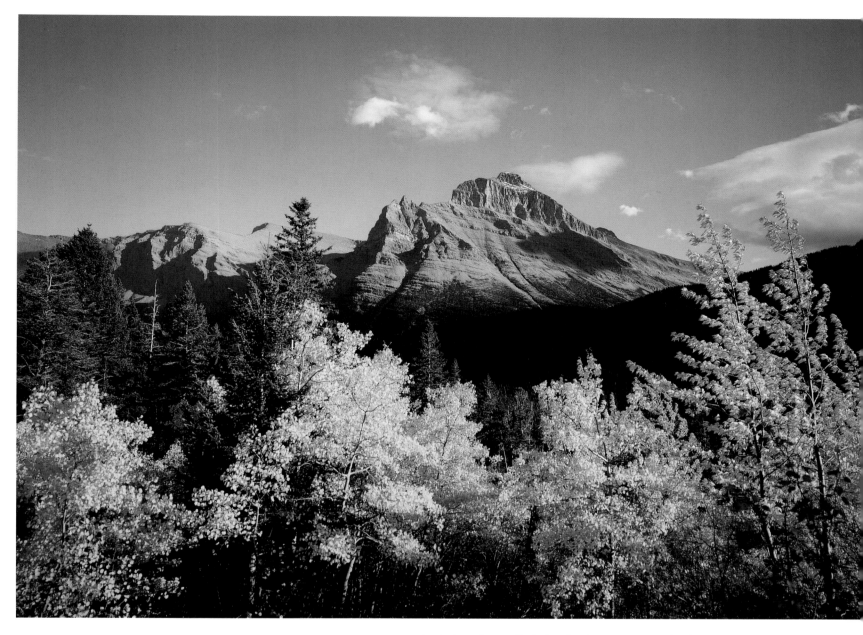

◁ Twilight reflects off Flathead Lake, a remnant of Lake Missoula, near Rocky Point. Flathead is the largest freshwater lake west of the Mississippi. △ Set off by quaking aspen, Little Chief Mountain, 9,541 feet high, reveals the rock strata formations prevalent throughout Glacier Park.

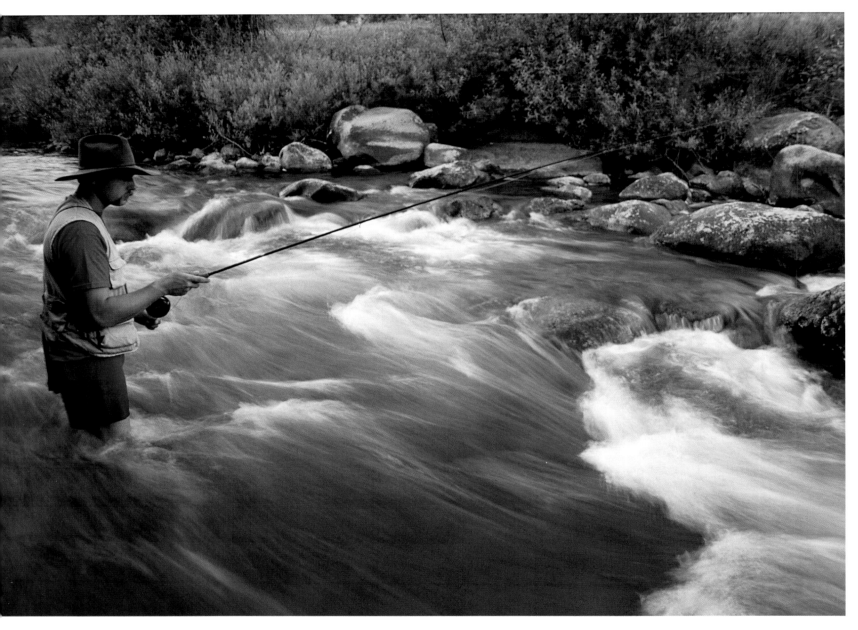

△ *Hook 'em cowboy!* Ed Jakubowski tries his luck in Lolo Creek's rapids.
▷ A granite notch high on 10,157-foot Trapper Peak reveals the erod-
ing mountains of the Selway-Bitterroot National Wilderness Area.
▷ ▷ Remarkably preserved by the dryness of the Montana climate, the
Graves House, left, rests beside the Methodist church in the abandoned
town of Bannack in southwestern Montana. Named for the Bannack
Indians who had occupied the area, the town was established in 1863.
It was the largest city (population eight thousand) in Montana Territory.

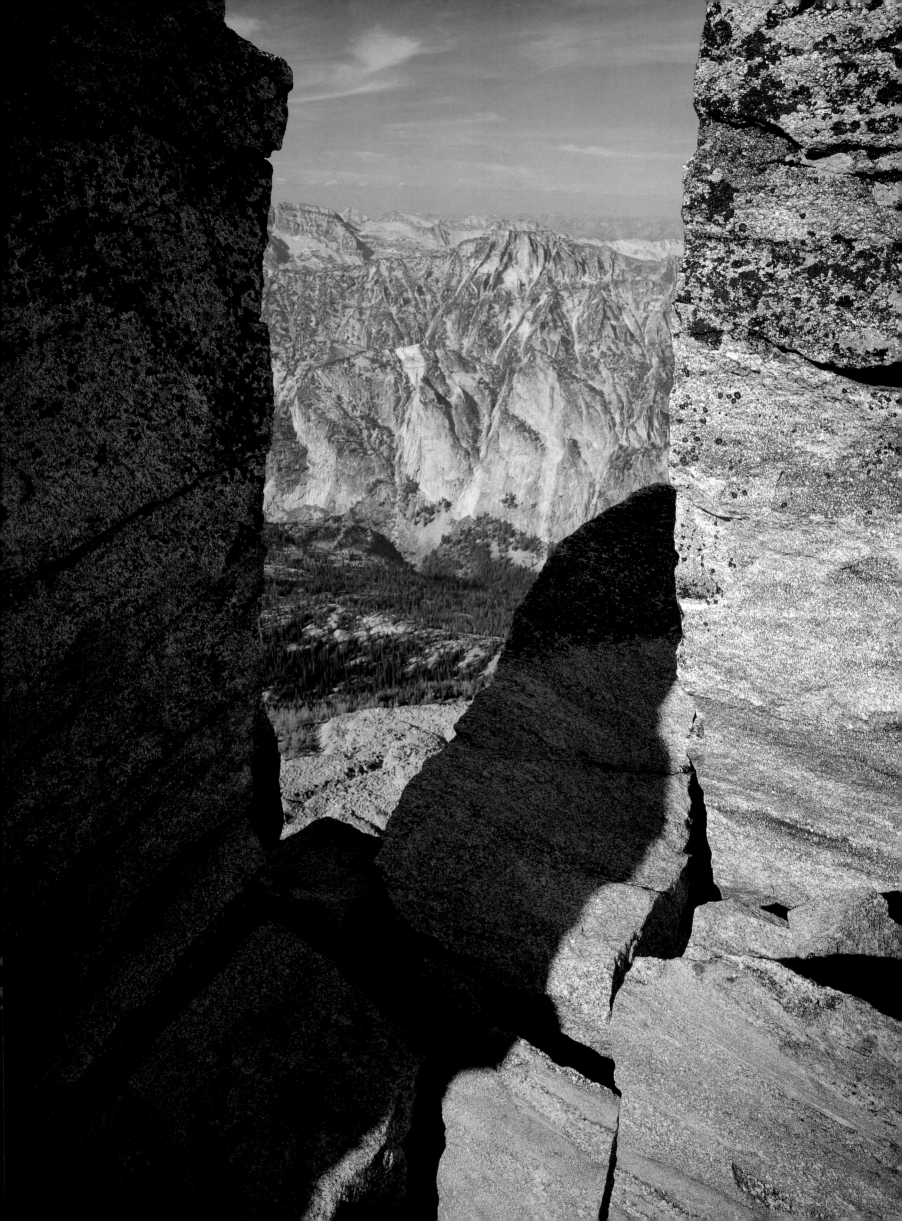

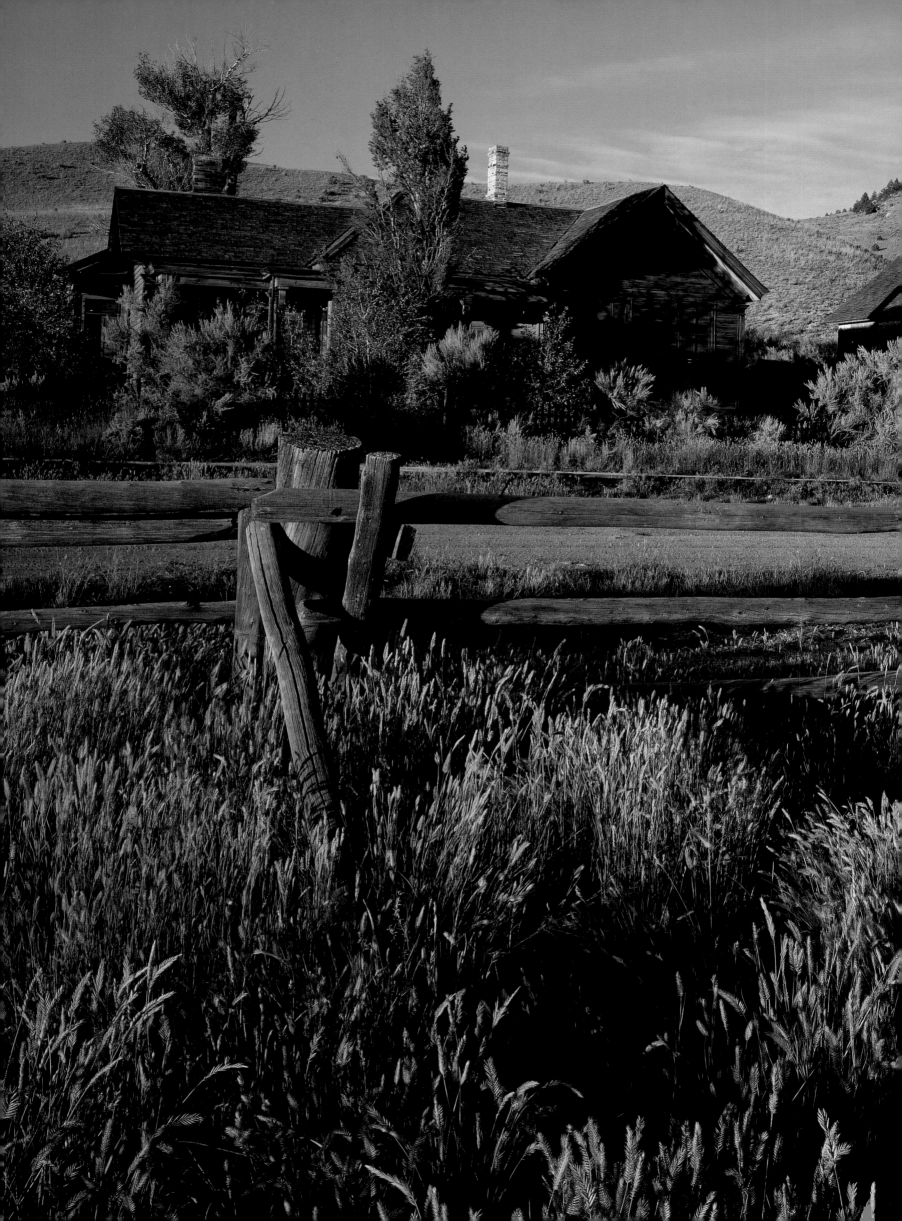

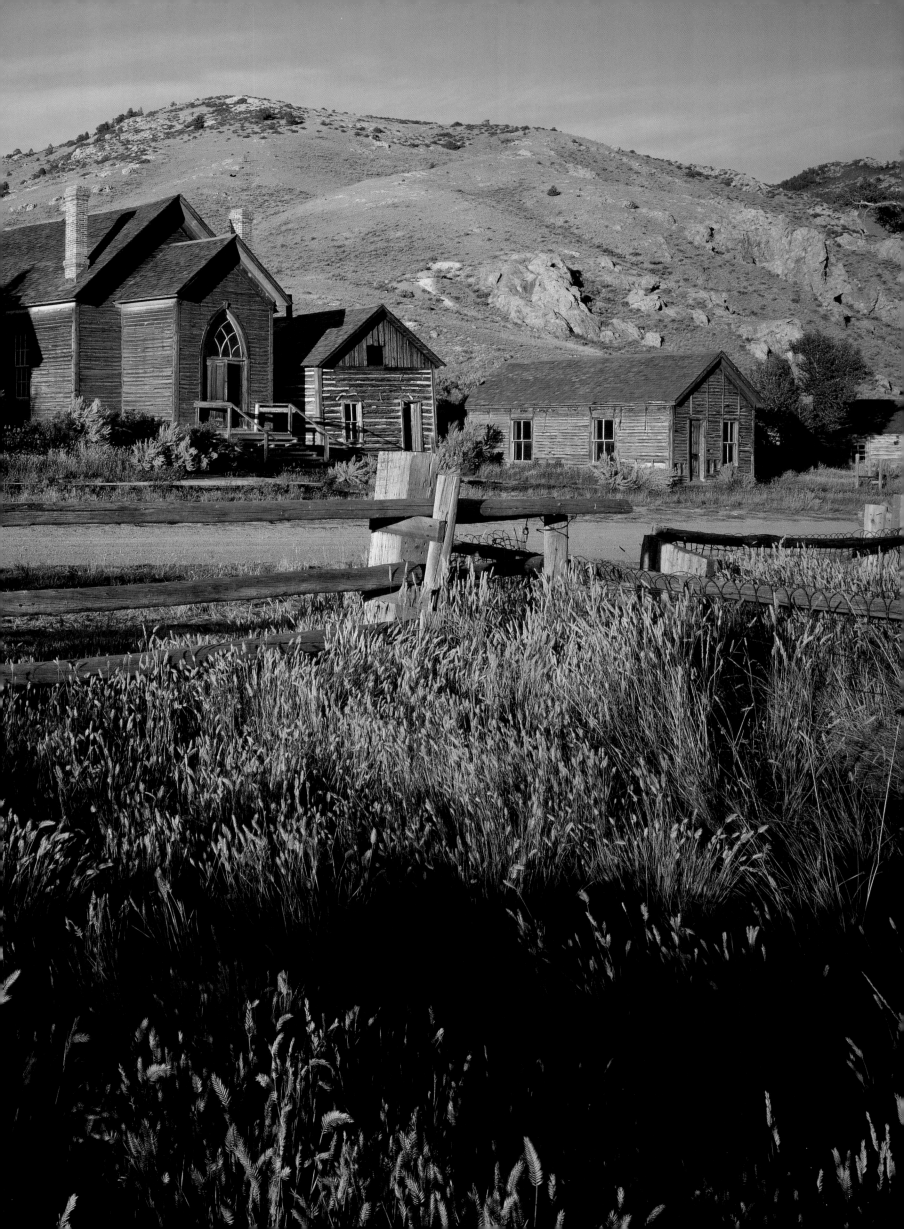

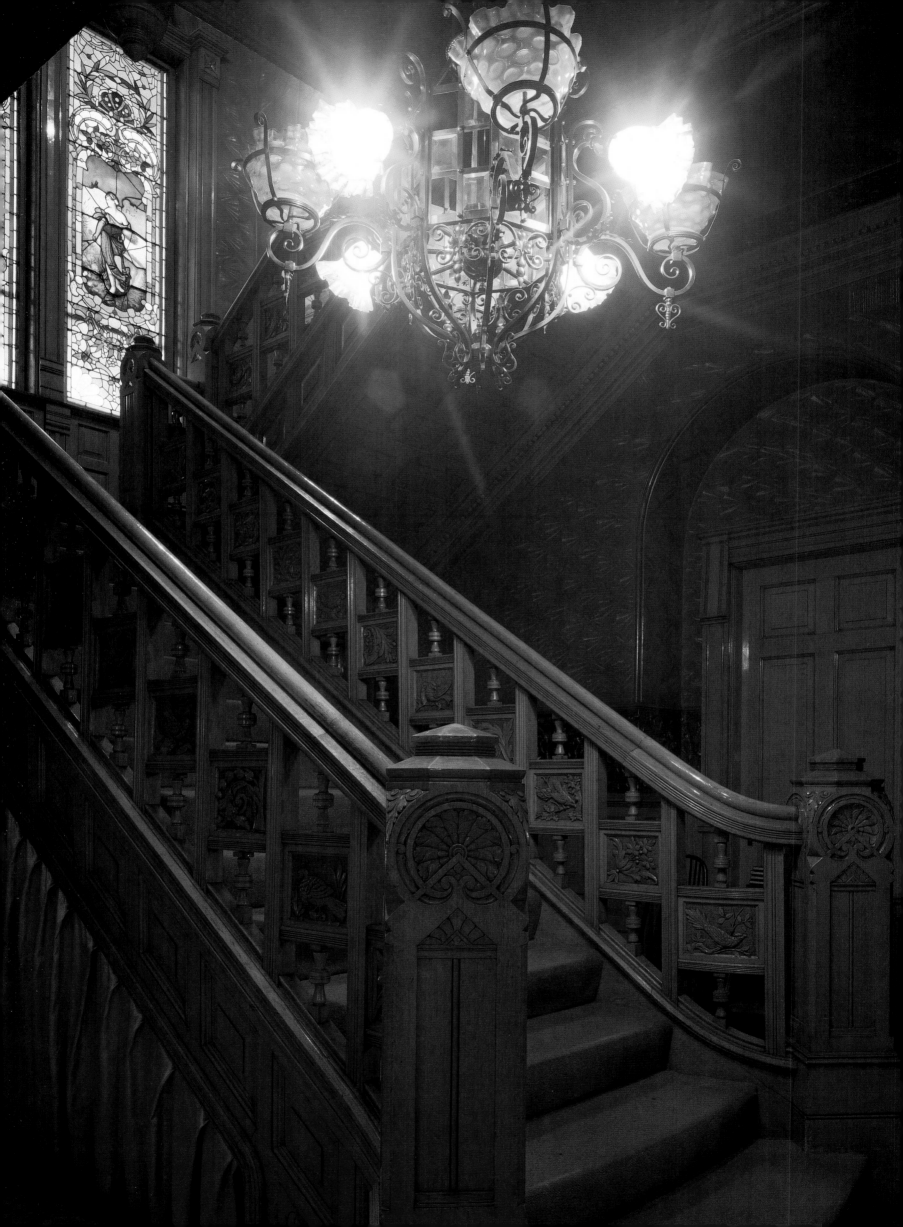

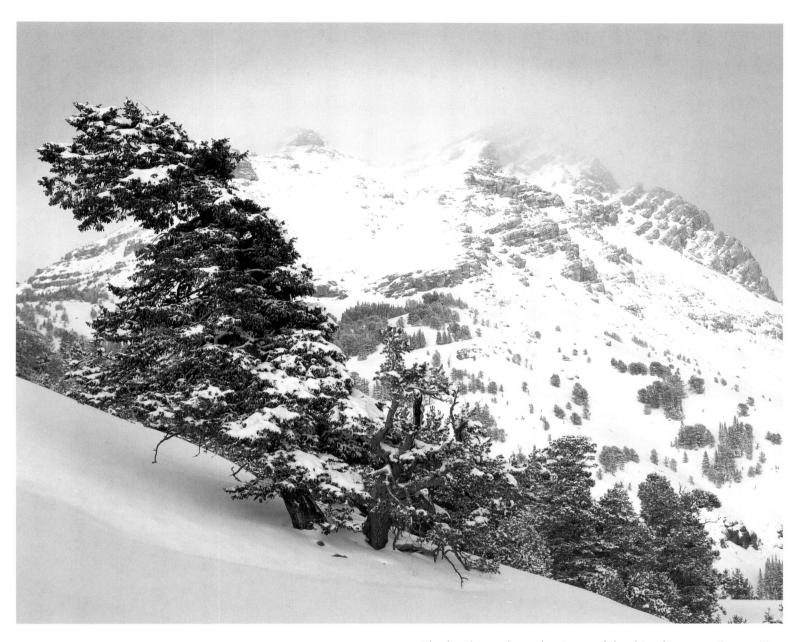

◁ The hand-carved grand stairway of the thirty-four-room Copper King Mansion is lighted by stained glass windows and ornate lamps. In the 1880s, the mansion was the Butte home of mining industrialist W. A. Clark.
△ Among winter recreational opportunities available on Sphinx Mountain are cross-country skiing and downhill skiing. The 10,876-foot Sphinx Mountain is situated in the Lee Metcalf Wilderness Area.

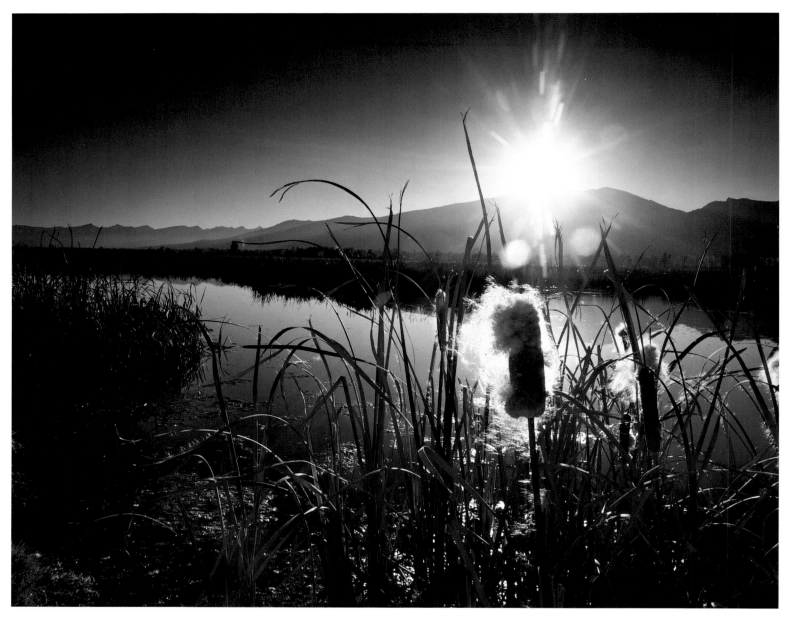

△ Cattails are backlit at the Lee Metcalf Wildlife Refuge in the Bitterroot Valley. The refuge is named for Montana's former U.S. Senator Lee Metcalf, who served in Congress from 1961 to 1978. He was an early conservationist who was responsible for providing protective designations for some of the state's most scenic and important areas. ▷ The Humbug Spires Primitive Area, near Butte, has been proposed for federal Wilderness designation. These massive outcroppings of quartz monzonite present rock climbing challenges for climbers of every ability.

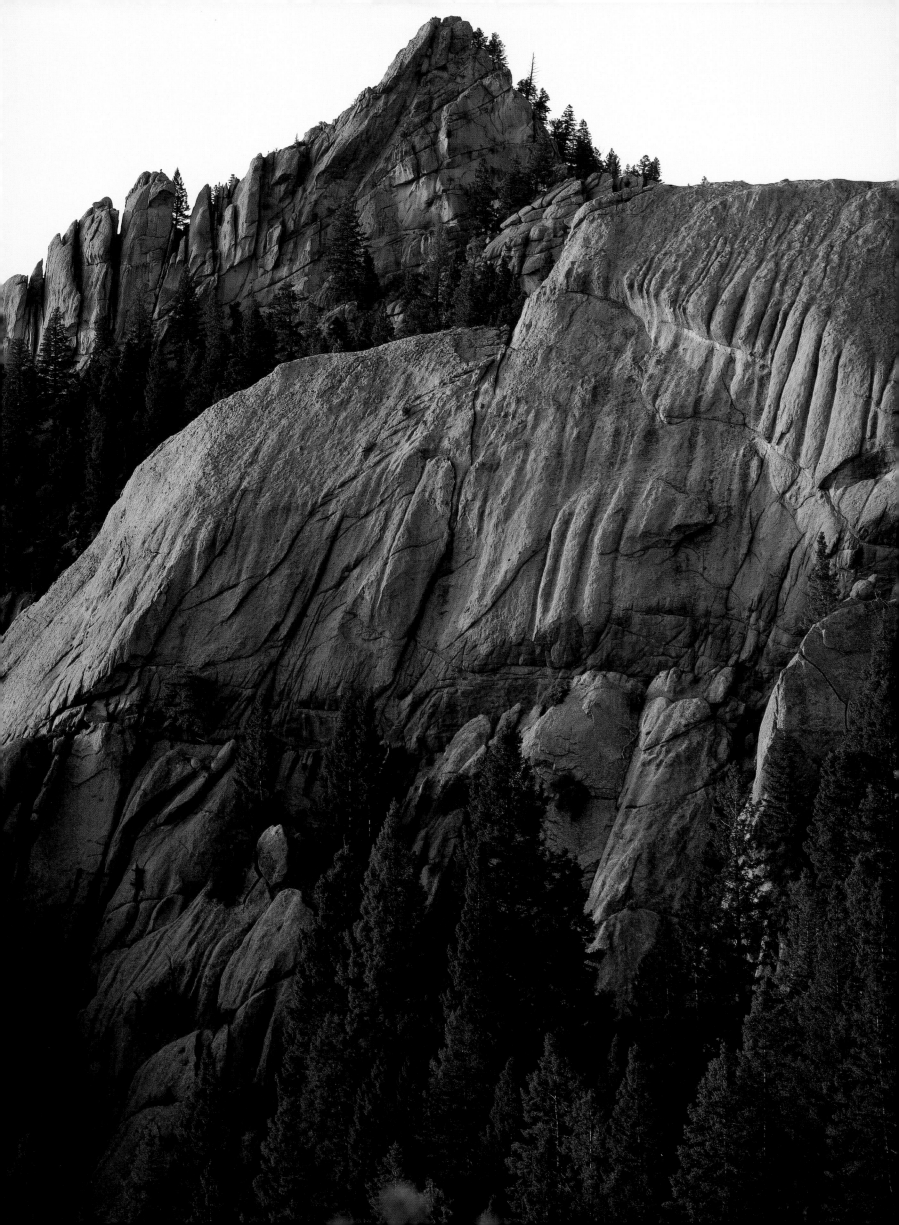

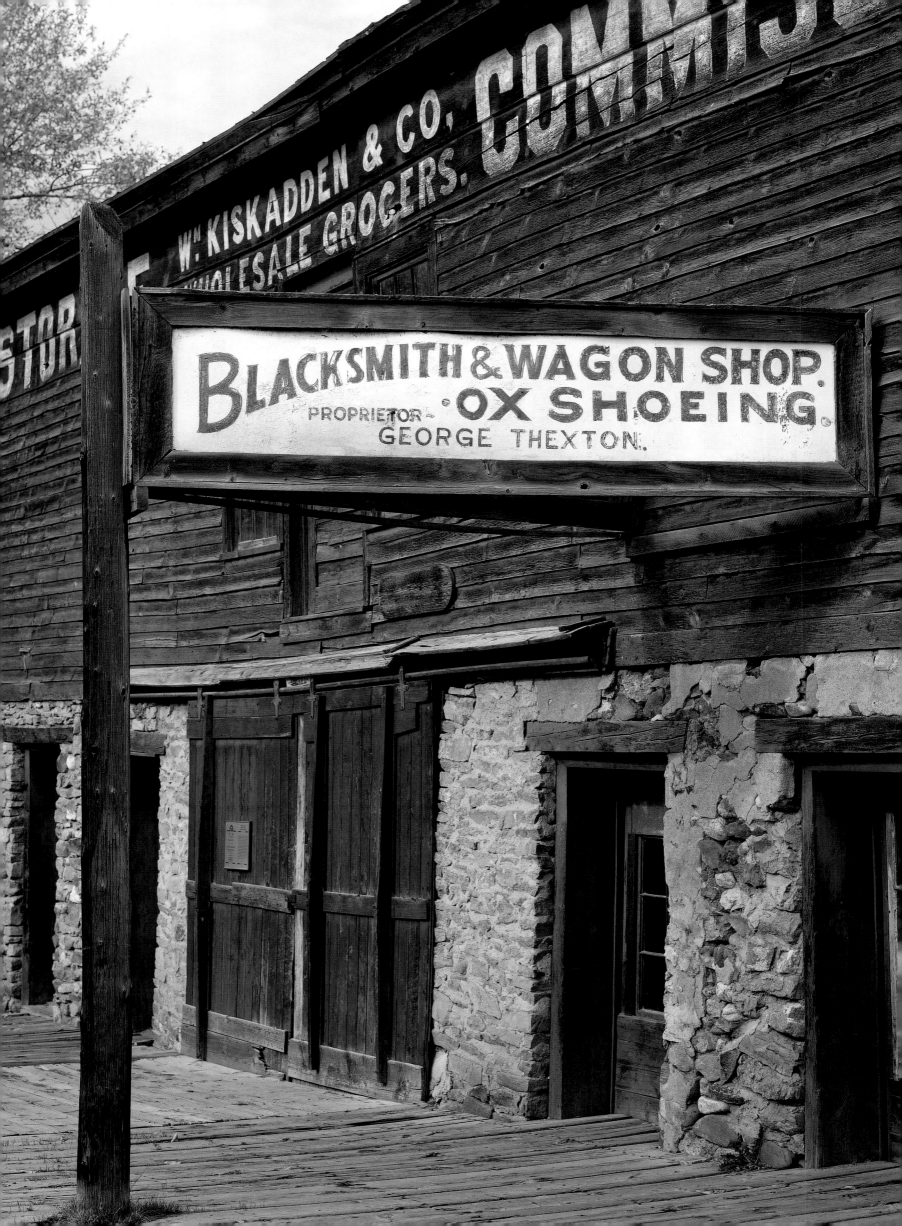

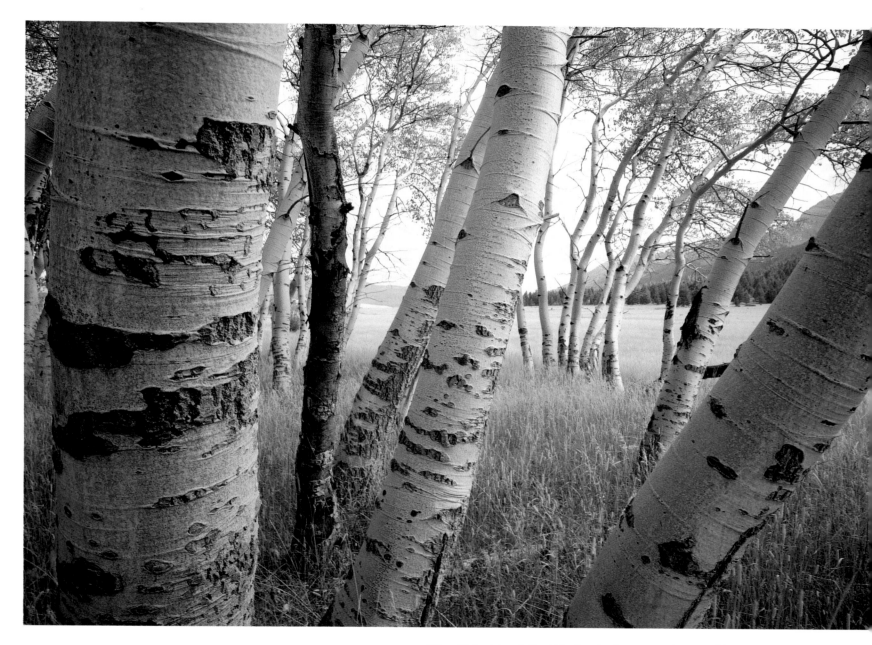

◁ Wm. Kiskadden & Co. Wholesale Grocers and its neighbor, George Thexton's Blacksmith & Wagon Shop Ox Shoeing, once held respected places in the daily lives of the residents of Virginia City. At its peak, Virginia City boasted nearly thirty thousand residents, who enjoyed a variety of entertainment ranging from Shakespeare plays to opium dens.
△ Aspen is perhaps the most widely distributed tree in the nation. This stand is near the Red Rocks Lake National Wildlife Refuge. From 1898 to 1917 the Monida-Yellowstone Stage Line brought visitors to the area.
▷ ▷ A snag gracefully breaks the reflection of the Bitterroot Mountains on Lake Como high in the wild country near the Montana-Idaho border.

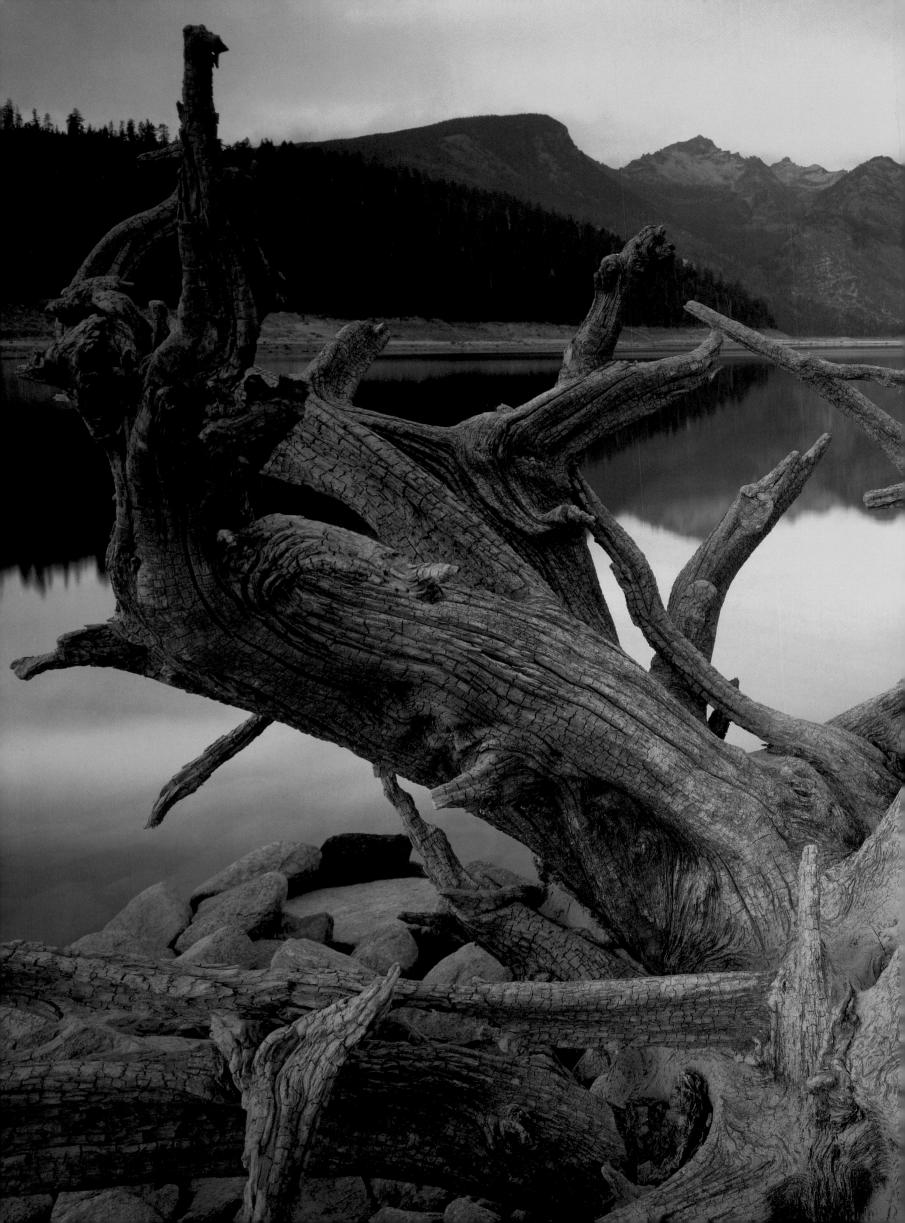

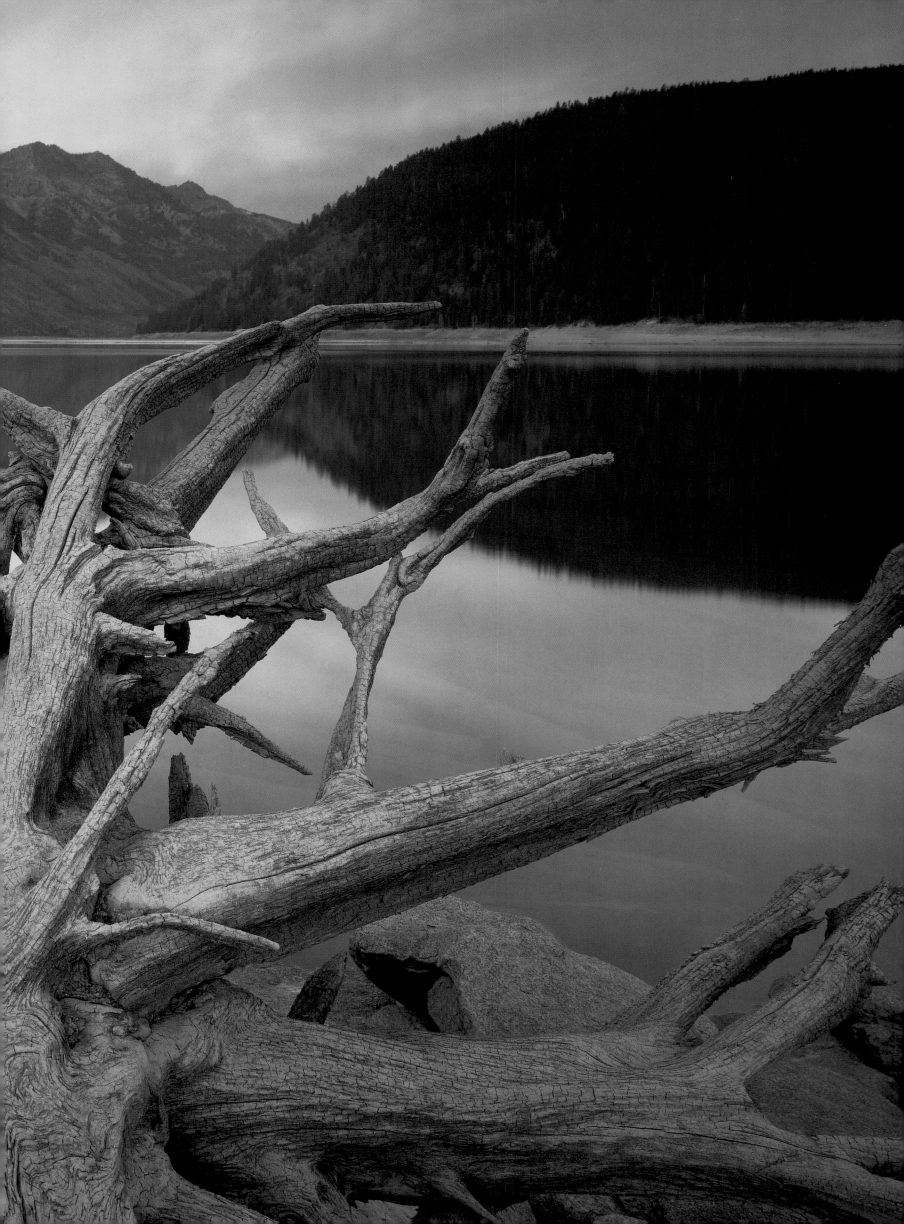

△ Set off by the steep slate roof, the ornate facing of the attic windows
of the Victorian Copper King Mansion looks out on uptown Butte.
The three-story mansion has been preserved as it was in the 1880s.

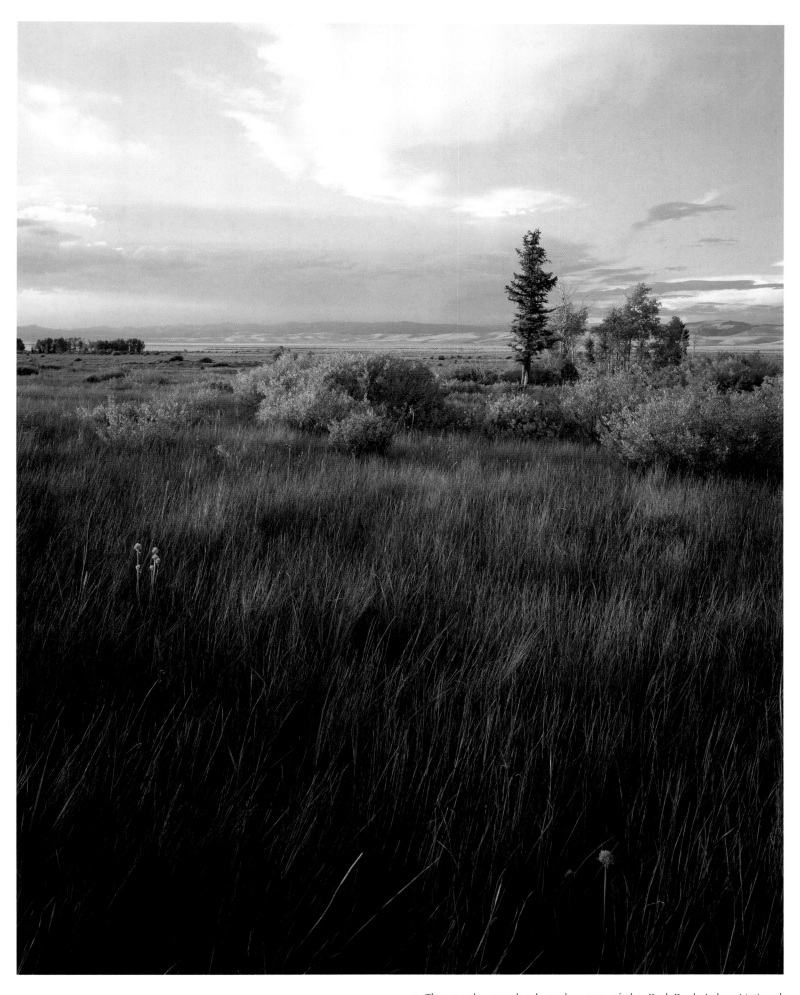

△ The marshy grasslands and waters of the Red Rock Lakes National Wildlife Refuge provide sanctuary for migrating birds, especially trumpeter swans. Endangered species, moose, and other wildlife also find protection.

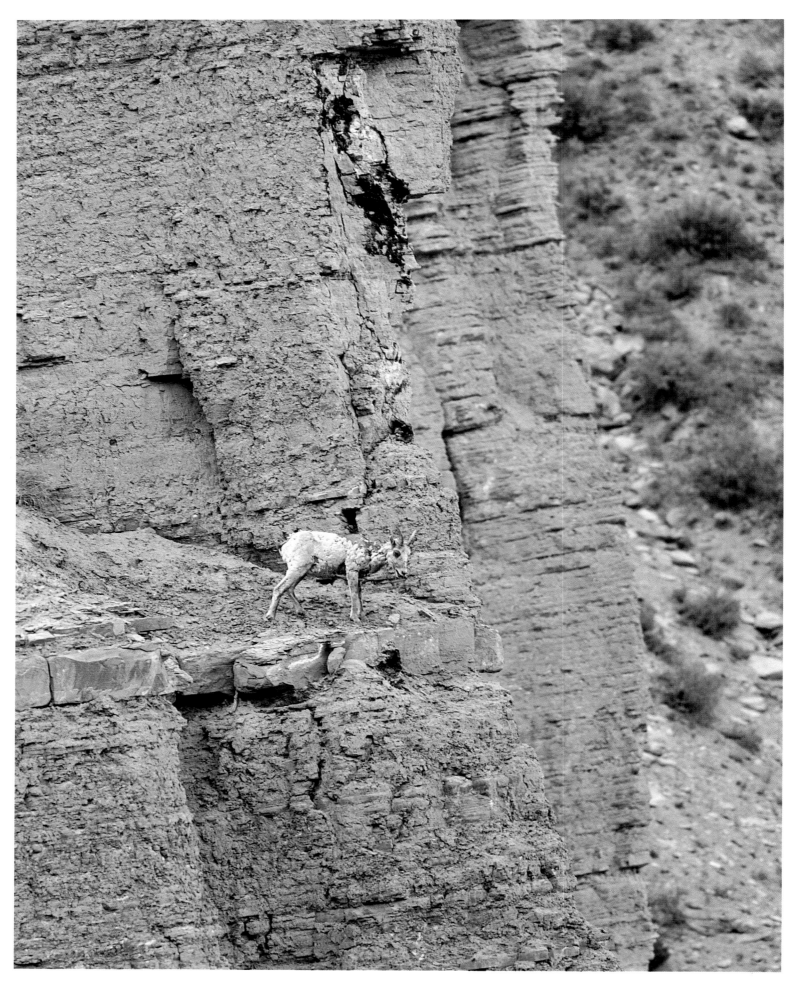

△ A bighorn sheep ewe peers over a cliff in Gardiner Canyon. The females give birth in the spring and lie in seclusion for a week prior to rejoining the herd with their lambs. Ewes may weigh up to two hundred pounds.

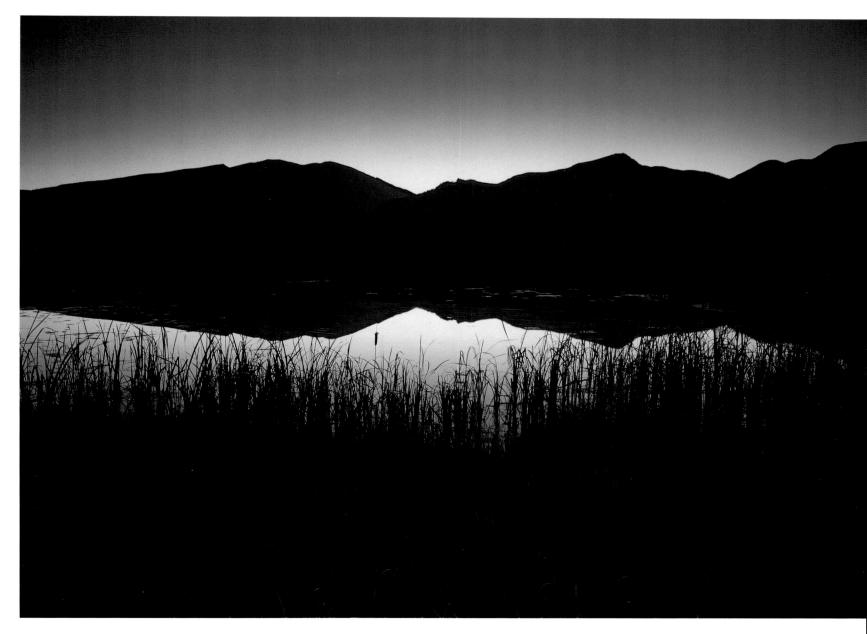

△ A long Montana twilight reveals cattails silhouetted against pond waters in the Metcalf Wildlife Refuge. The refuge was established in 1963 to protect habitats for migratory birds and a variety of wildlife.

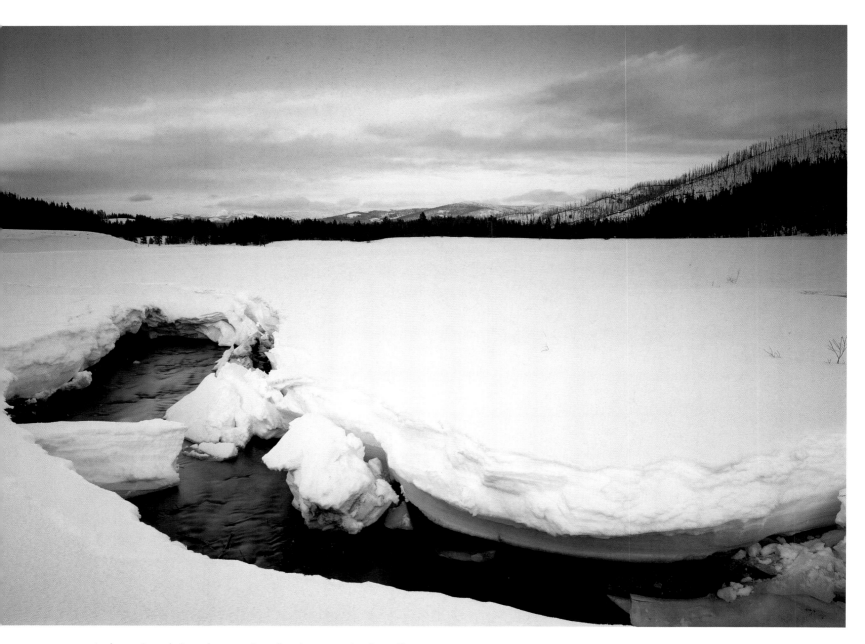

△ As late winter brings the promise of spring, snowbanks collapse into the upper Gallatin River near Fan Creek. In other seasons, the upper Gallatin is a popular site for fishing for trout, rainbows, and cutthroat.

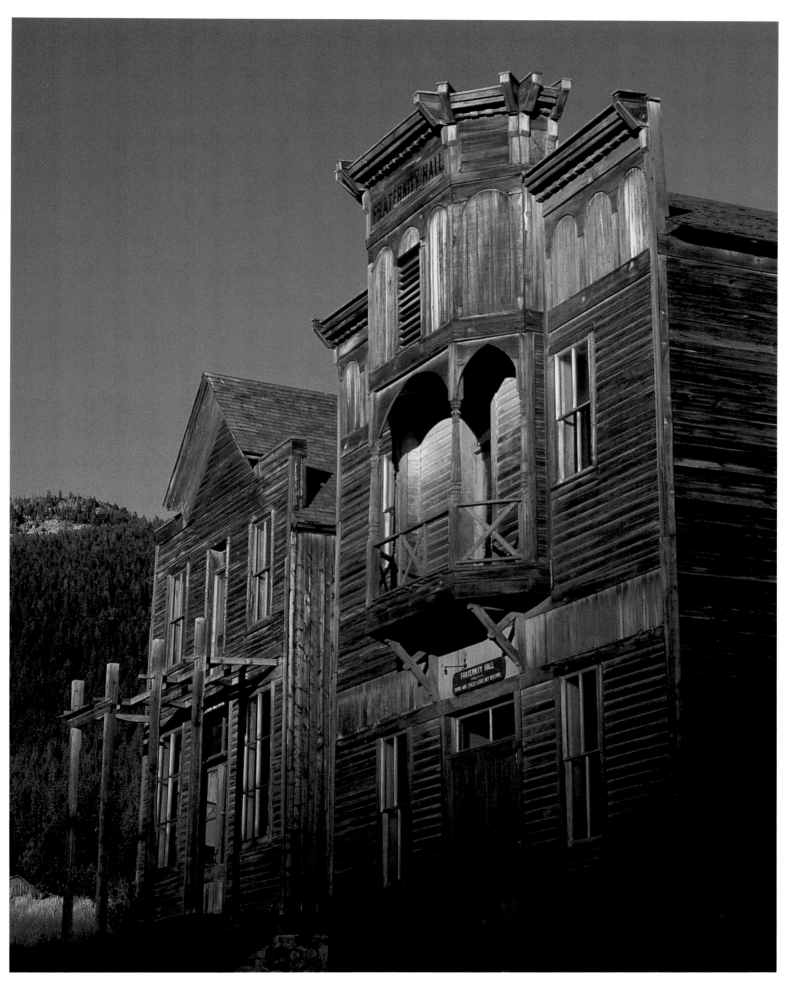

△ Elkhorn's Fraternity Hall and the next-door Gilliam Hall date from the late 1800s, when the mines reputedly produced some $14 million in silver.
▷ ▷ Most of Montana's mountains are big-shouldered, such as the Bridgers.

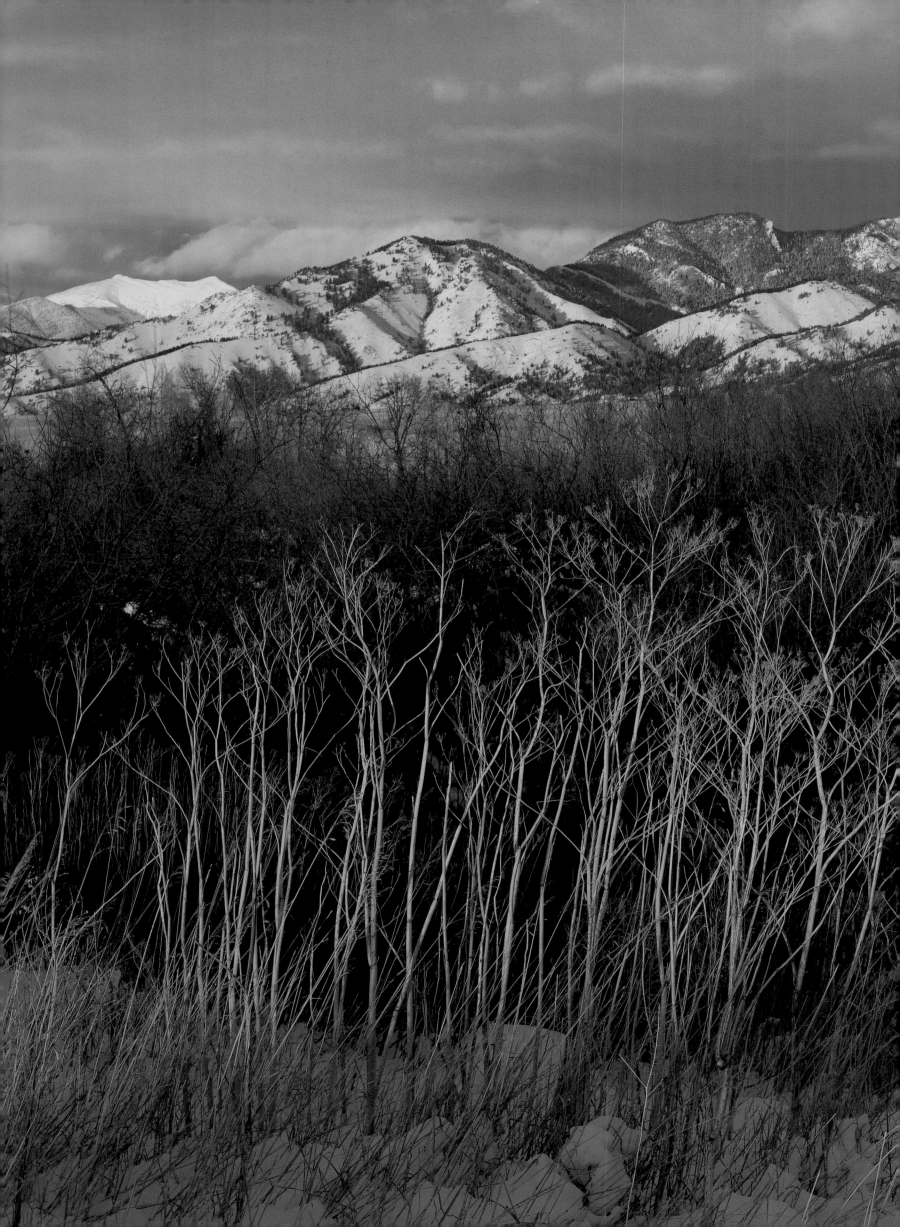

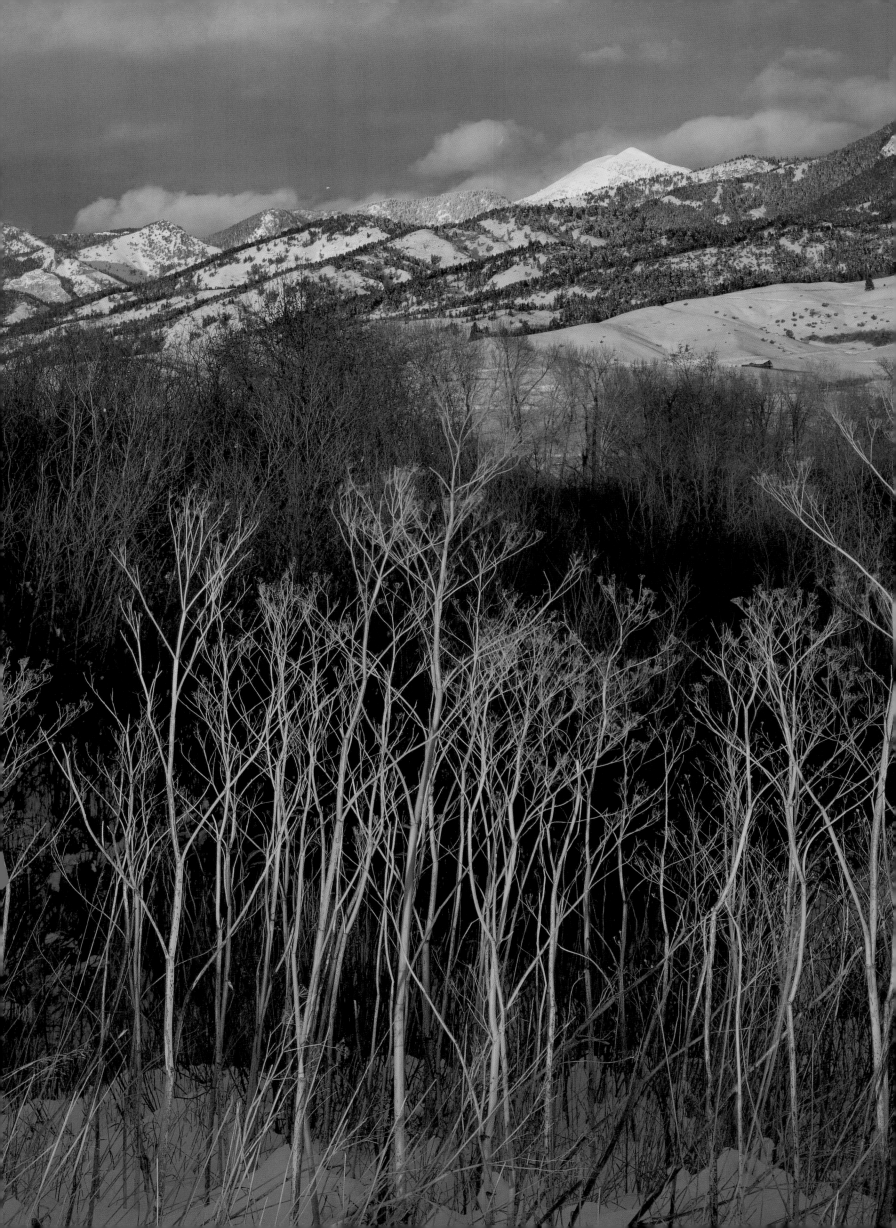

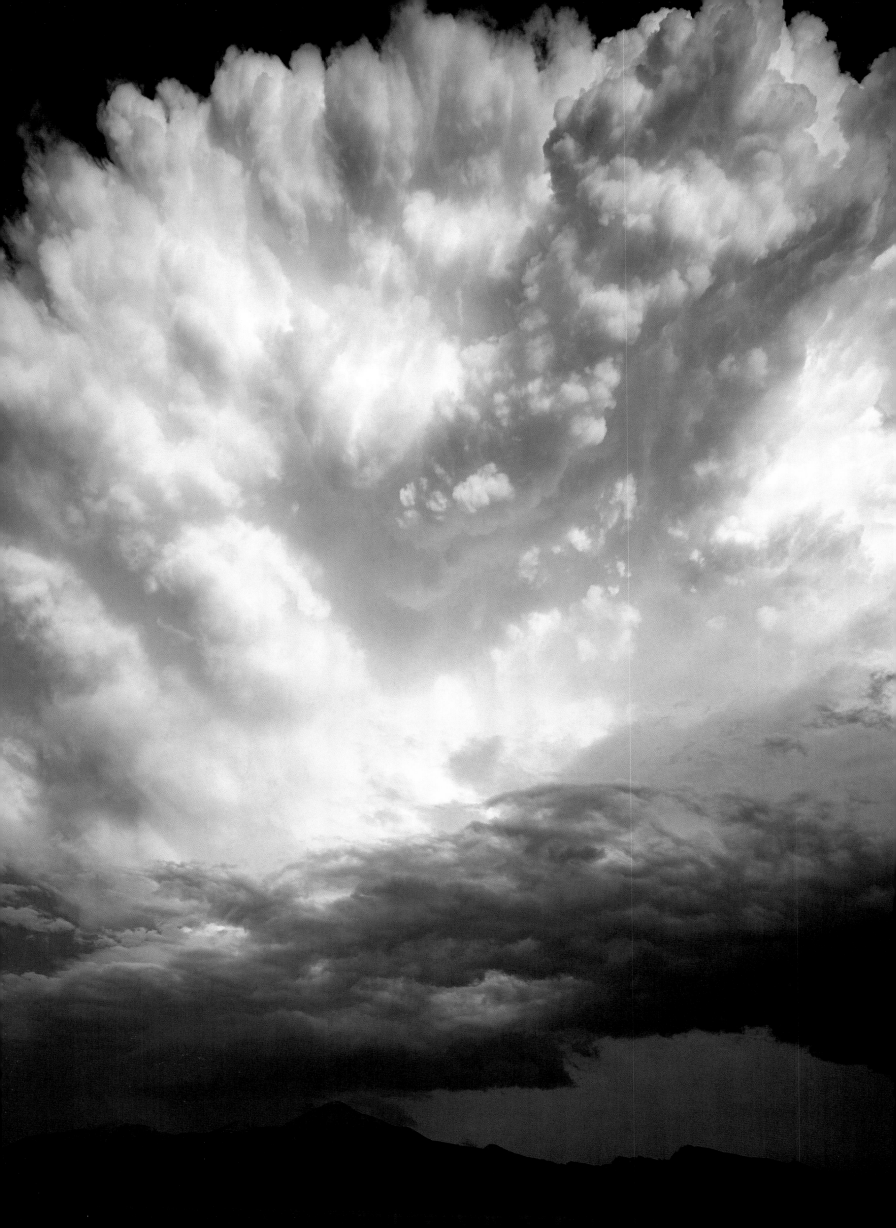

◁ Clouds over the Absaroka Mountains speak of thunder and rain, which will soon join sky and land as one. The Beartooth-Absaroka Wilderness Area provides habitat for large predators, such as grizzlies and wolves.
△ White-water rafters, next to House Rock on the Gallatin River, enjoy one of the state's many great rides. The Gallatin offers numerous rapids—House Rock, Mad Mile, and Bill's Rock to name just a few.

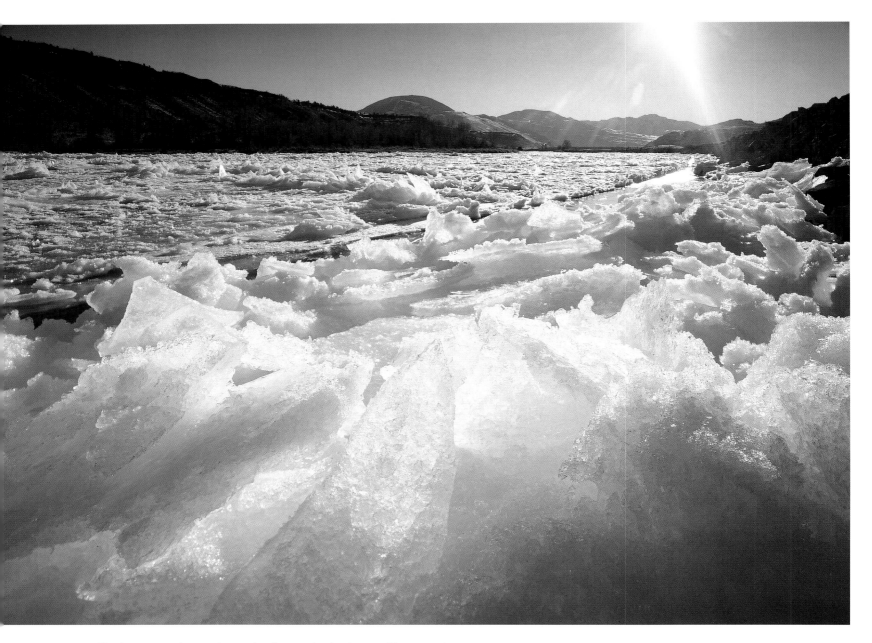

△ The longest undammed stretch of water in the Lower 48 states, the Yellowstone River struggles in winter's grip. The Yellowstone begins as a mere trickle from Younts Peak in the Teton Wilderness. Over the next 676 miles, it grows to a powerful, turbulent river before it joins the Missouri.
▷ These rounded, smooth, striated boulders hold the geological history of this bank of the Yellowstone River. In 1999, *National Geographic* magazine declared that the Yellowstone was "the Last Best River."

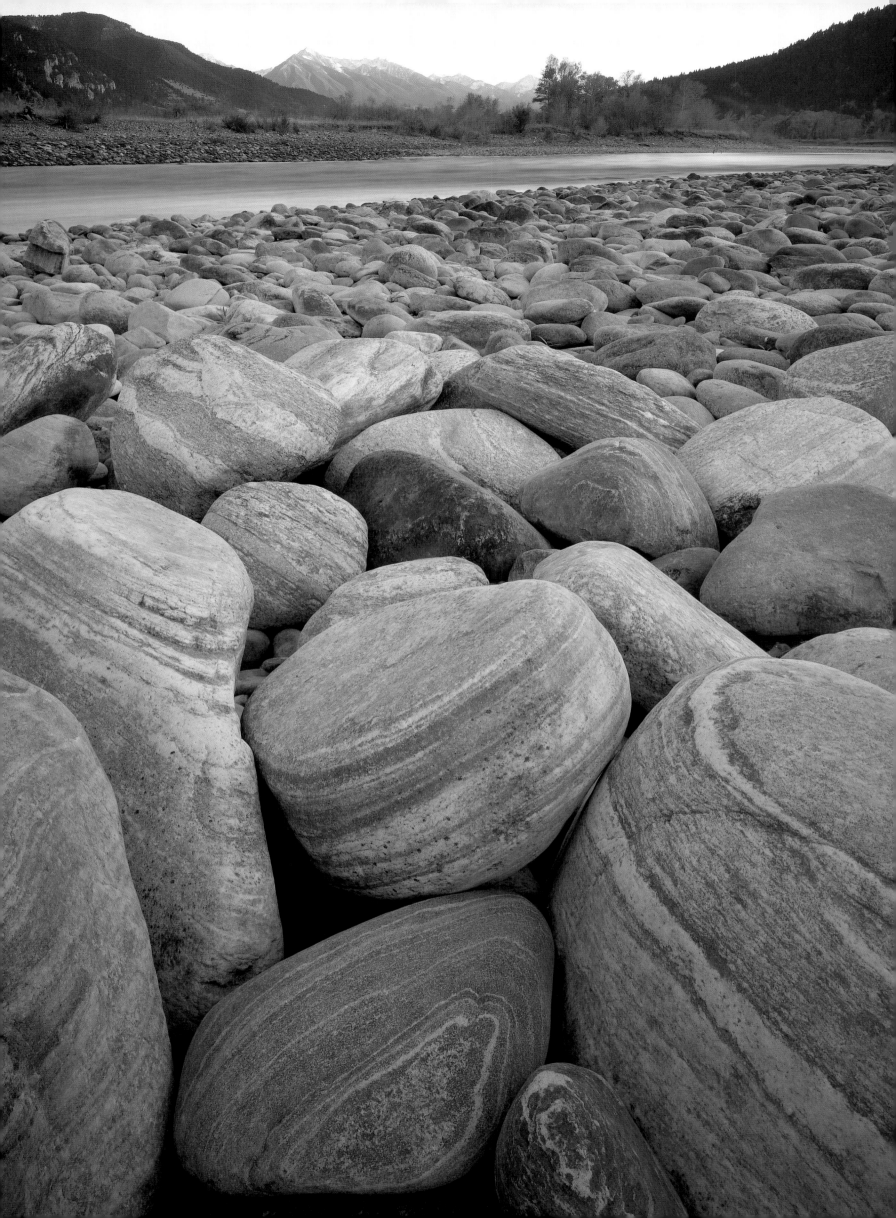

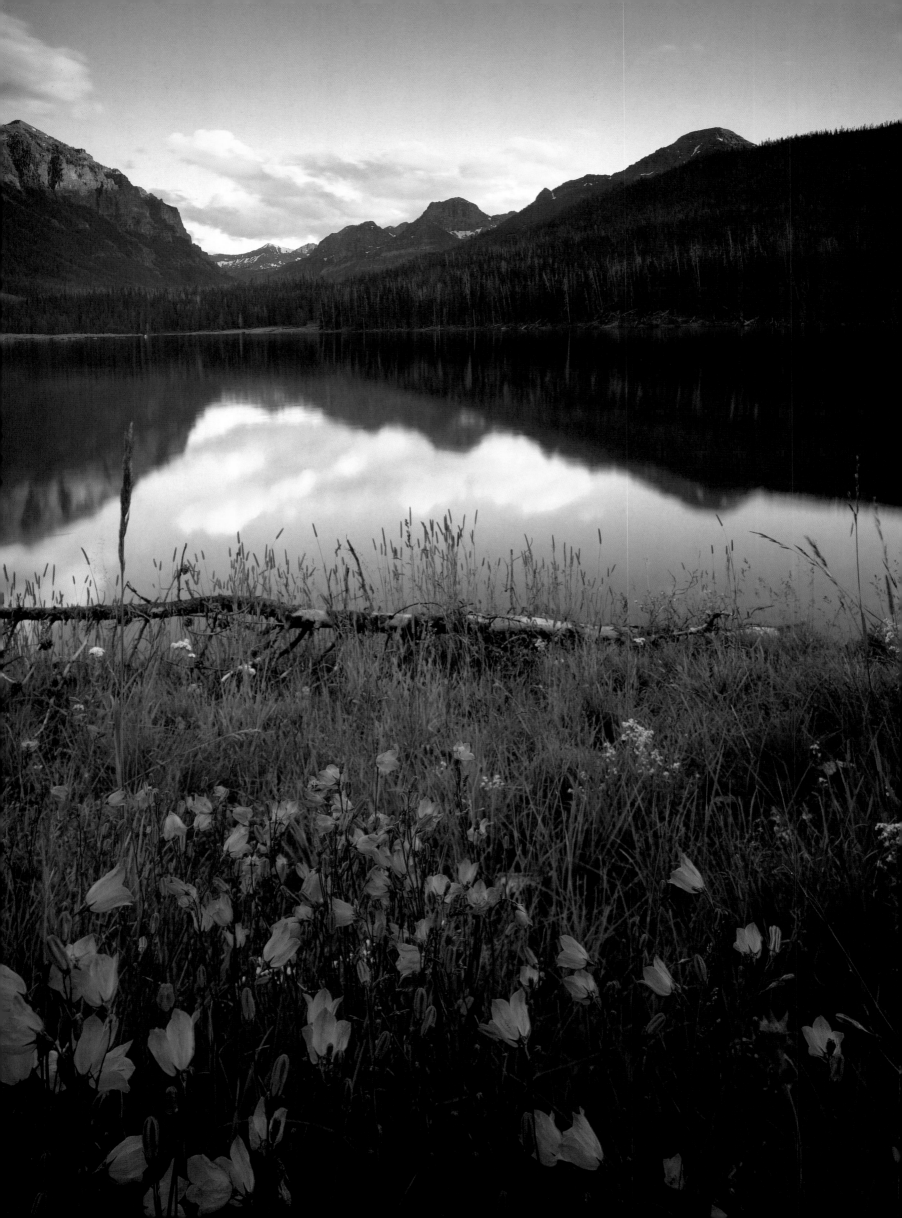

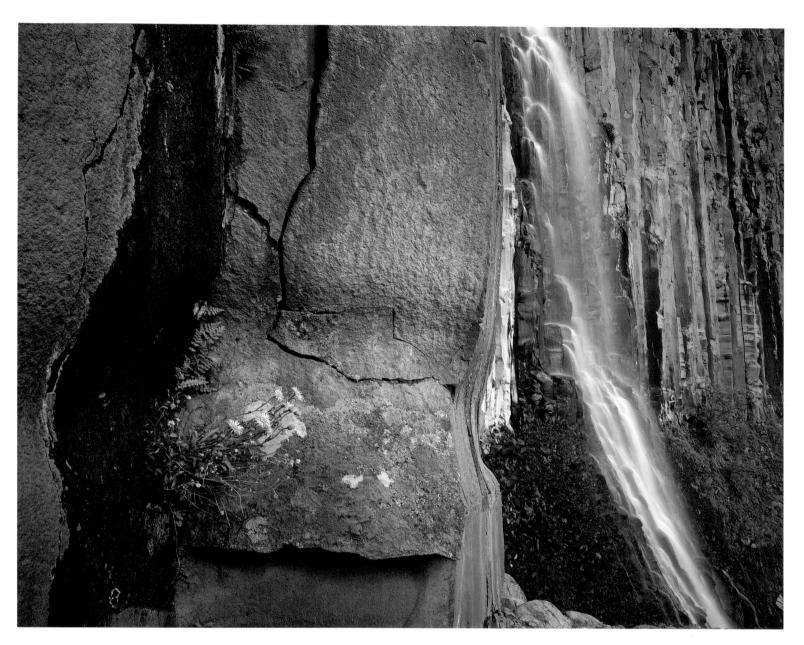

◁ The bell-shaped flowers of the perennial harebell herald spring along the Hyalite Reservoir near Palisade Falls in the Gallatin National Forest.
△ A miniature Alpine daisy, finely attuned to its wild environment, clings in delicate balance with the tumbling waters of Palisade Falls.
▷ ▷ A double rainbow encircles Golf Course and Rifle Range, near Yellowstone's Black Canyon and Rattlesnake Butte.

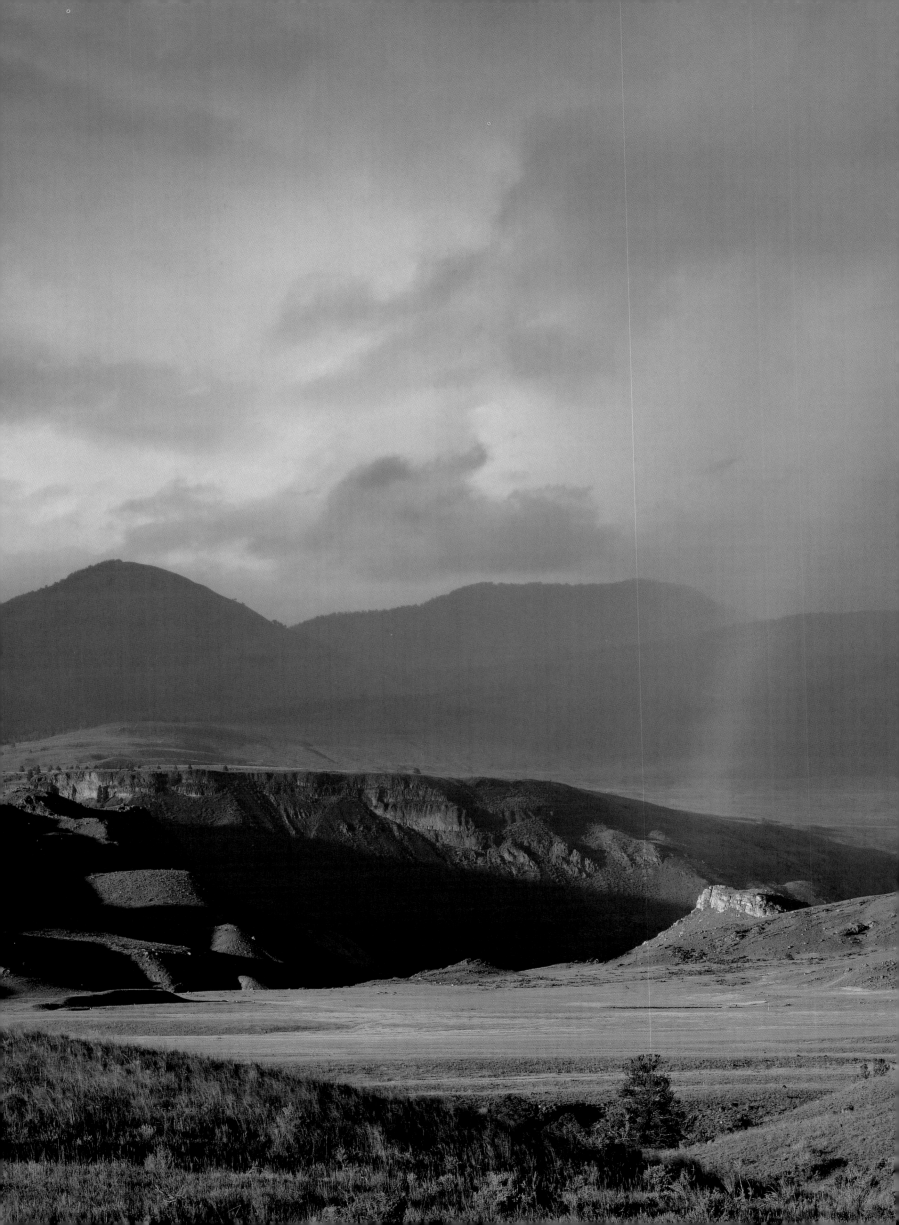

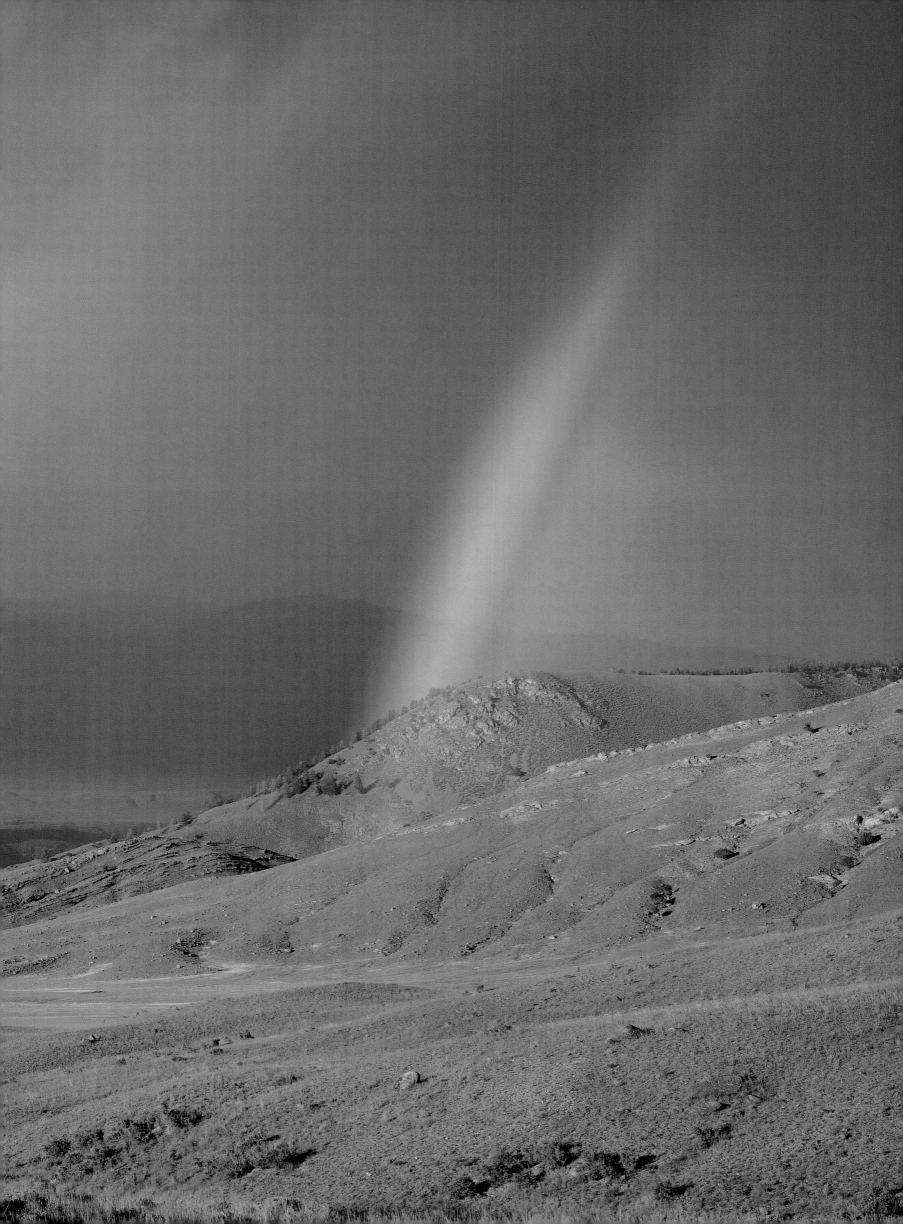

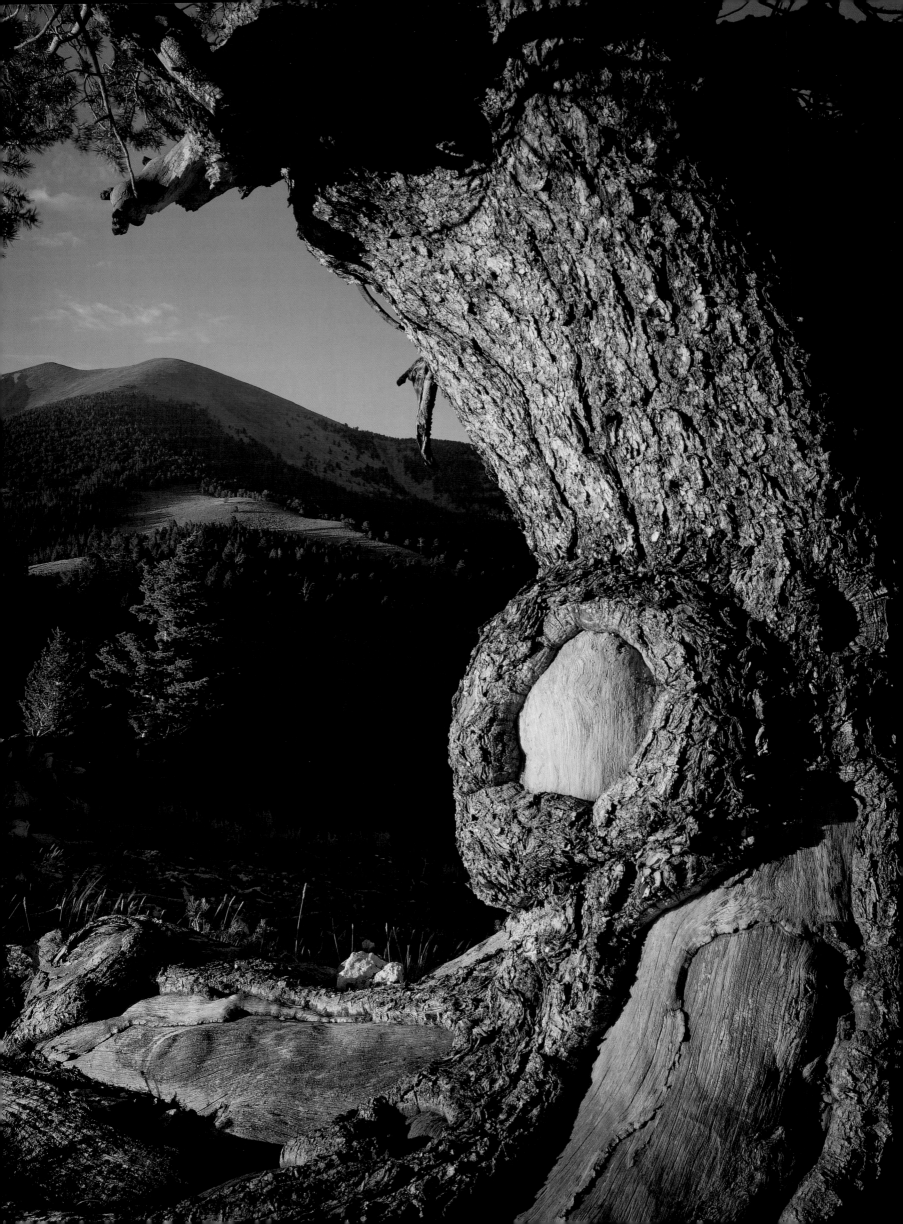

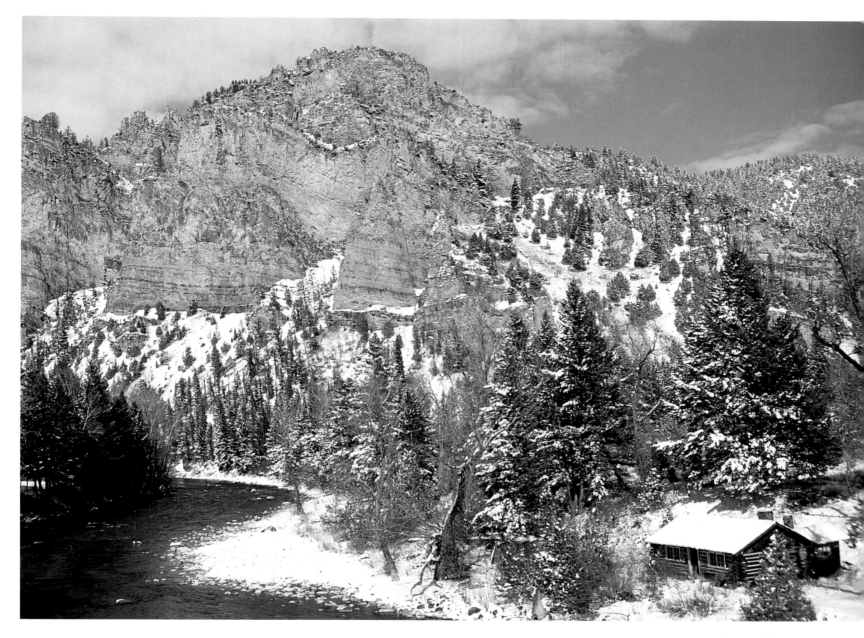

◁ A pine tree, roots creeping around rock outcroppings in the Dice Creek drainage, frames Baldy Mountain in the Pioneer Range, which has been proposed for Wilderness designation before the U.S. Congress.
△ A lone cabin nestles in the trees near the snow-banked Gallatin River.

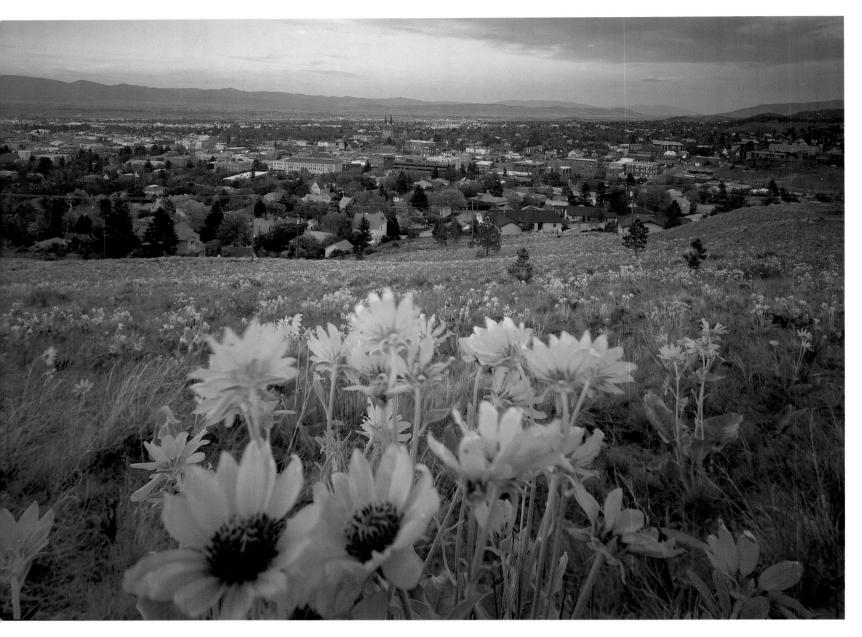

△ Balsam leaf flowers overlook Helena, seat of the state's government and the site of early gold discoveries. The gold-producing creek, now covered by the city's main street, is appropriately named Last Chance Gulch.

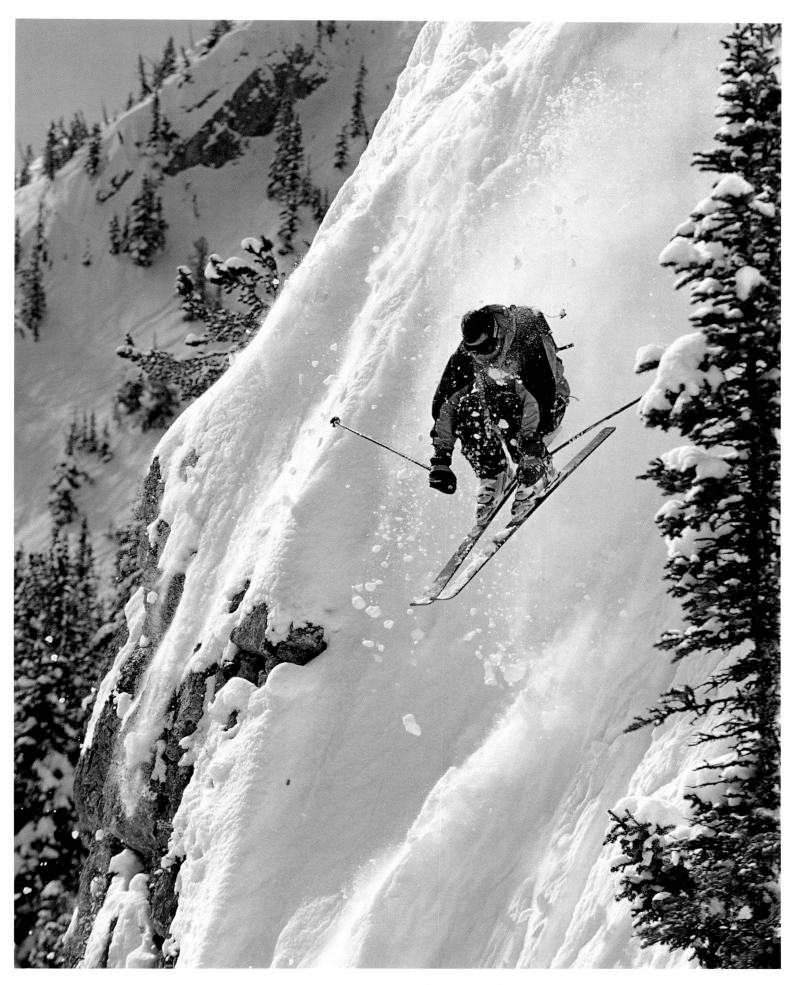

△ The state's world-class ski areas attract thousands of skiers annually. The slopes offer every class of skiing from beginner to extreme. Here, expert skier Eric Knoff takes to the air on Bridger Bowl's infamous ridge.

△ In the town of Bannack, once the state's territorial capital, a young cowboy pans for gold, and the look on his face says he has "struck pay dirt." During Bannack Days the ghost town comes alive again with Sheriff Henry Plummer, gold miners, stagecoaches, old-time dancing, and gun fighters.

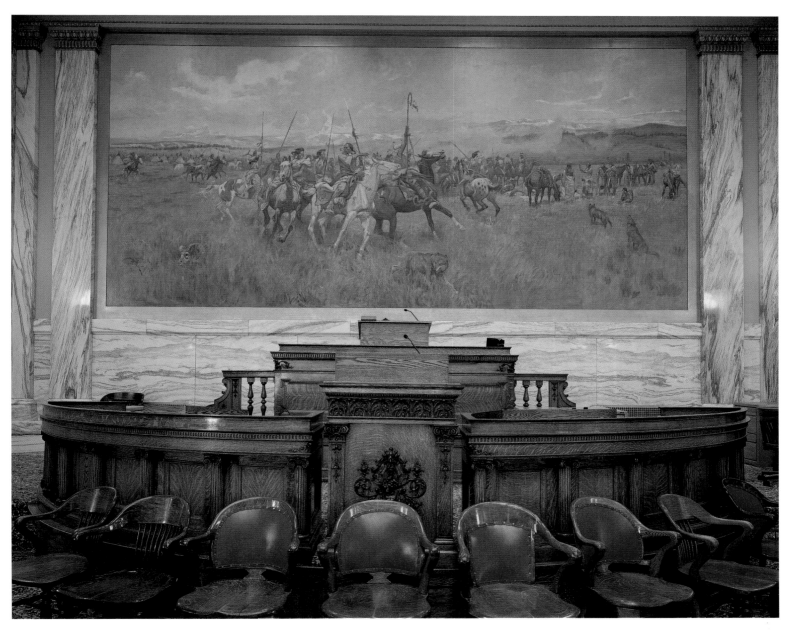

△ In 1911 the cowboy artist Charlie Russell was commissioned by the state to paint a large mural to be mounted in the new House of Representatives wing of the capitol. The monumental twenty-five-by-twelve-foot canvas, *Lewis and Clark Meeting Indians at Ross' Hole,* reminds Montana legislators that this land once belonged to others.
▷ ▷ The great prairie empire bordering the west front of the Rockies is occasionally dotted with glacial potholes such as this one near Haystack Butte.

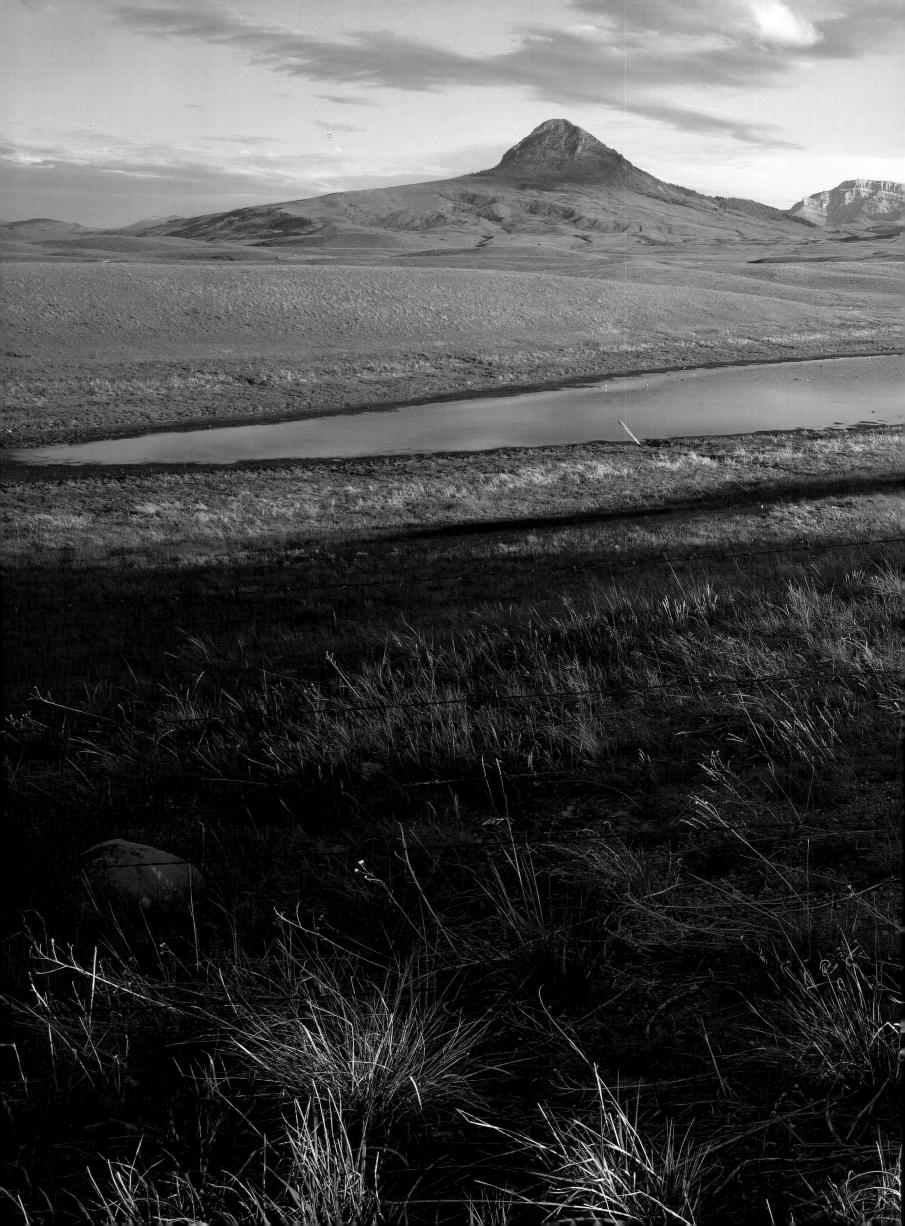

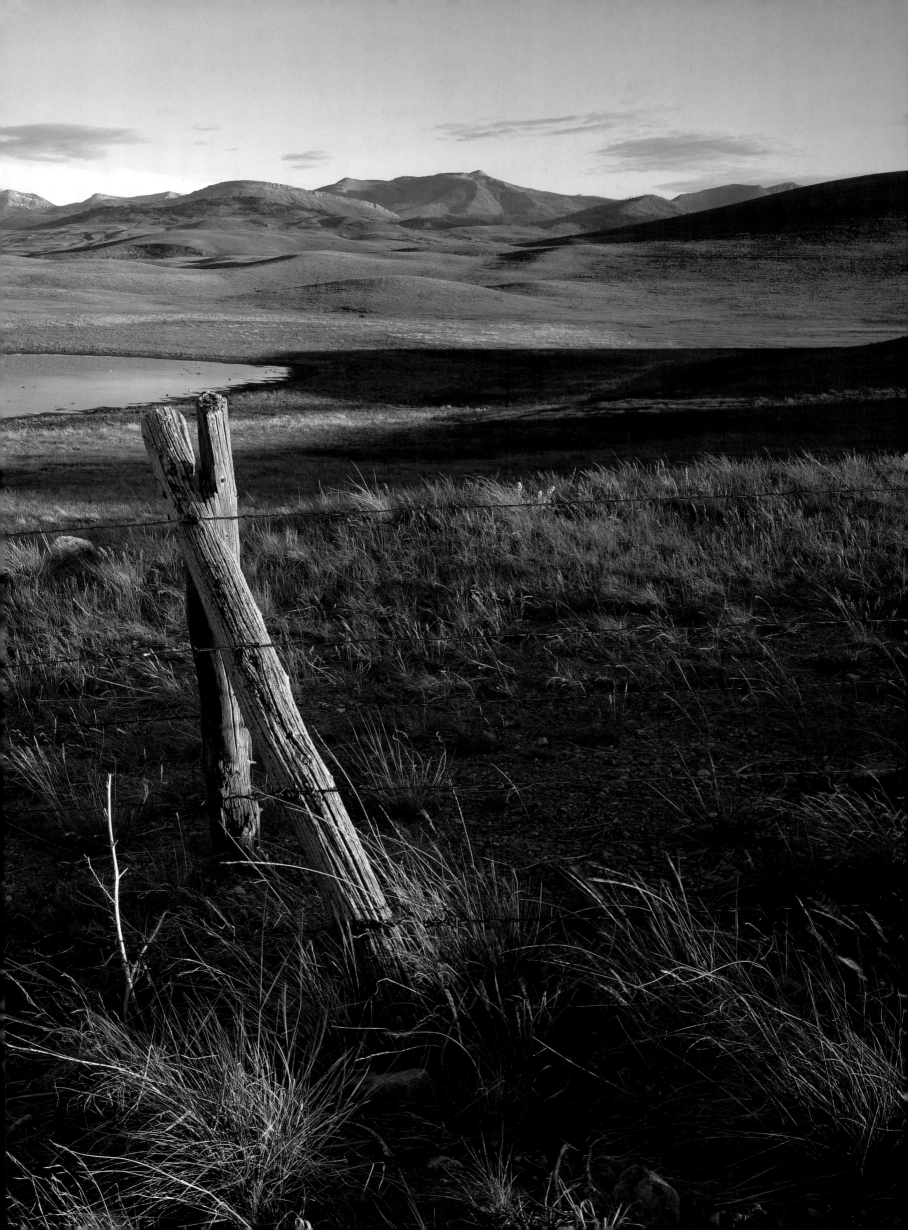

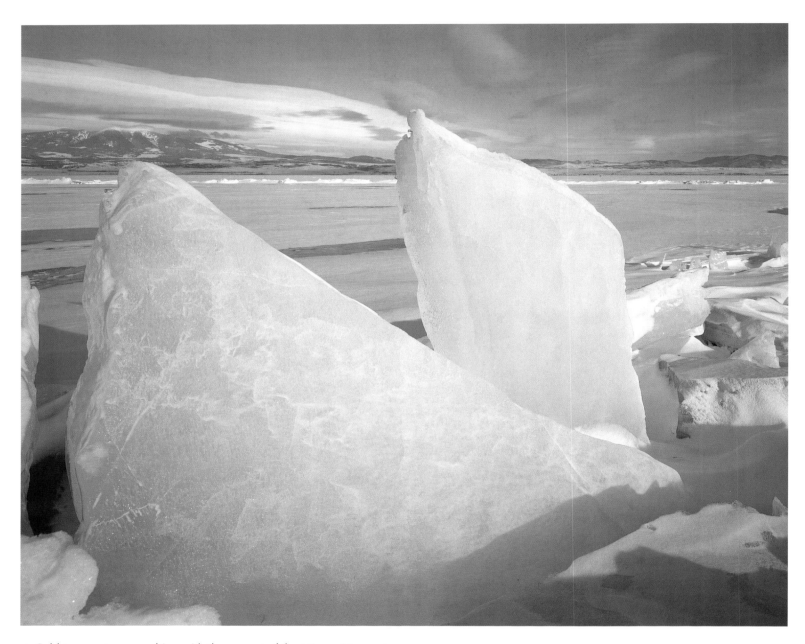

△ Cold temperatures combine with the current of the Missouri to create standing ice in Canyon Ferry Reservoir near Helena, the state's capital.
▷ The proud Irish freedom fighter and Montana's Territorial Governor, Thomas Francis Meagher, is silhouetted against Montana's capitol. Meagher, sentenced to death in Ireland, escaped and made his way to the United States. A Civil War hero, Meagher wrote and lectured prior to his still-unsolved disappearance from a Missouri River steamboat at Fort Benton.

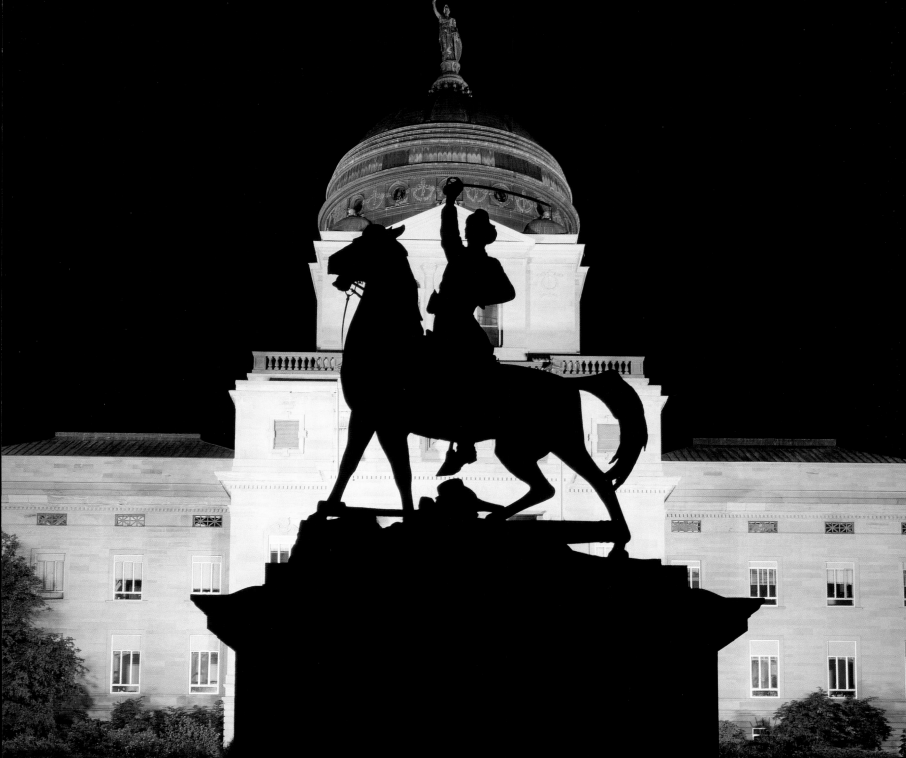

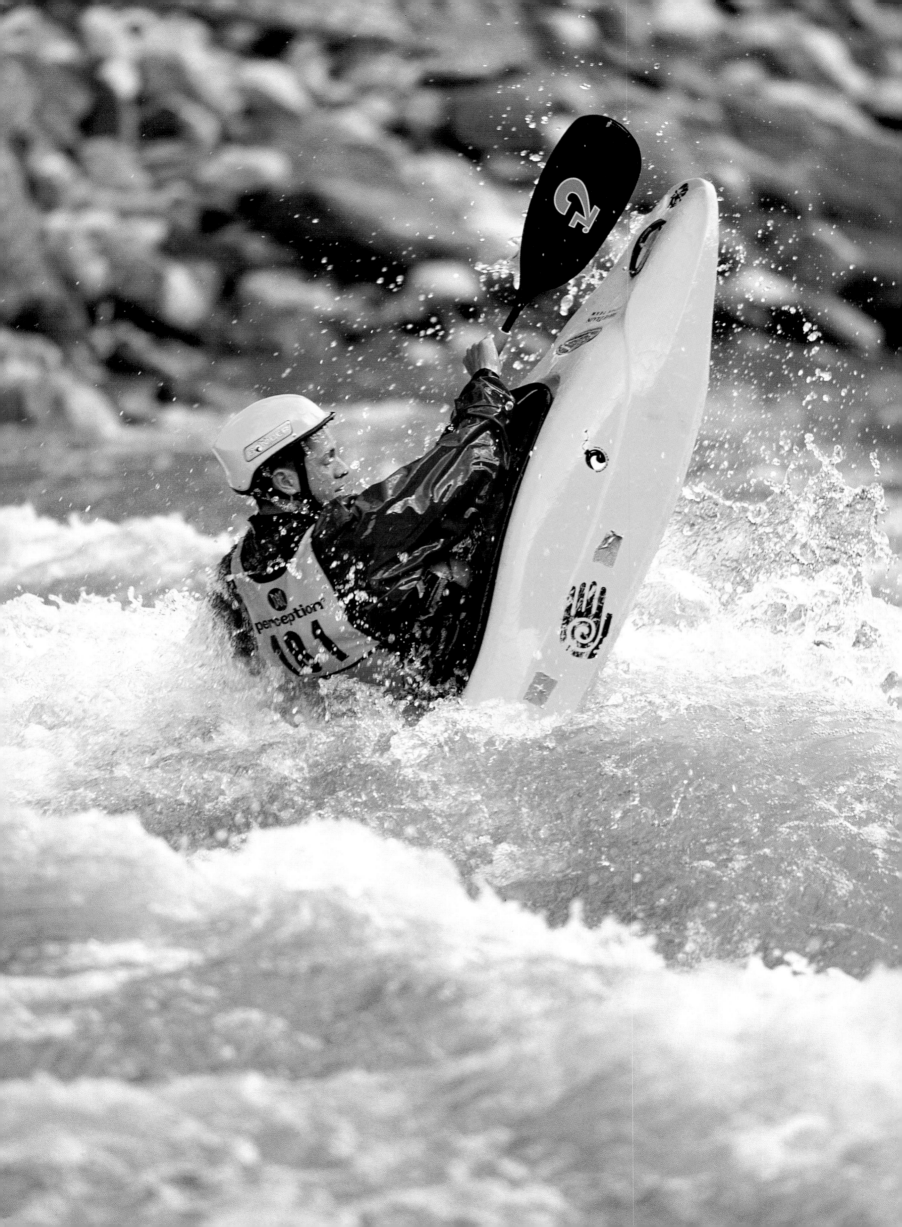

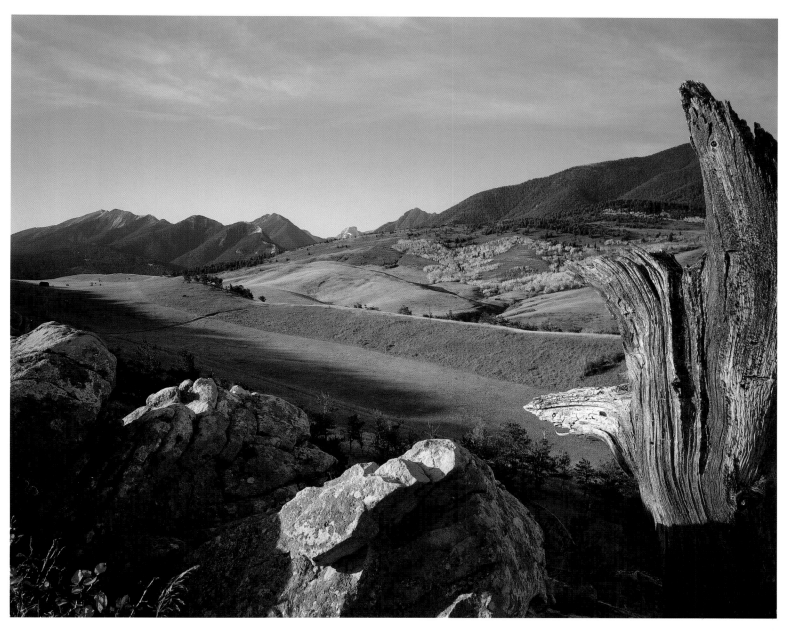

◁ A kayaker rides the whitewater of the Gallatin River. Other recreational opportunities along the river include camping, rafting, and fishing.
△ Wood, rock, and sky complement the Absaroka Mountains along Upper Mission Creek Road in the Gallatin National Forest. The forest is part of the one-third of Montana that is held for the public under national ownership.

△ Painted ladies augment a small bouquet of dandelions among the grasses
of the forest floor. The painted lady may be the most widespread butterfly
in the world. It is also known as the thistle butterfly and the cosmopolitan.
▷ Autumn's gold flanks the Gallatin River, named by Lewis and Clark
on July 27, 1805, in honor of Secretary of the Interior Albert Gallatin.
▷ ▷ Dried, twisted, and decaying roots and the broken rock of a limestone
outcropping set off the snowy Beartooth Mountains in the background.

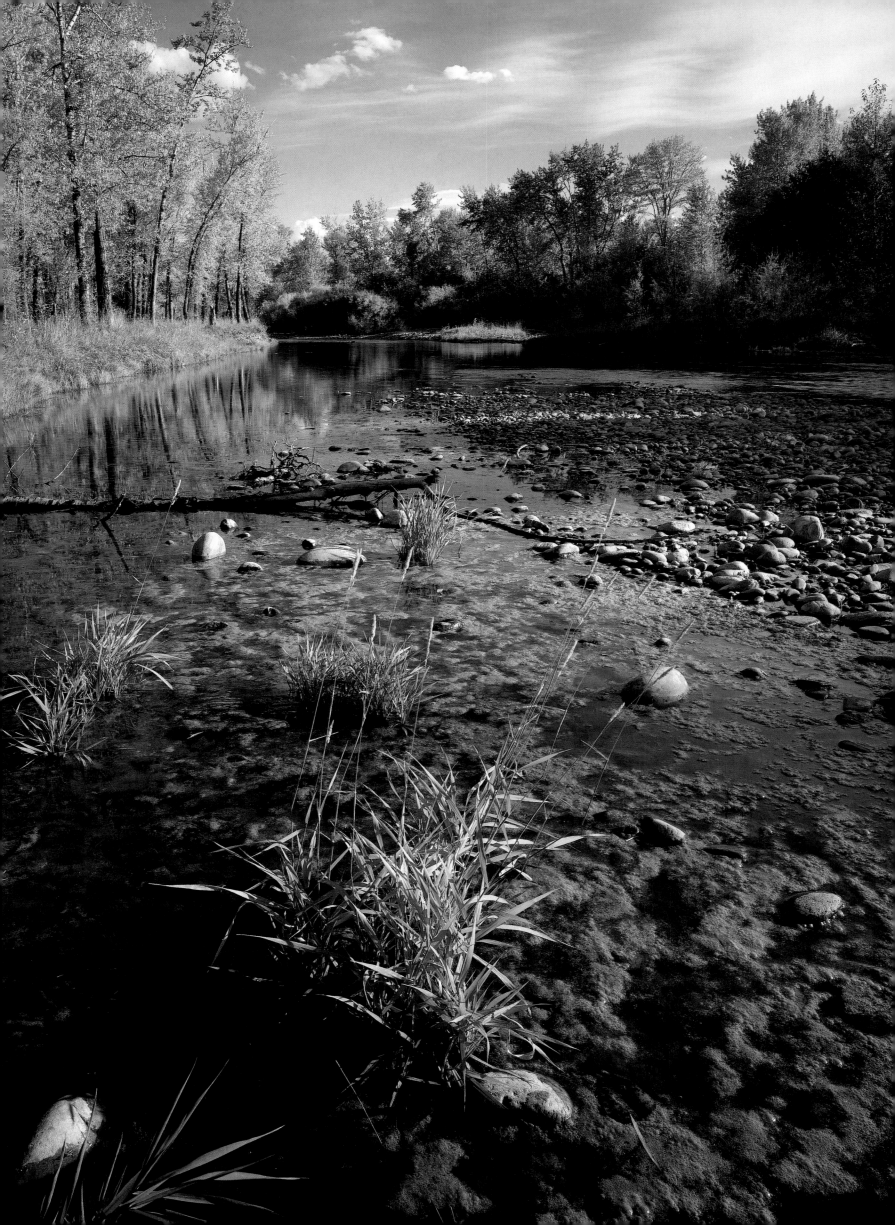

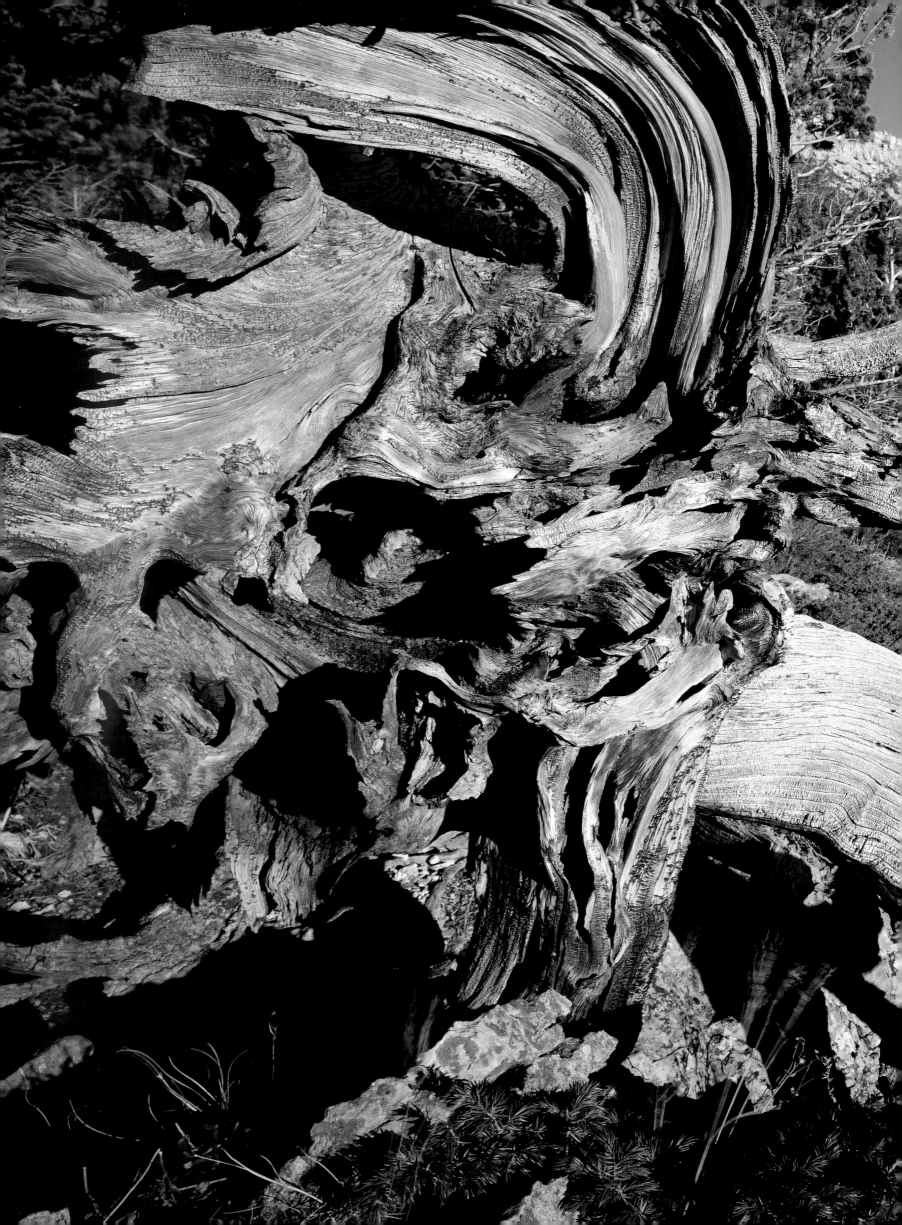

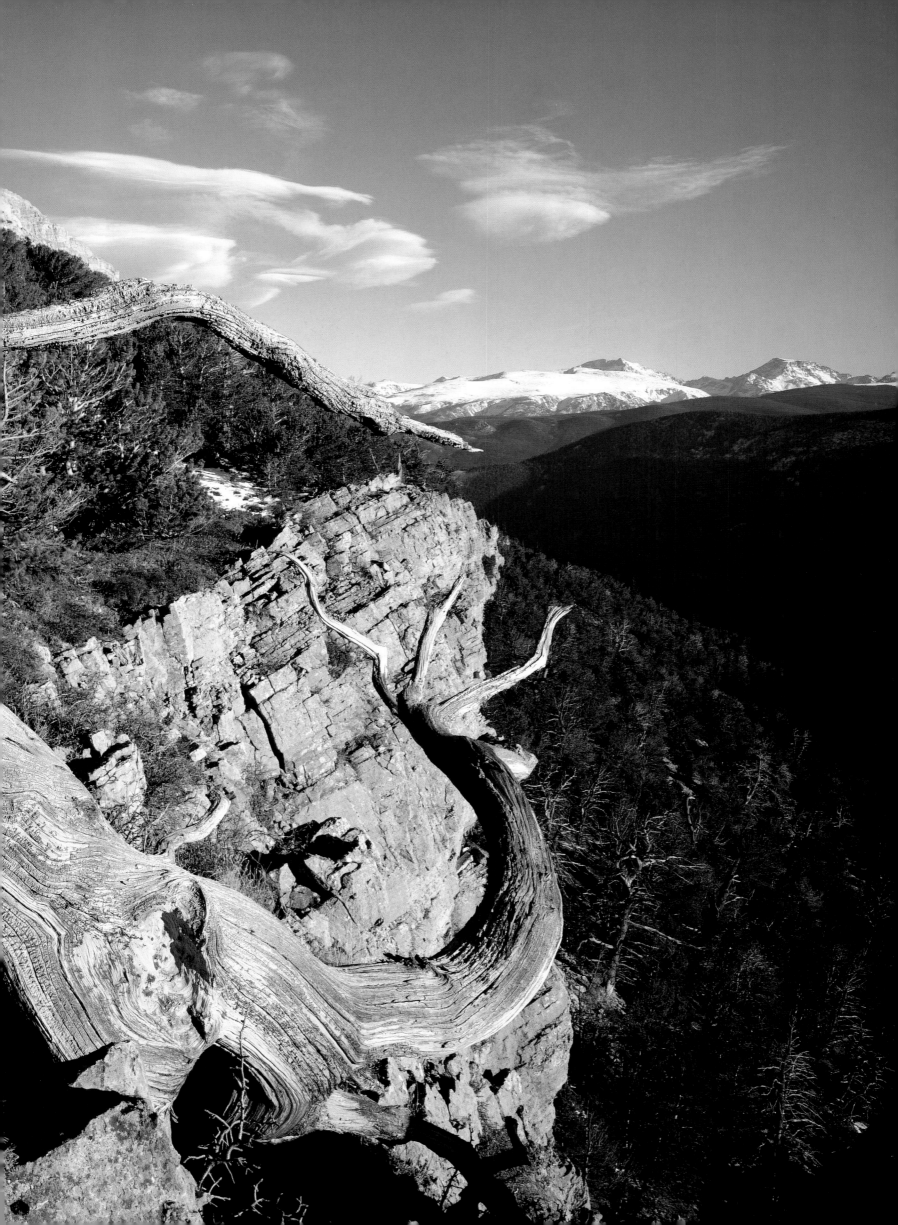

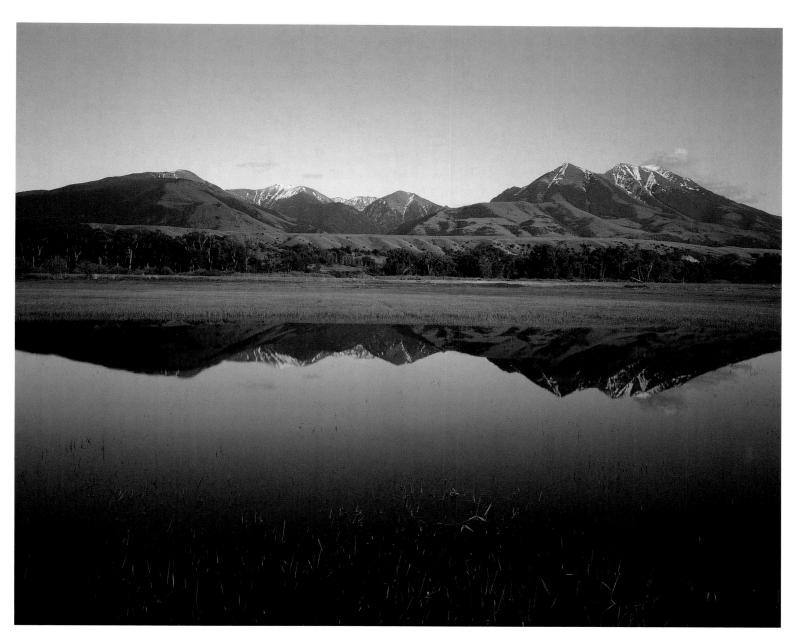

◁ Water, wind, and pollen residue sort, shape, and wear the rocks and boulders of the Crazy Mountains. The Crazy Mountains offer many things— snow-fed lakes, broken cliffs, nearly vertical peaks, saw-tooth ridges, and lush alpine slopes. Mountain elevations range from 5,590 to 11,214 feet. △ The Paradise Valley, north of Yellowstone Park, is home to some of the state's earliest ranch families as well as many of our newest arrivals.

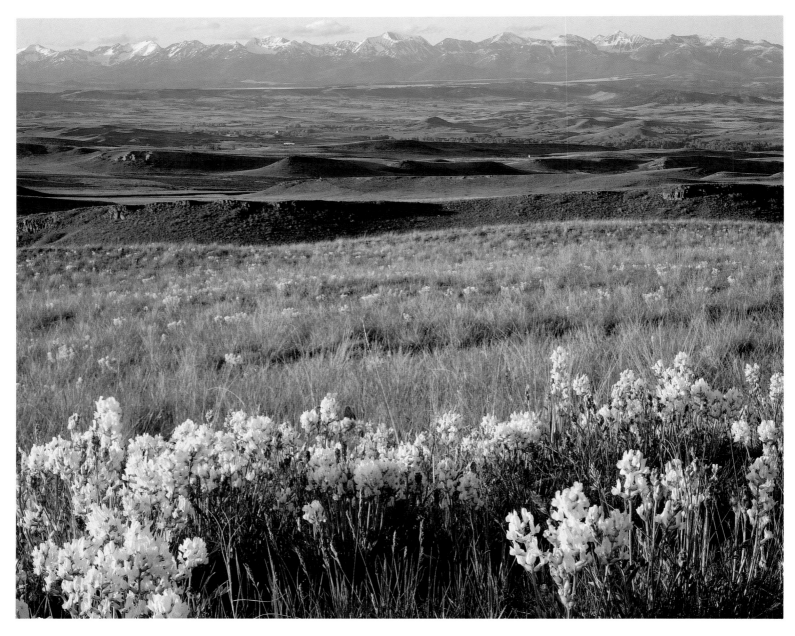

△ White lupines grace the Shields Valley, with the Crazy Mountains on the horizon. The Shields Valley nestles between the Bridger Mountains to the west, the Crazy Mountains to the east, and the Absaroka Mountains to the south. One of the state's prime trout streams, the Shields River, meanders through the valley.

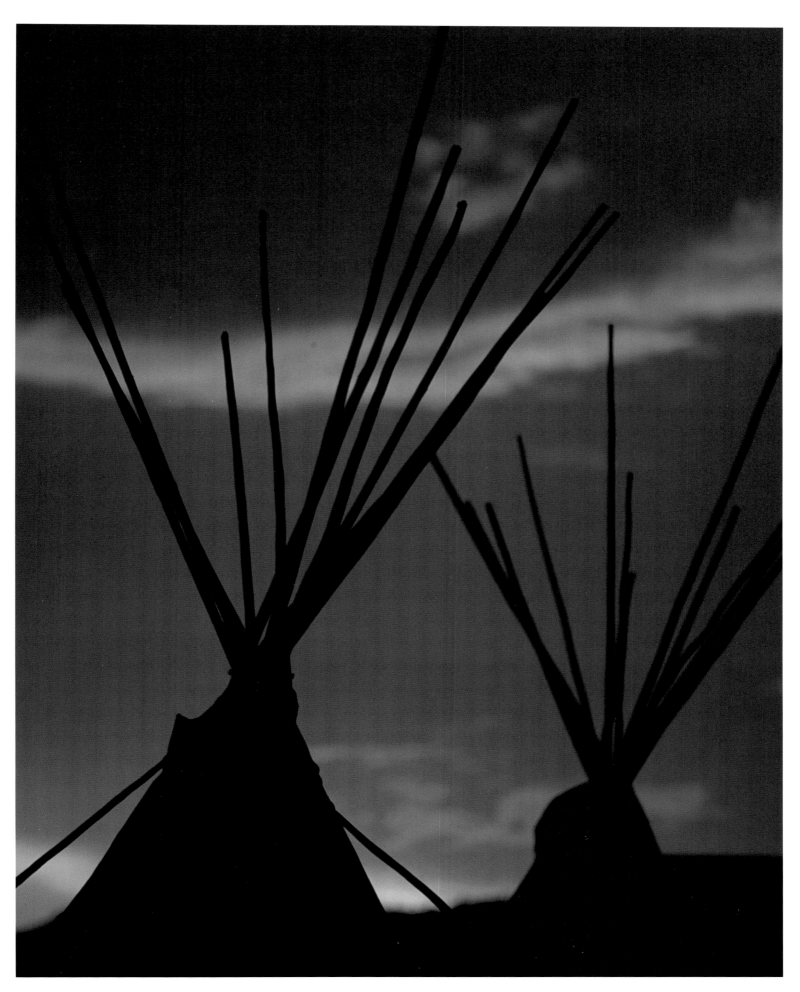

△ Native lodges—tepees—rise stark and black against the last light of sunset. Because of their efficient design and their historical significance, traditional tepees are still popular today.

△ The impressions of early artists can still be seen in these deer figures in Pictograph Caves located near Billings. The sophistication of our early Native American artists is evident in these and other rock paintings in various locations throughout Montana.

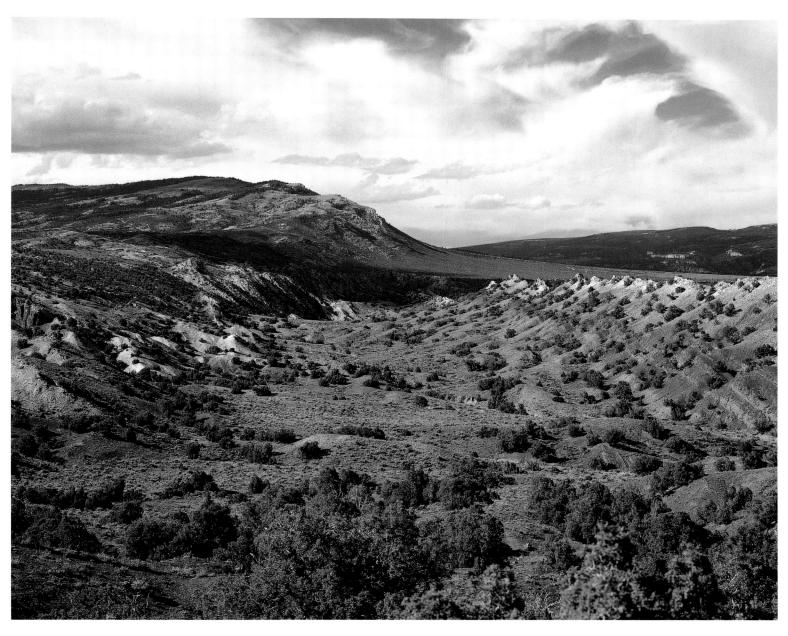

△ The Crow Indians still know these lands as home. Red Rock Canyon is located in Crow Country, with Red Pryor Mountain and the Pryors beyond. The Pryors, named for Nathanial Pryor of the Lewis and Clark Expedition, lie in traditional Crow Country. Starting from the badlands to the south, the mountains rise five thousand feet in just twenty miles.
▷ ▷ Big Horn Canyon, surrounding the Yellowtail Reservoir, is the setting for this winter canyon suite. Yellowtail Dam, at the mouth of Bighorn Canyon, impounds flows of the Bighorn River for multipurpose use.

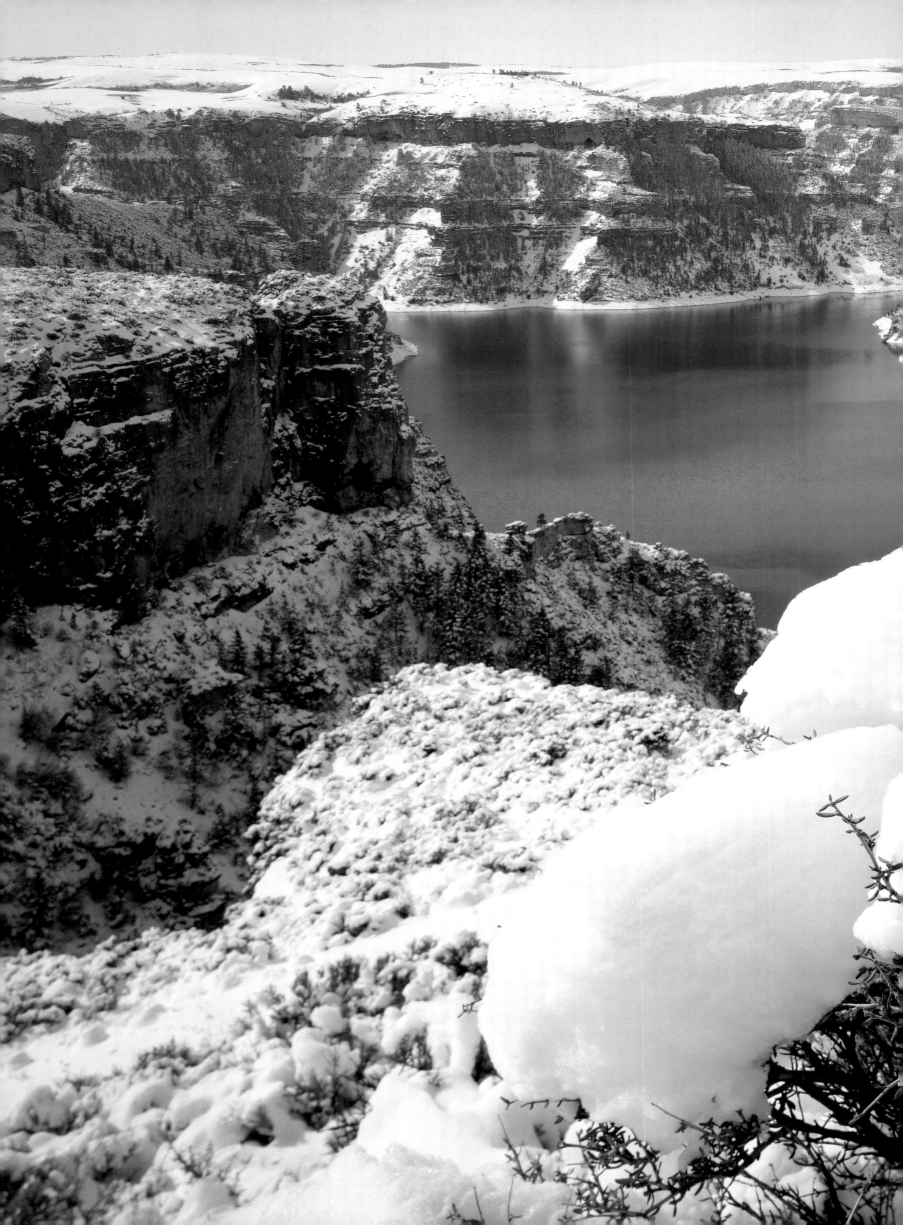

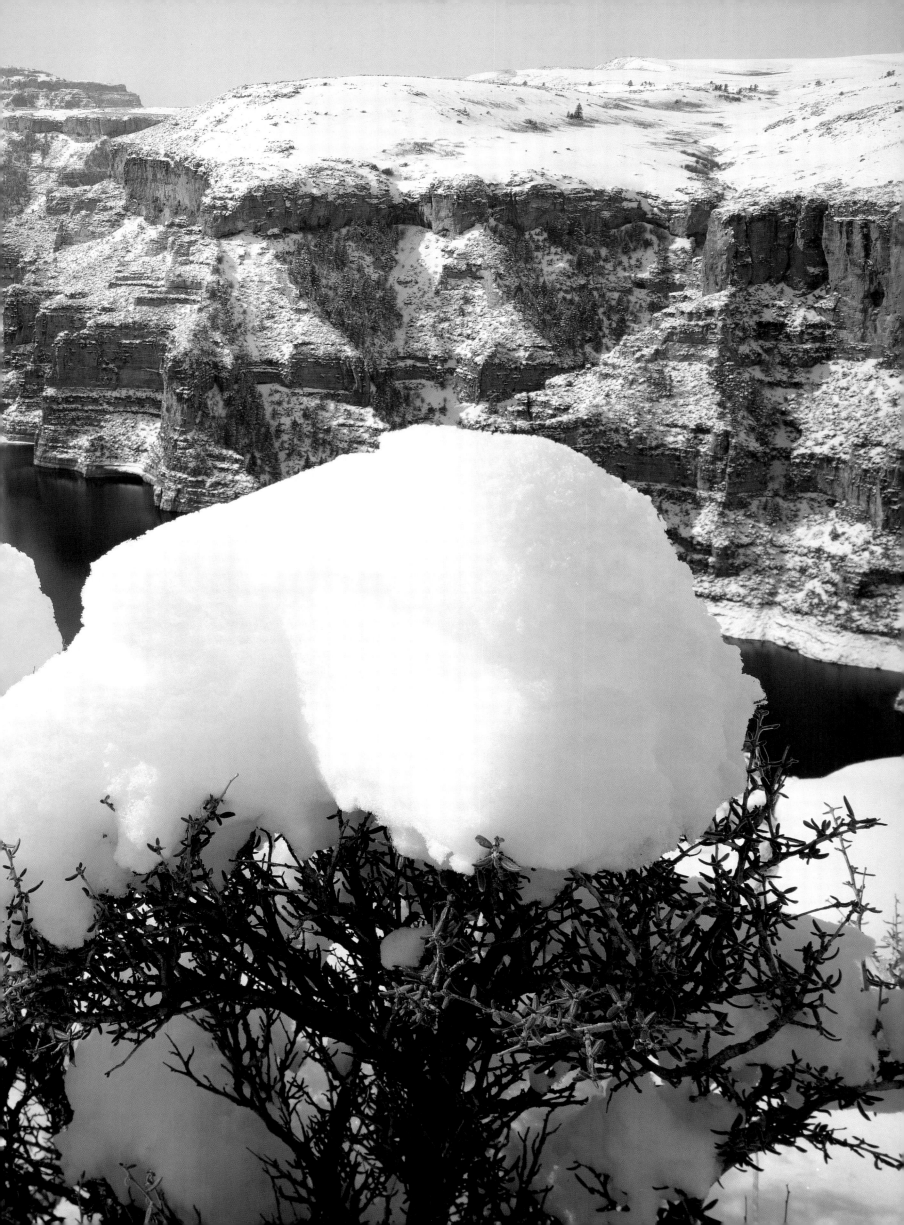

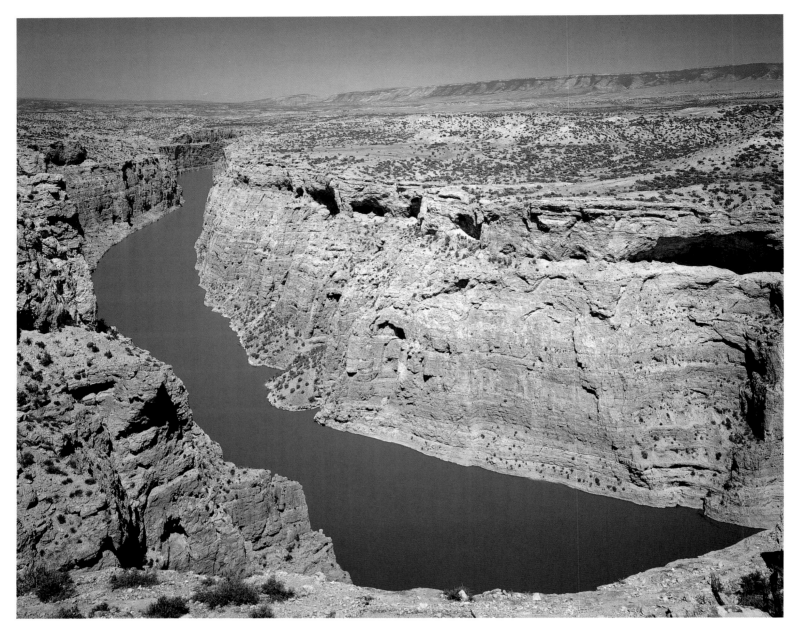

△ The Wild Horse Range of the Pryor Mountains is seen beyond the colorful cliffs and slow-moving waters near Devil Canyon Overlook.
▷ Dead cedar bakes on the sunbathed rocks of the Pryor Mountain Wild Horse Range, so named because some 120 wild horses range this wild land.

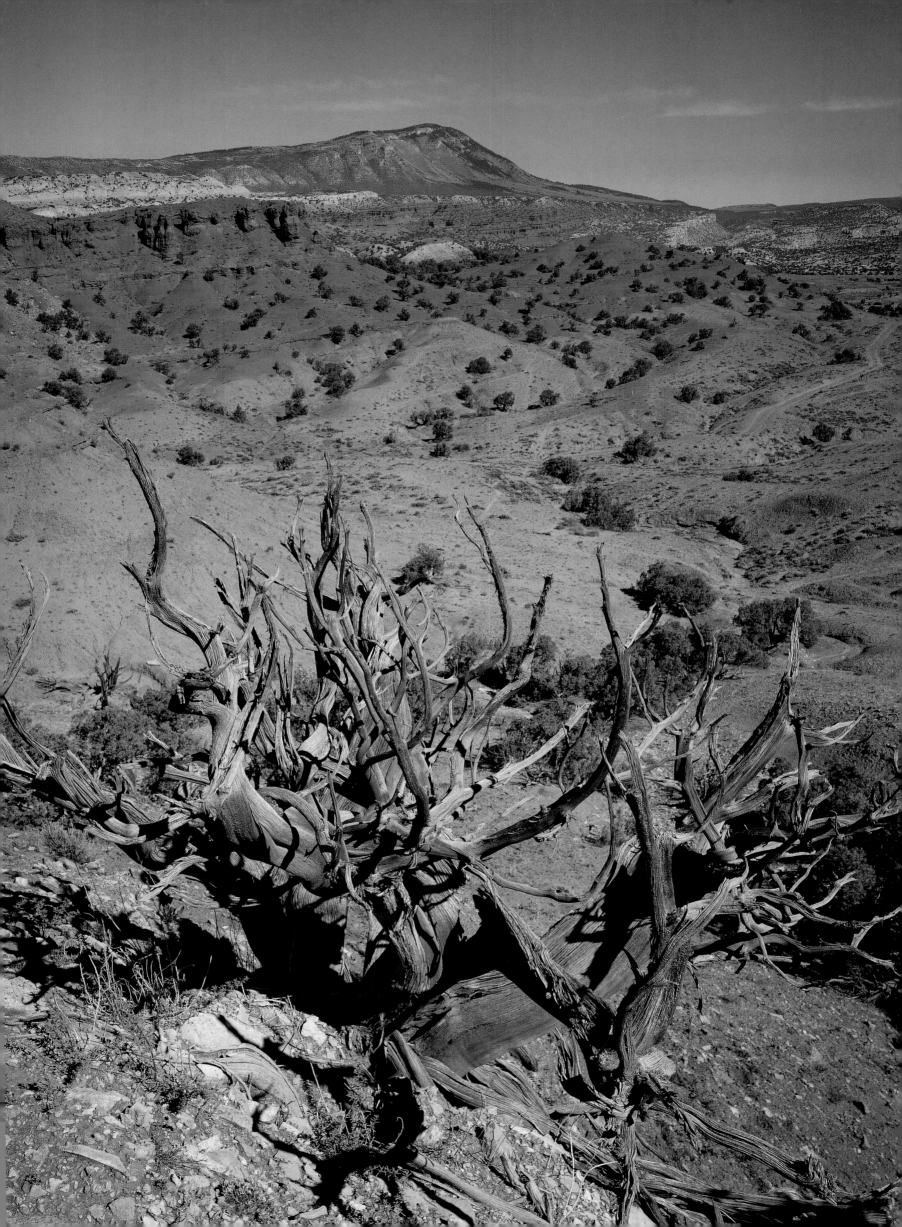

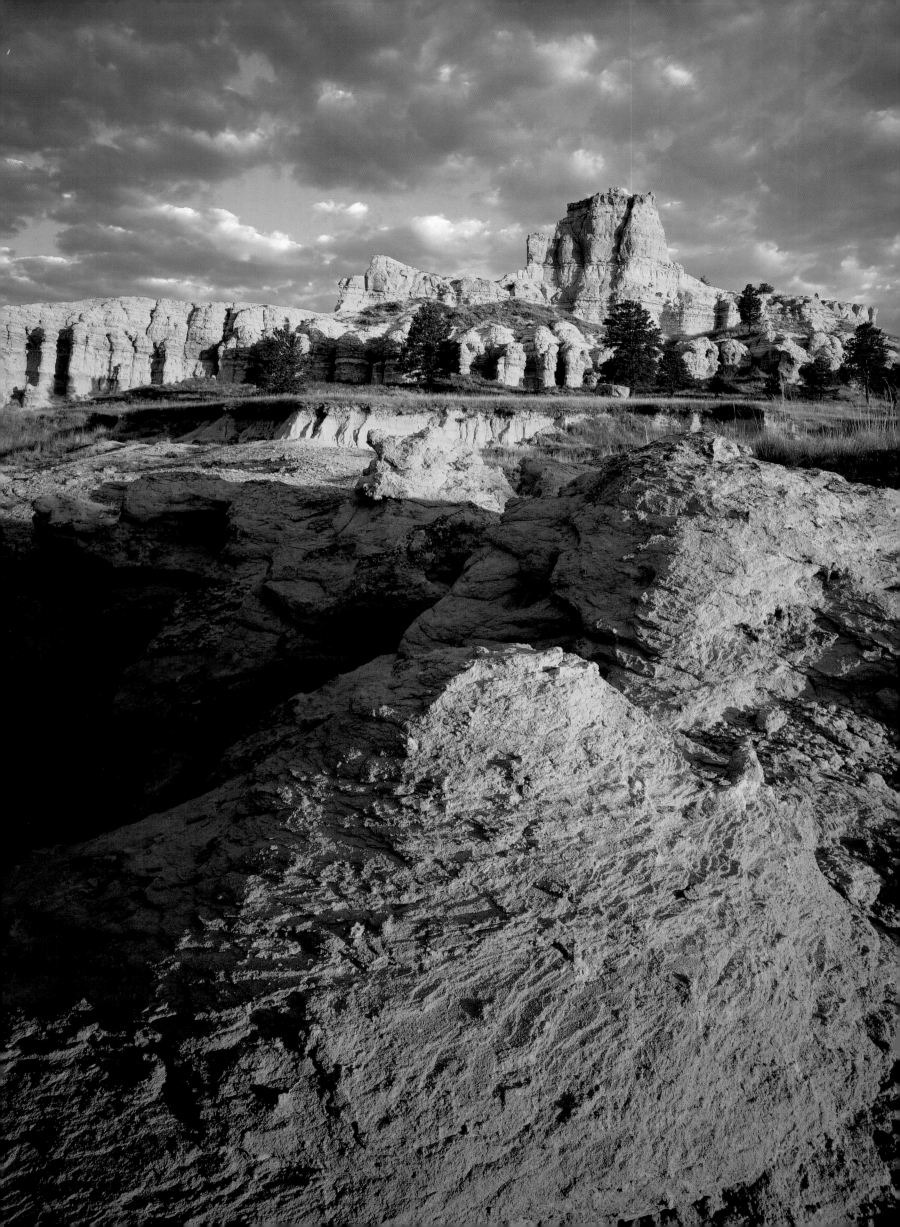

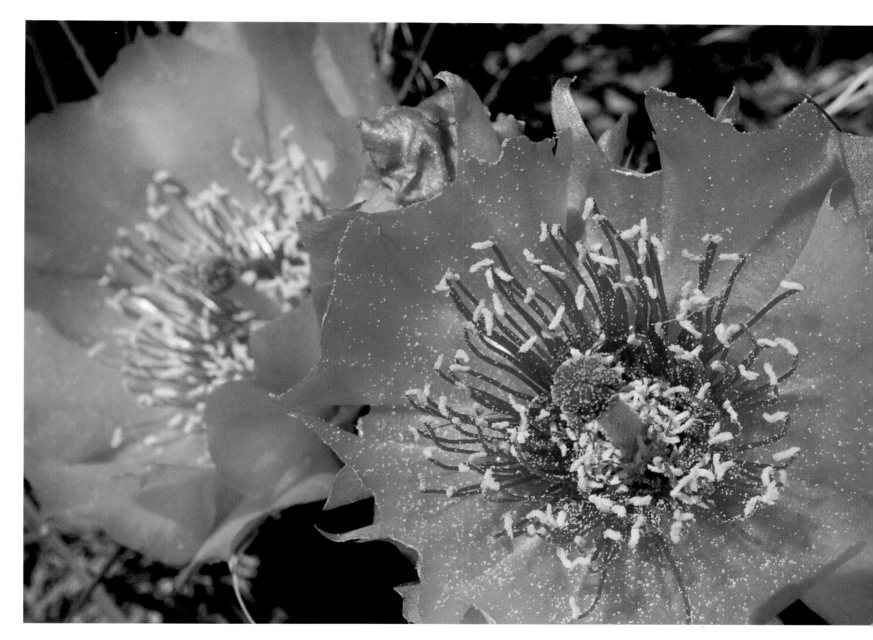

◁ Sandstone formations provide the pedestal for a National Landmark, Capitol Rock, in the Custer National Forest. Capitol Rock is so named because the massive white limestone uplift resembles the nation's capitol.
△ "The Prickly Pear is now in full blume," wrote Captain Meriwether Lewis, "and forms one of the beauties as well as the greatest pest of the plains."

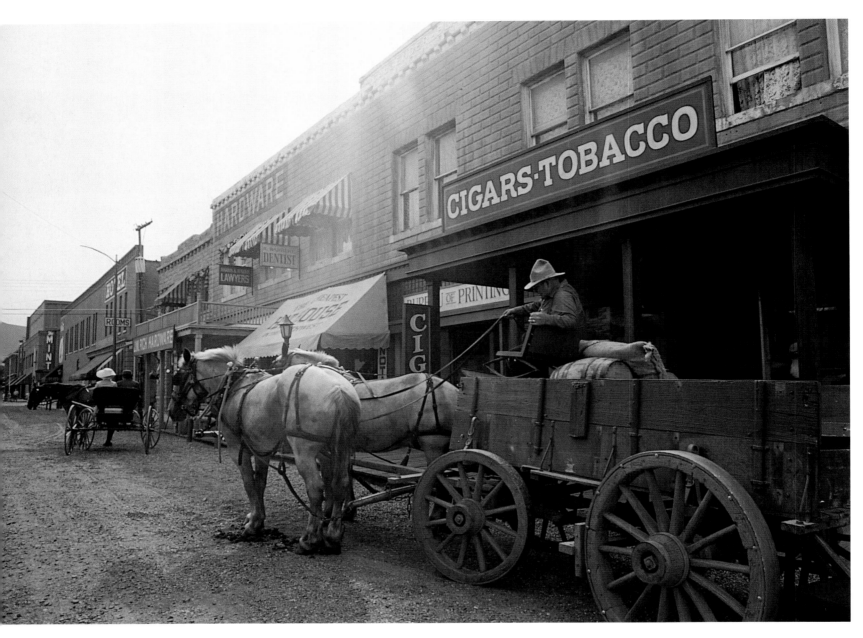

△ The natural scenery and the towns of Montana have been the back-drop for many movies. One such movie is *A River Runs Through It,* directed by Robert Redford. The movie used this scene in Livingston.
▷ The grace and beauty of nature's infinite shapes are evident in rocks in the lapping waters of Bell Creek in the Lewis and Clark National Forest.
▷ ▷ Timberline Creek trickles into the sunset-tinted waters of Lake Timberline high in the Absaroka-Beartooth National Wilderness Area.

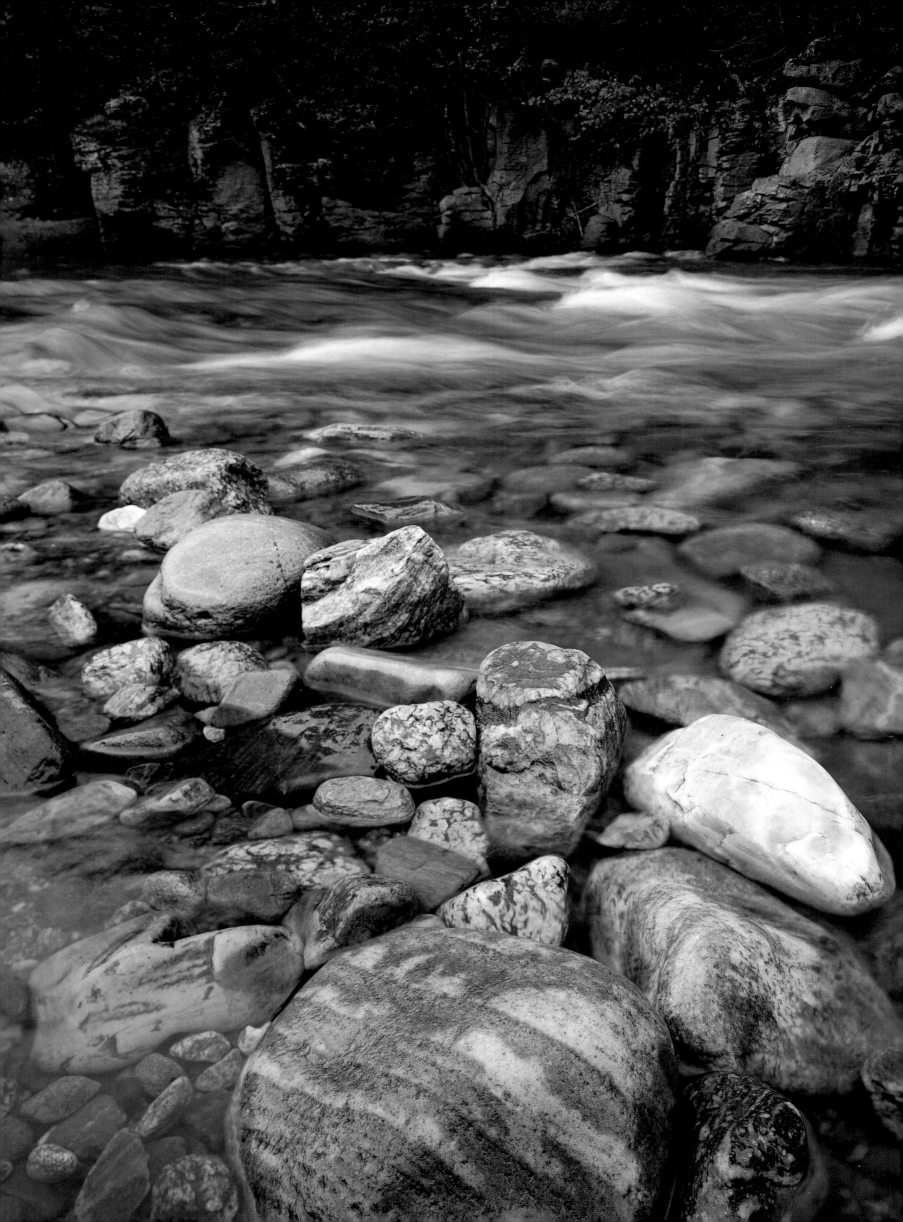

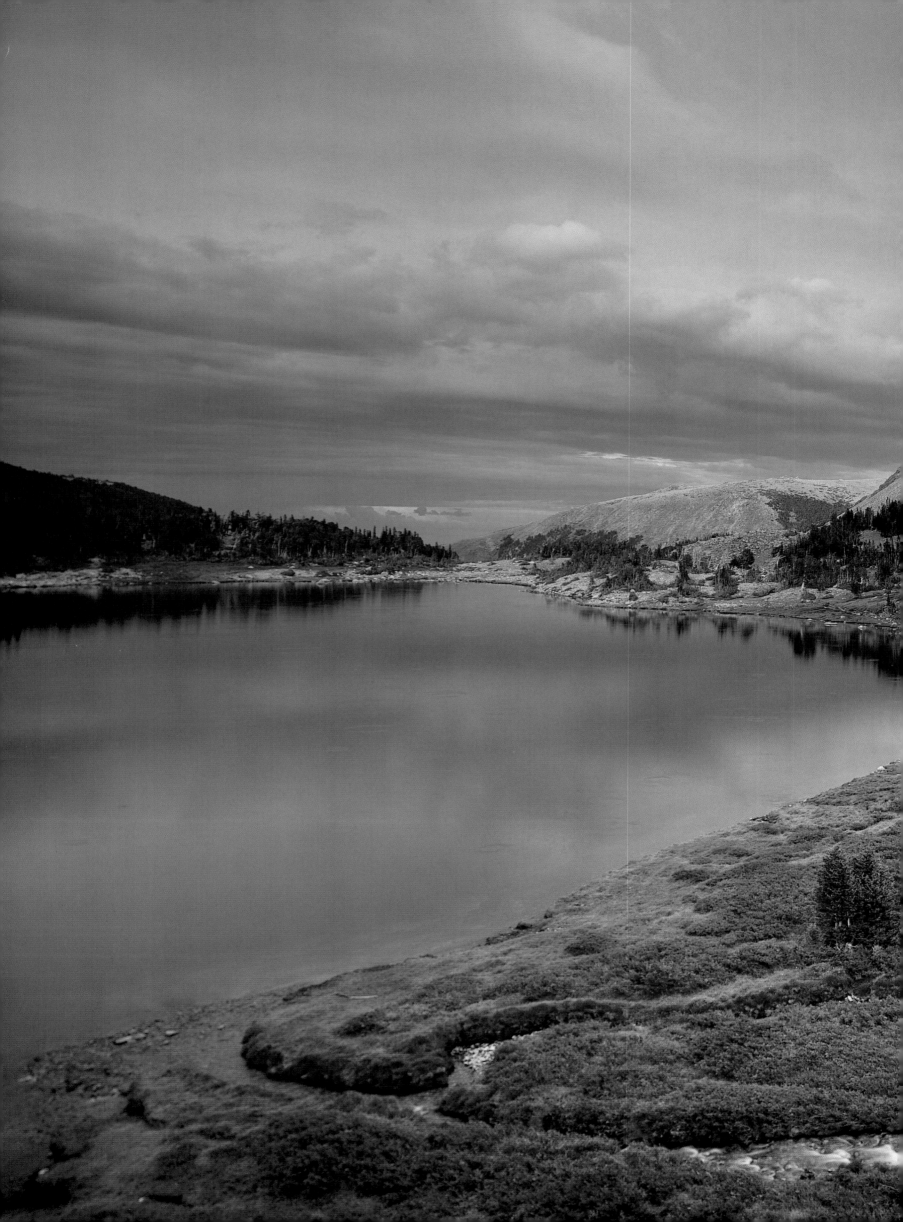

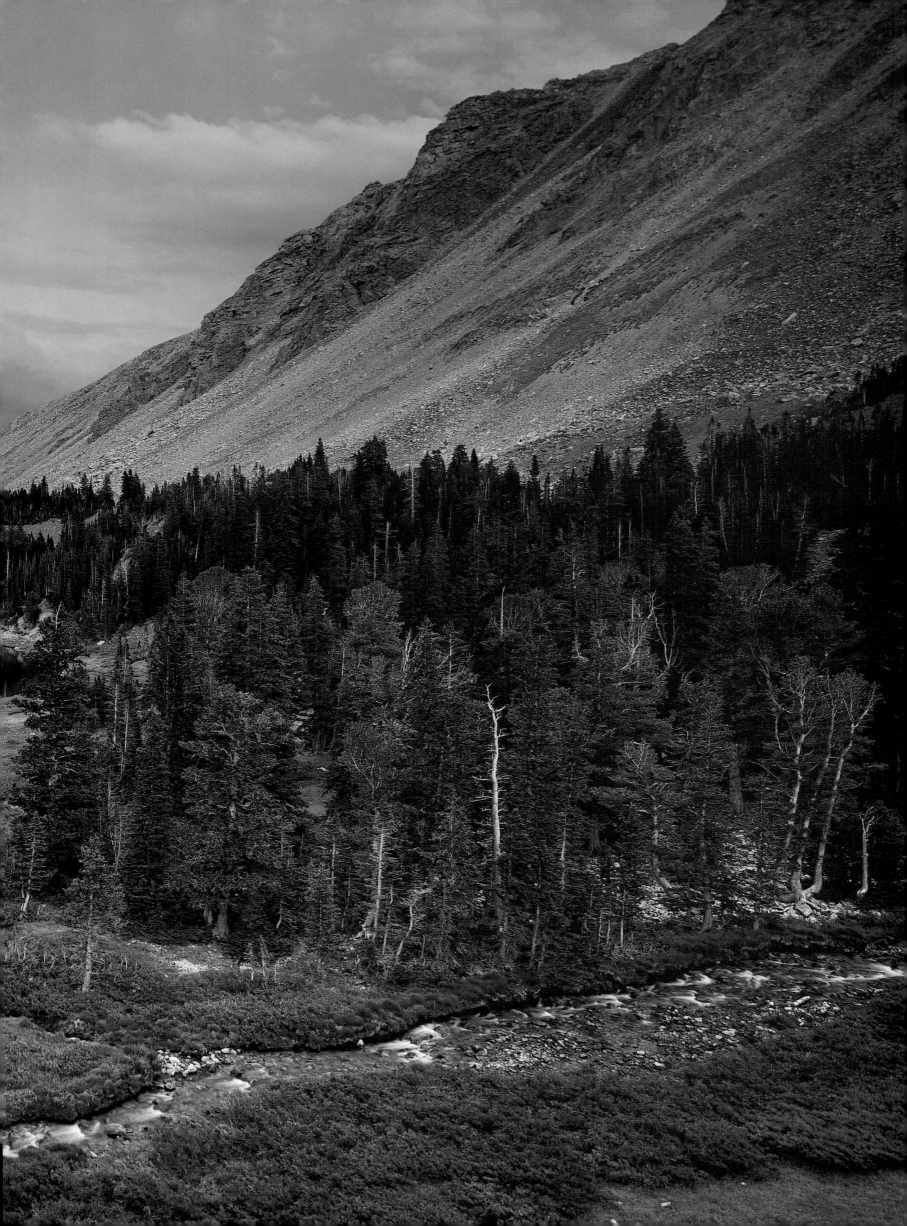

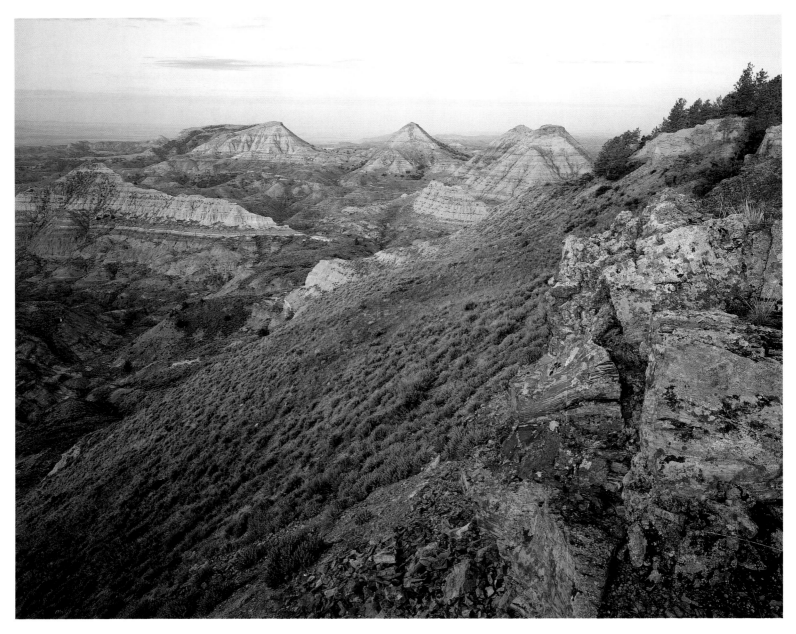

△ Flaming scoria rock greets the sunrise in the Yellowstone River Valley. Scoria is formed by coal seam fires that bake the surrounding material. The material, usually clay, hardens into a red, bricklike rock. Erosion resistant, scoria is found capping soft clays that make up the badlands of eastern Montana. These lands have been proposed for wilderness protection.
▷ Prickly pear cactus blooms within the Charles M. Russell National Wildlife Refuge. Named for the western artist who often painted these lands, the national wildlife refuge contains approximately 1,100,000 acres.
▷ ▷ Makoshika, with its formations of capstones, towers, and mounds, is Montana's largest state park with 8,834 acres of geologic wonderland.

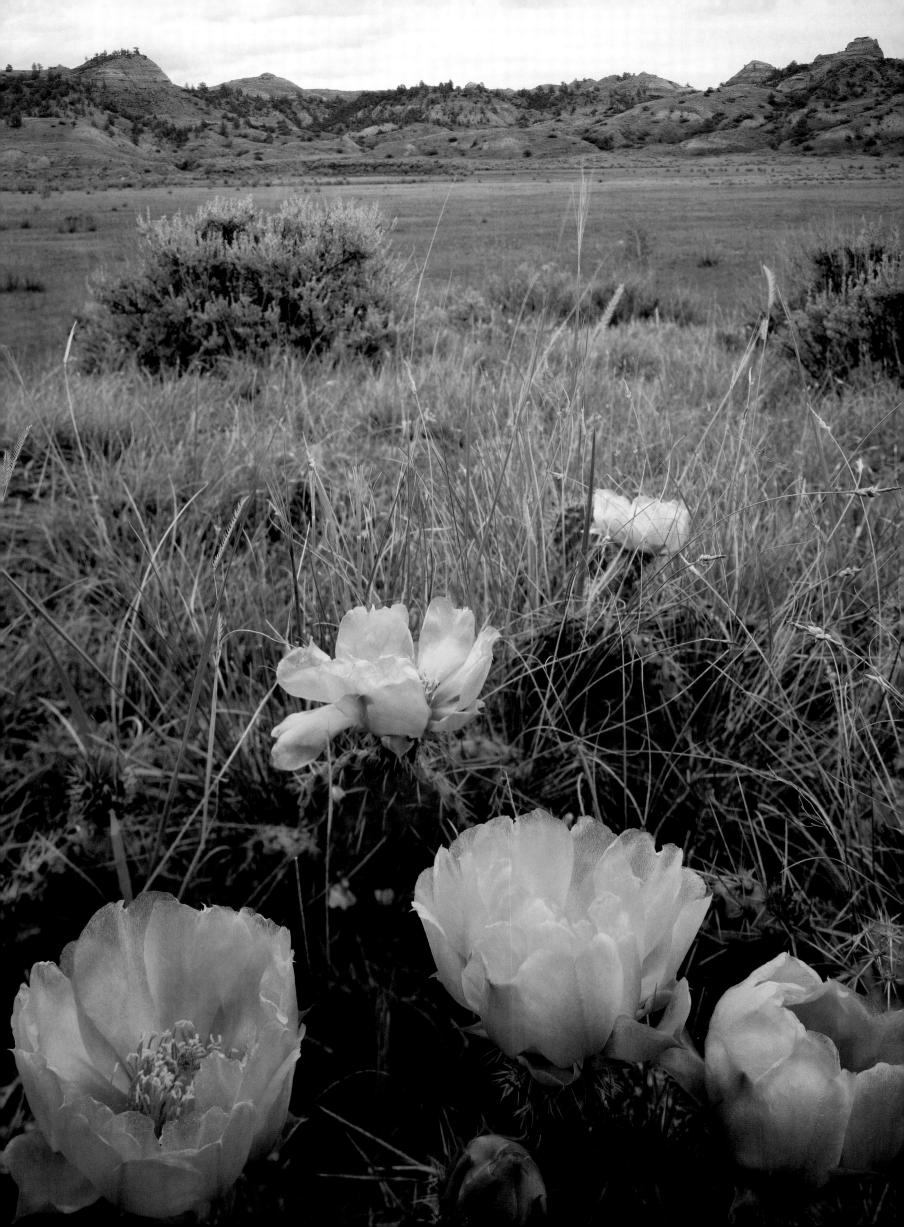

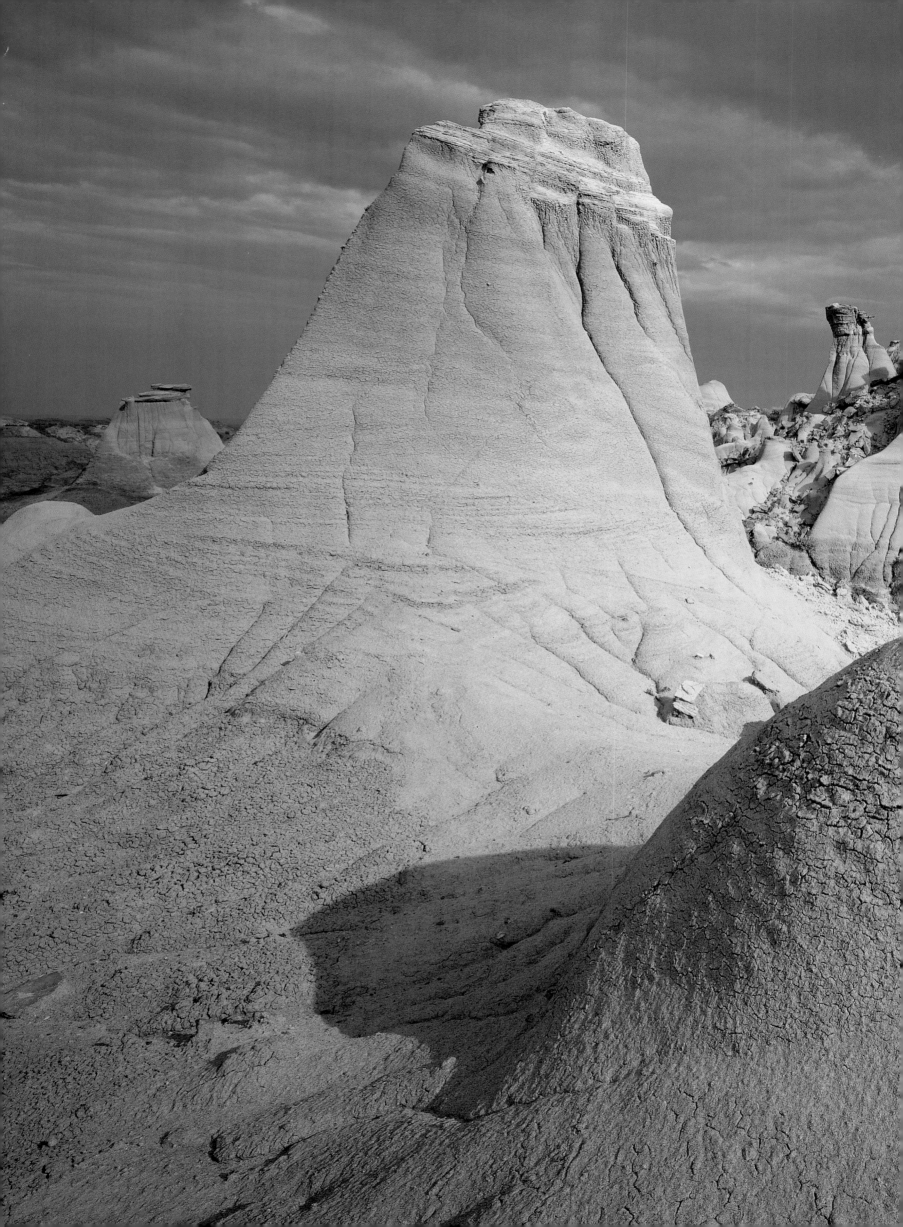

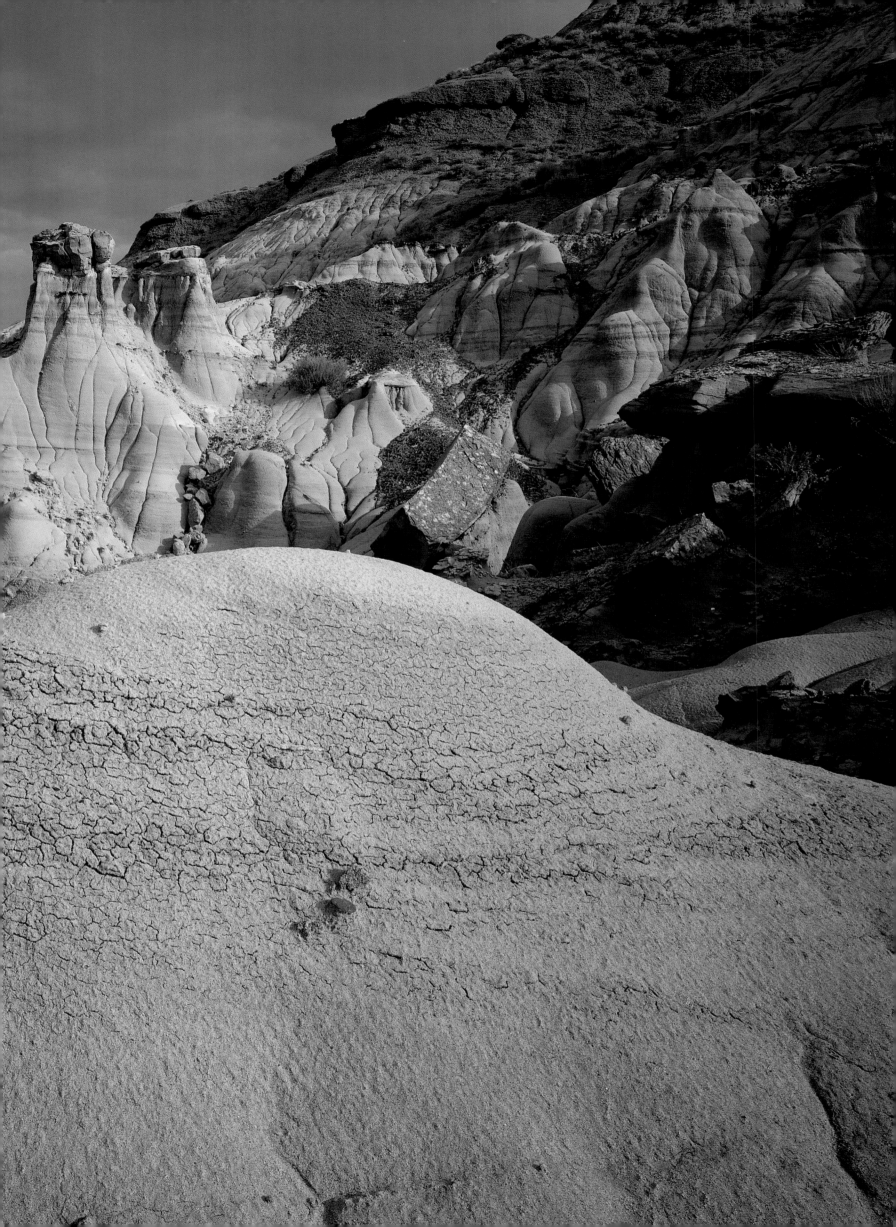

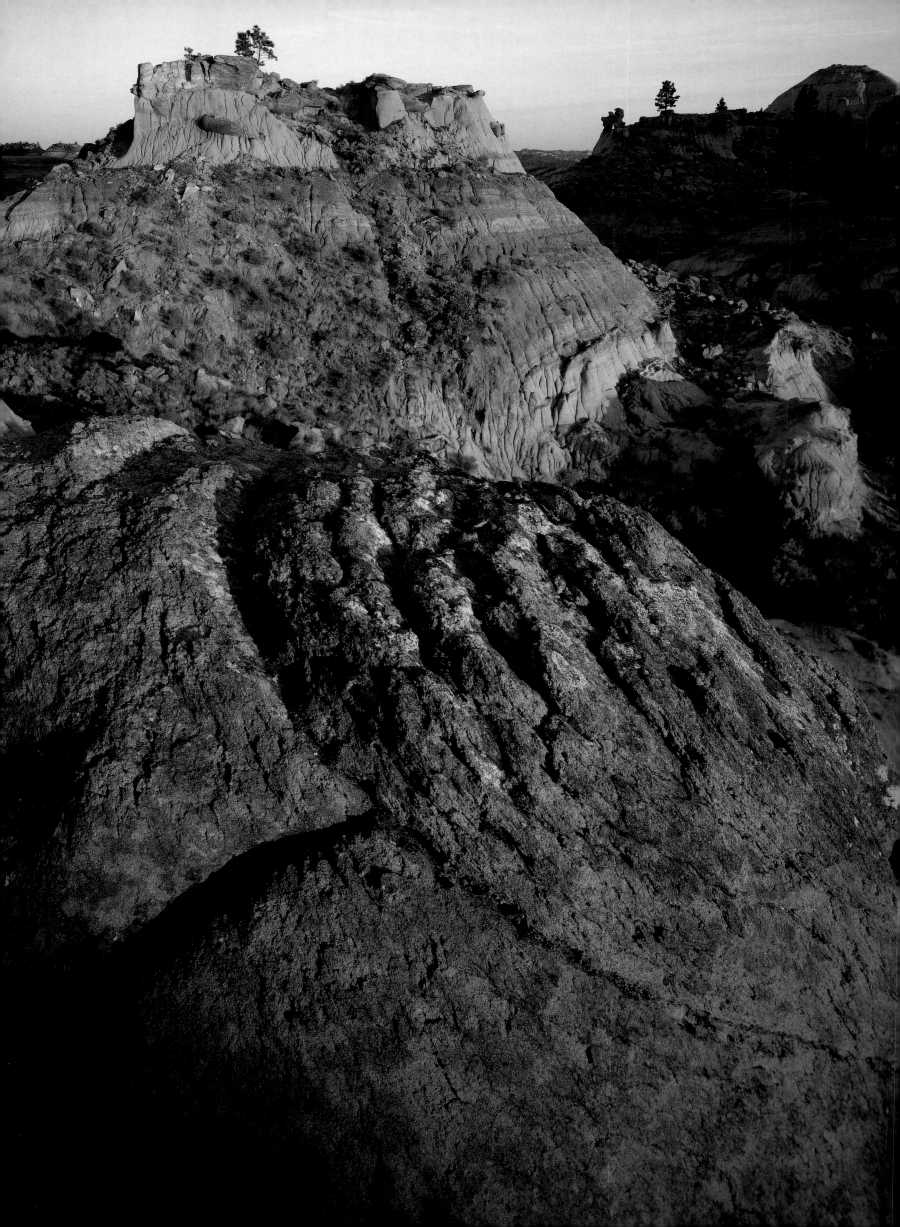

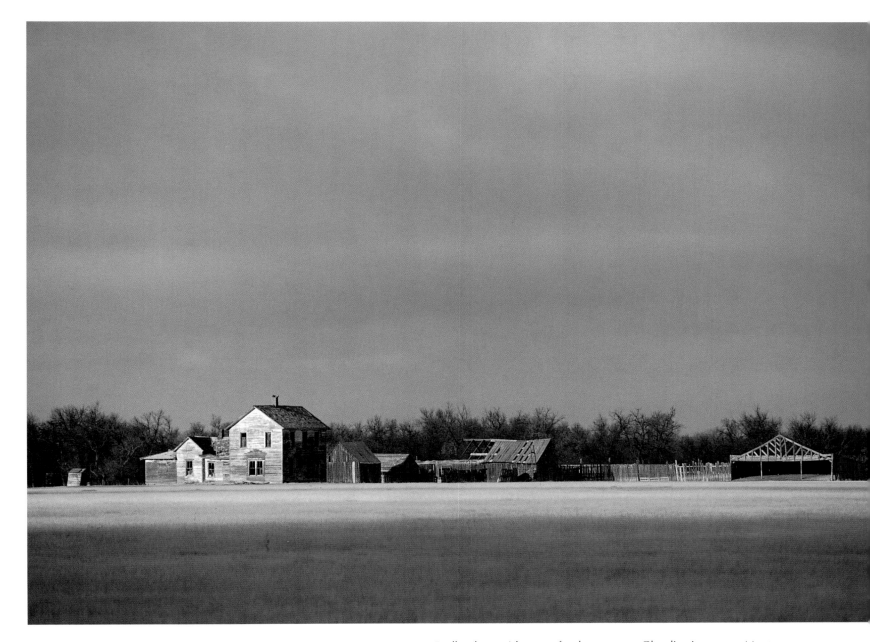

◁ Badlands provide treats for the eye near Glendive in eastern Montana.
△ Lured west by the Homestead Act of 1862 and the Great Northern Railroad's promise of "a farmer's paradise," many thousands of citizens sought Utopia, attempting to extract a living from harsh, unyielding land.
▷ ▷ The open spaces of the high plains of eastern Montana provide ample territory for an abundance of prairie grasses and flowers.

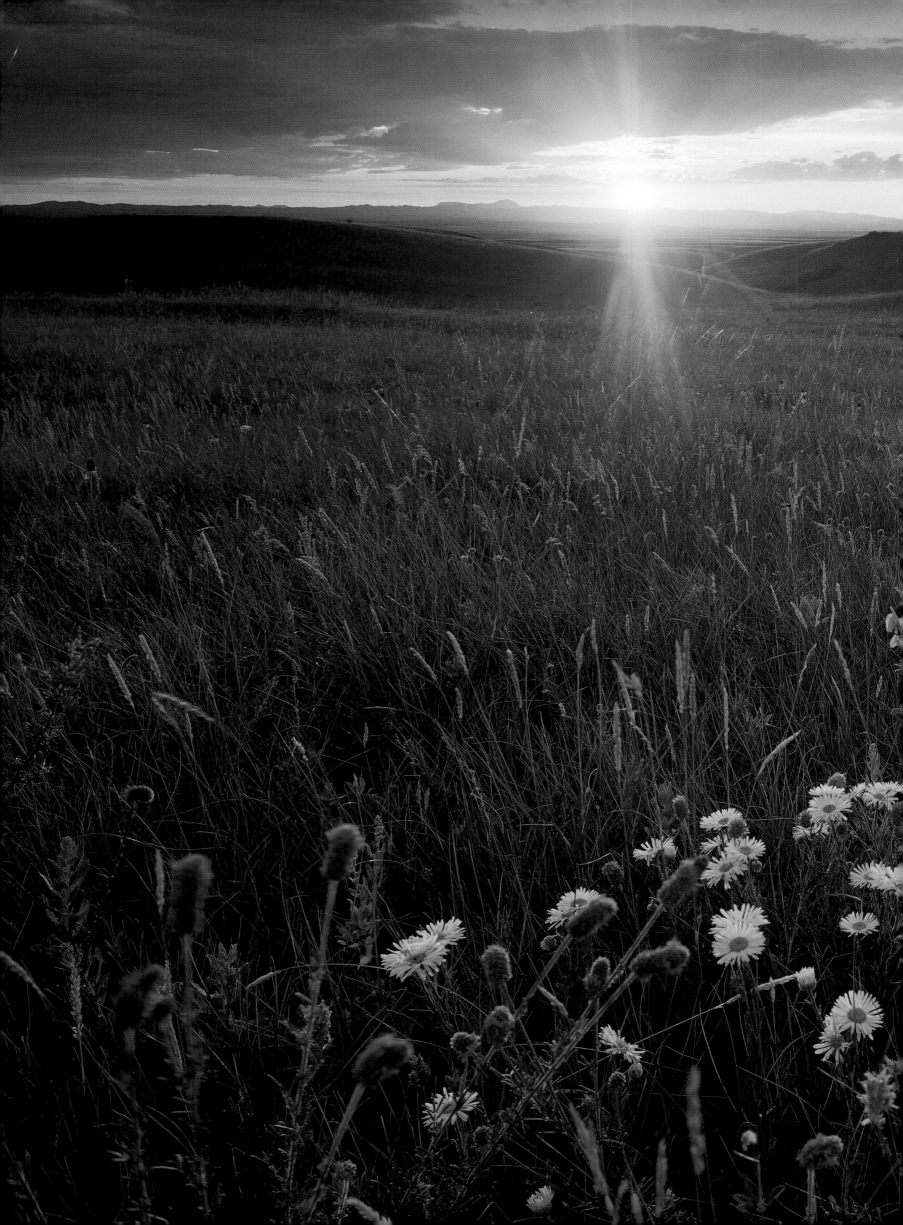

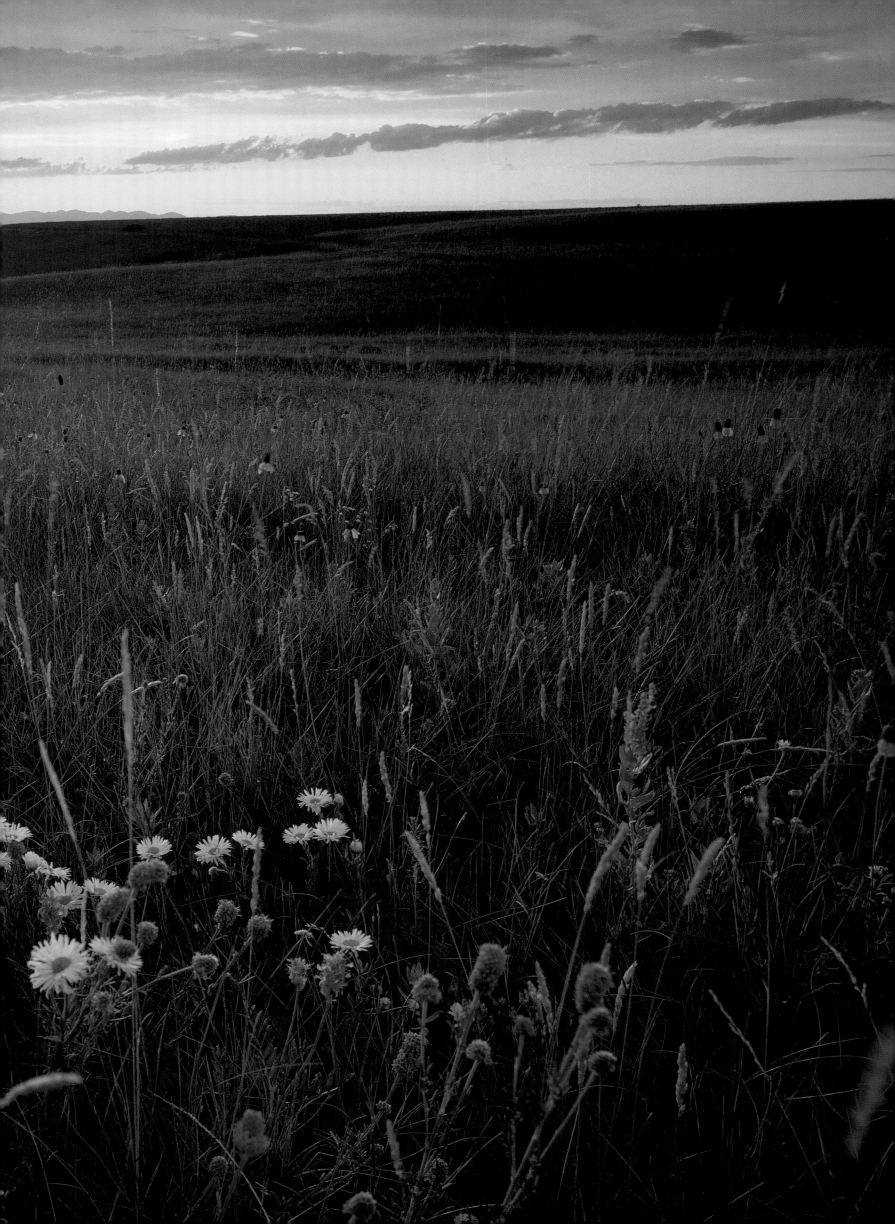

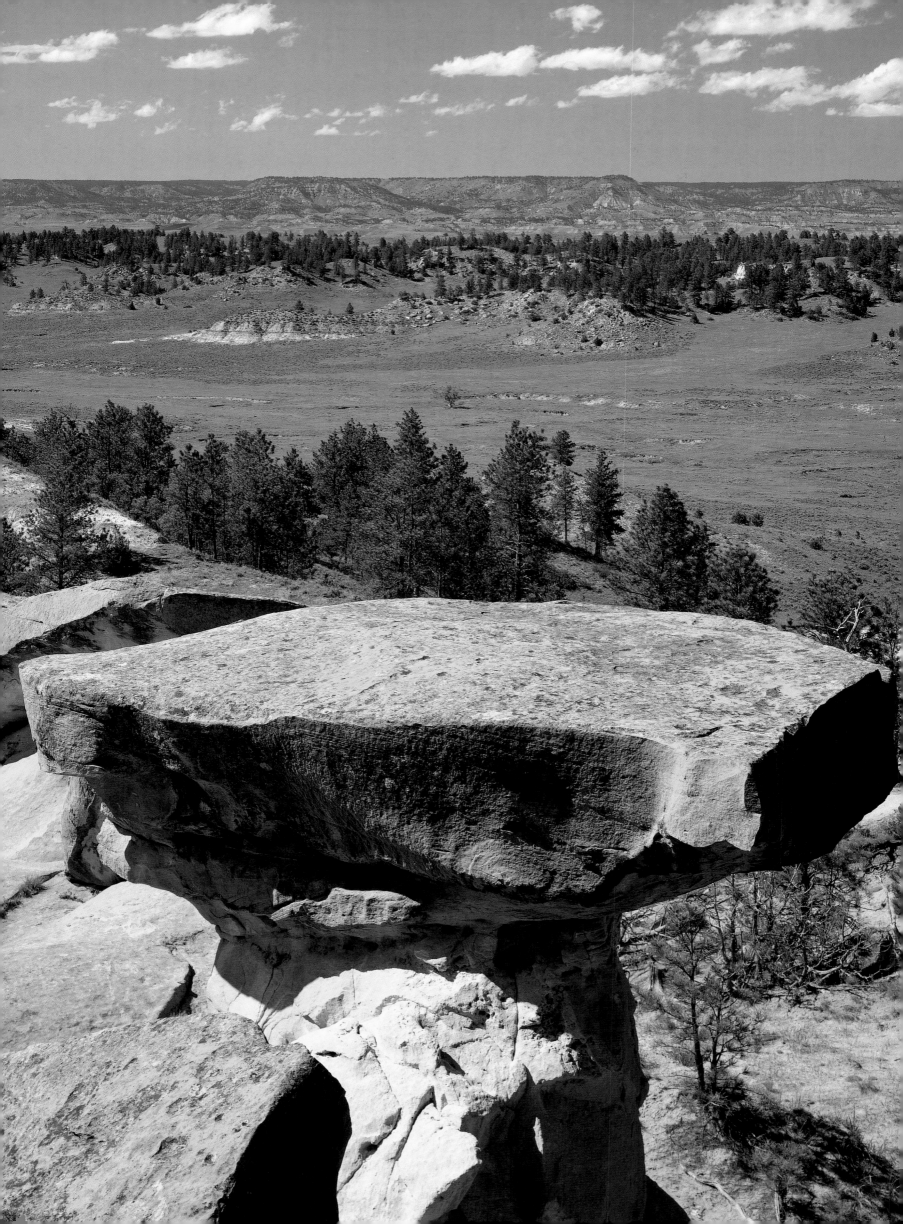

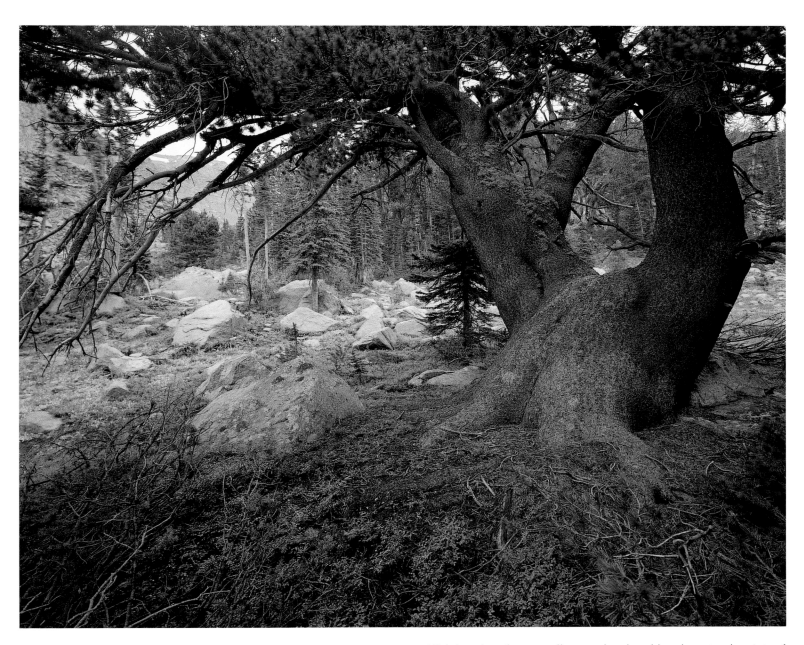

◁ High benches, forests, valleys, and rocks add to the natural variety of scenery in the Tongue River Breaks. For eons, wind and water shaped the sandstone, creating caves in the canyon walls. Generations of Stone Age people dwelled here for perhaps as long as ten thousand years. The area also contains cultural sites revered by the Northern Cheyenne people.
△ Finding root in the shallow, rocky soil, whitebark pines are common in the subalpine zones around six thousand feet above sea level. Their seed cones provide nourishment for numerous species of wildlife, ranging from birds and rodents to grizzly bears.

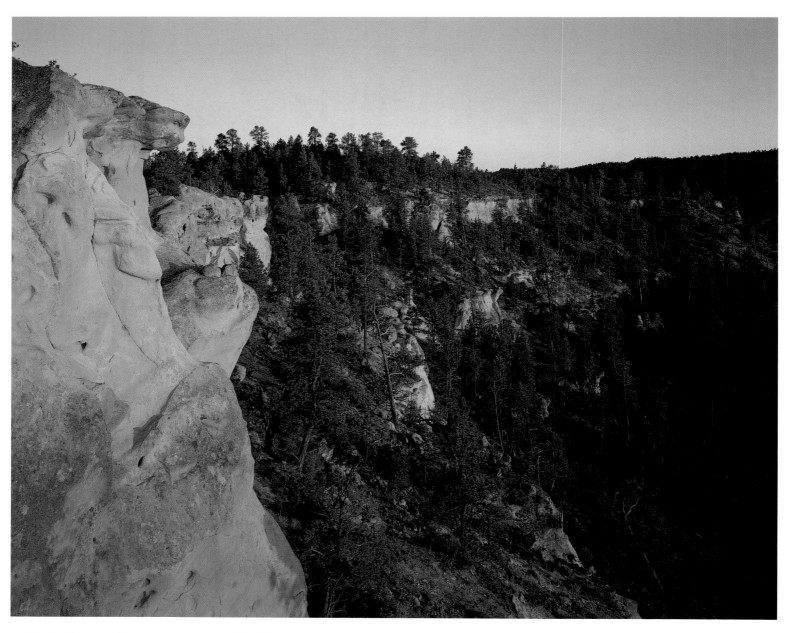

△ The breaks near the Tongue River provide a forested contrast to the waters which begin in Wyoming and flow through Montana's Big Horn and Rosebud Counties, joining the Yellowstone River at Miles City. ▷ North of the town of Jordan, the eroded hillsides form the Ried Coulee.

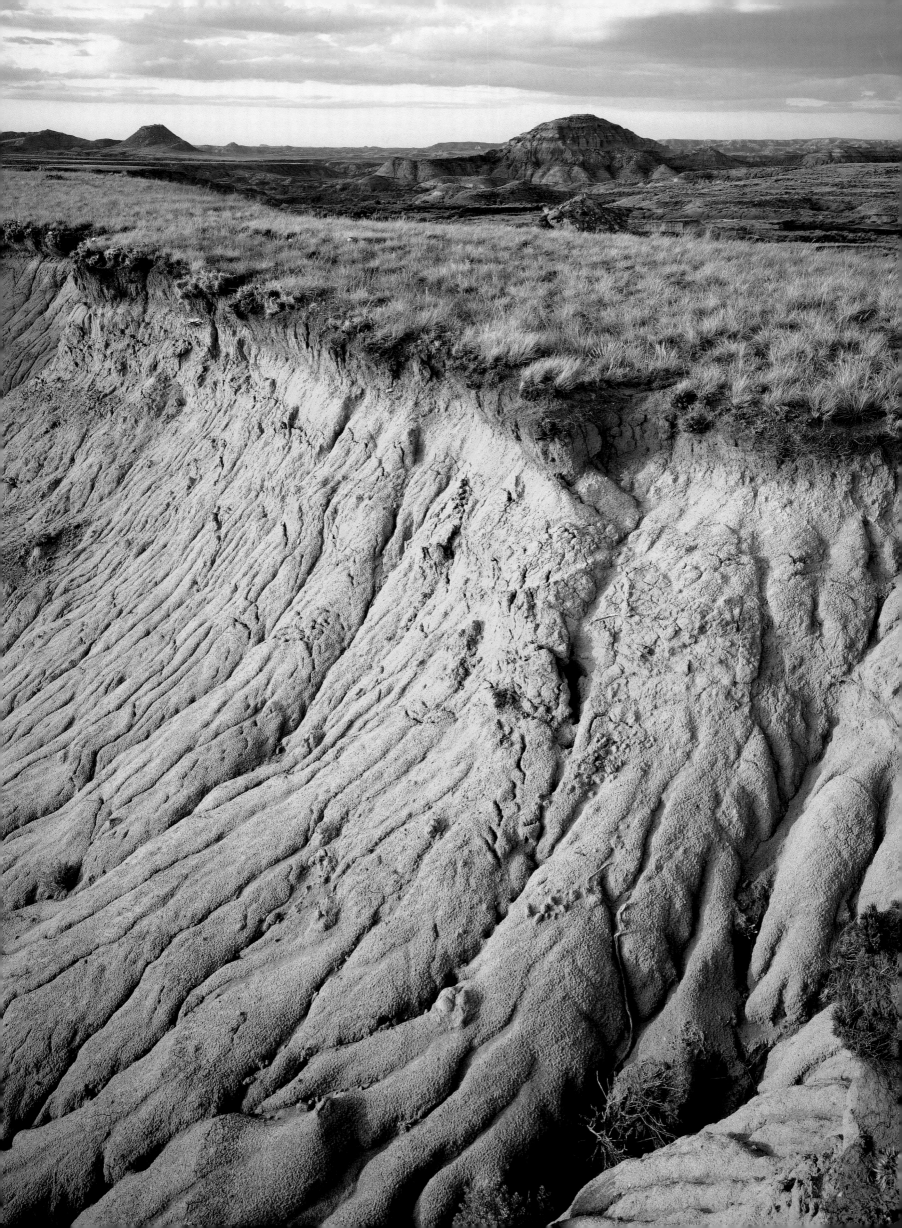

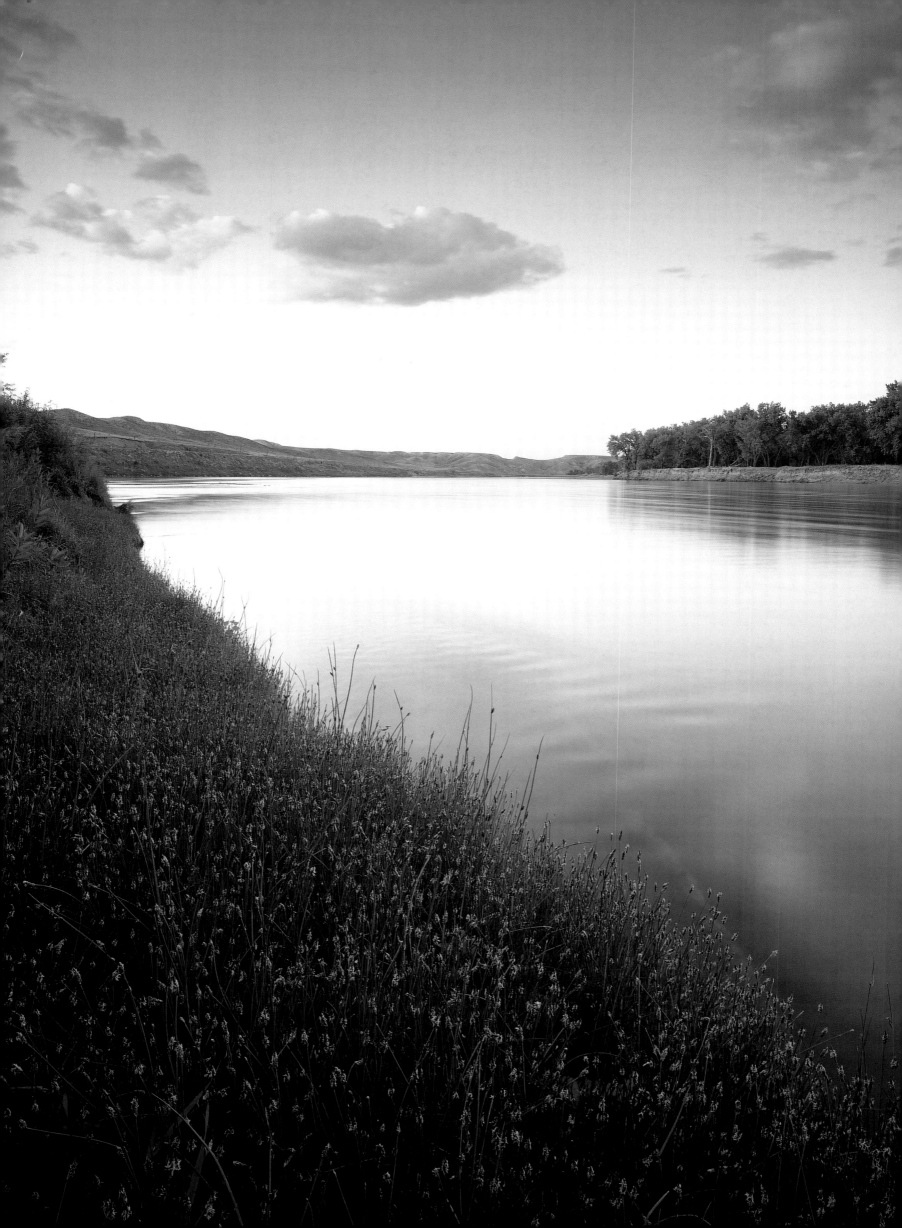

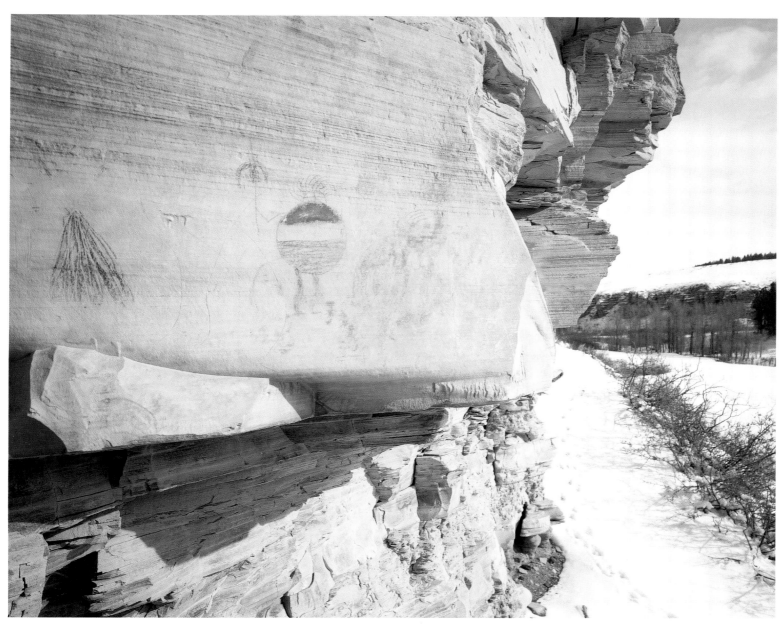

◁ Sedge along the Missouri River is not only beautiful; it also provides food for deer and elk. More than one hundred species of the flowers are found scattered throughout the Rocky Mountains and high plains.
△ These shield warriors, ancient images painted on stone (pictographs), are still visible in Bear Gulch Pictograph Canyon in the Big Snowy Mountains.
▷ ▷ A defiant capstone stands as a silent sentinel near Fort Peck Reservoir and the Missouri Breaks. As Lewis and Clark made their way through this area in 1805, they found it to be a wildlife mecca.

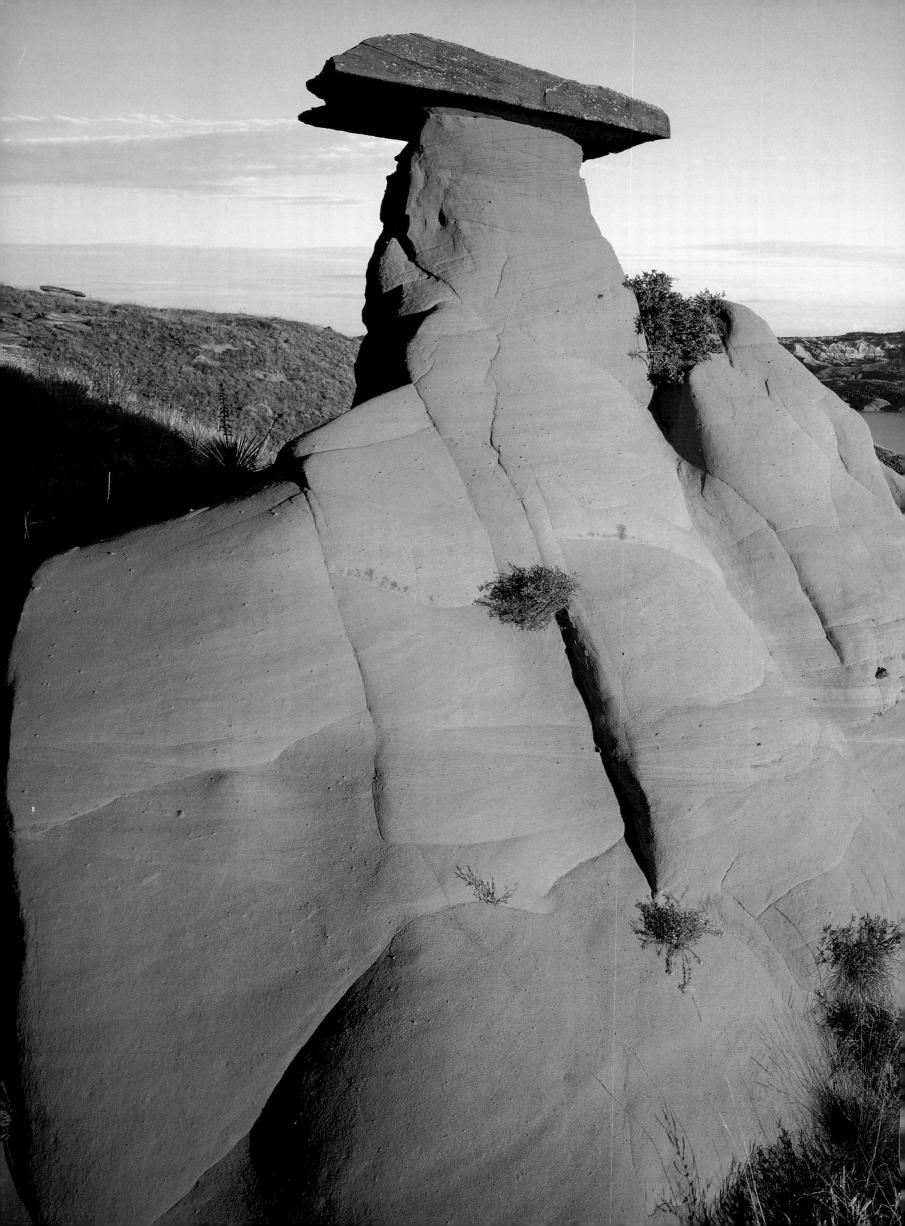

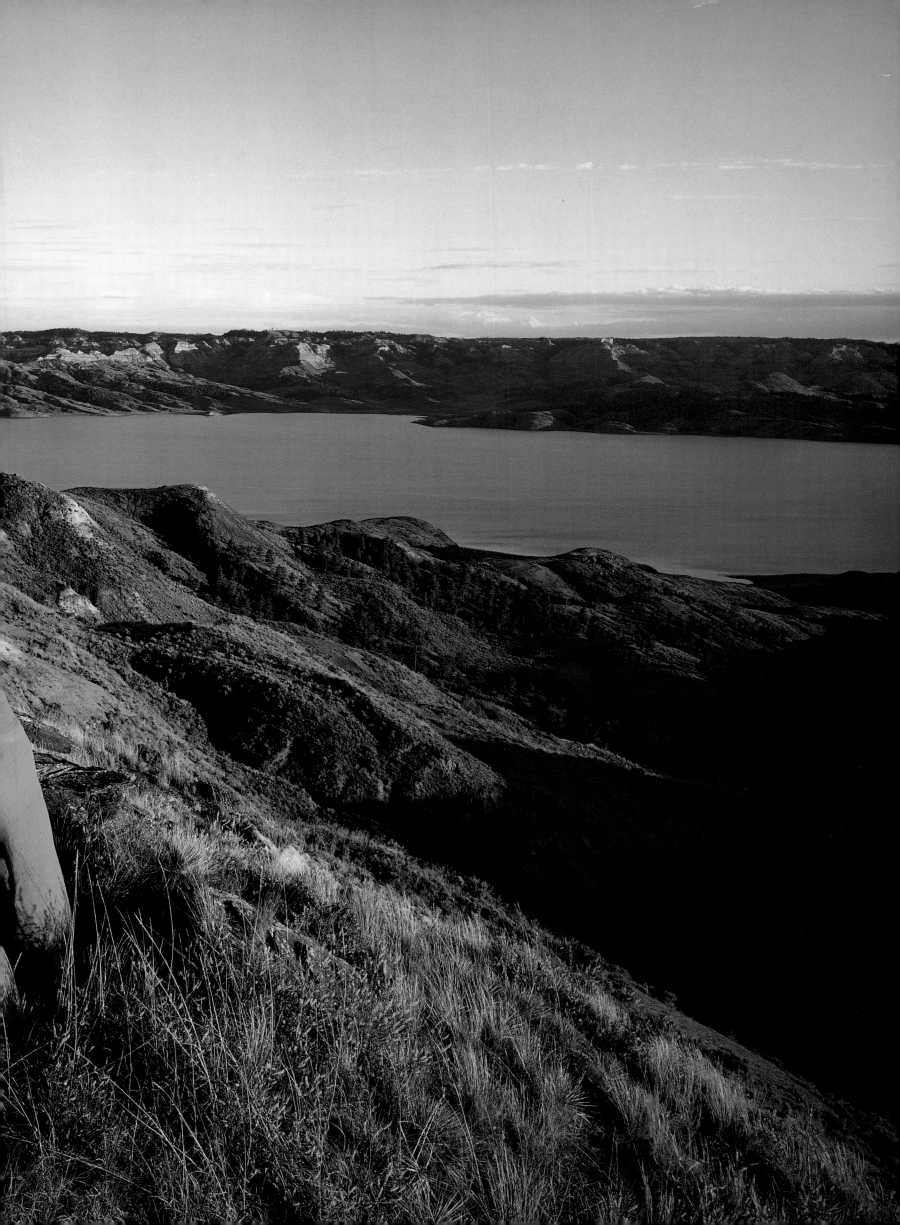

△ Early snow covers a wheat field near the town of Choteau, in Montana's farm country. Choteau began as a trading post and was named to honor the first family of the western fur trade—the Chouteaus.
▷ A frontier barber shop waits for customers in the recently renovated Havre Beneath the Streets. The town of Havre, founded in 1891, was named for the birthplace in France of the parents of one of the town's earliest residents—Guy DesCelles.

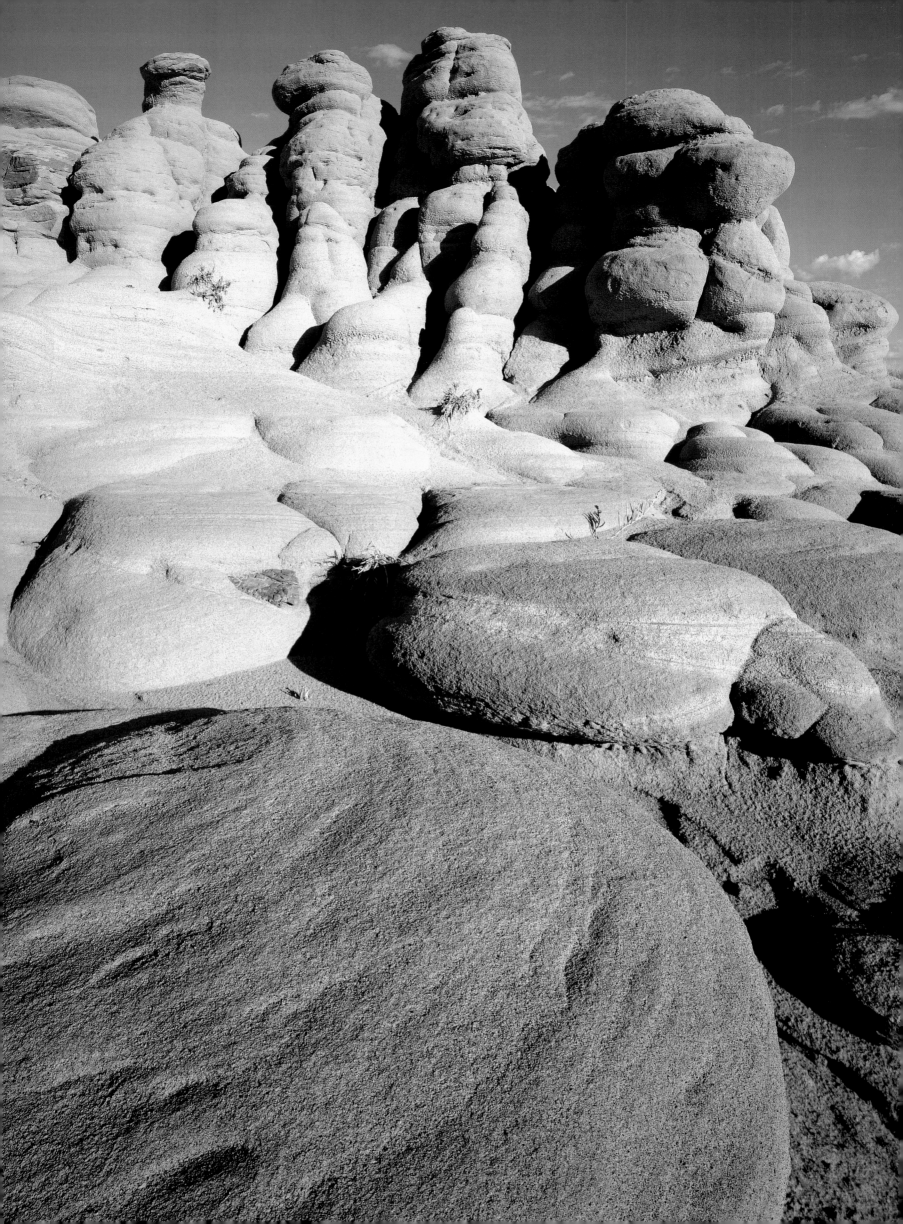

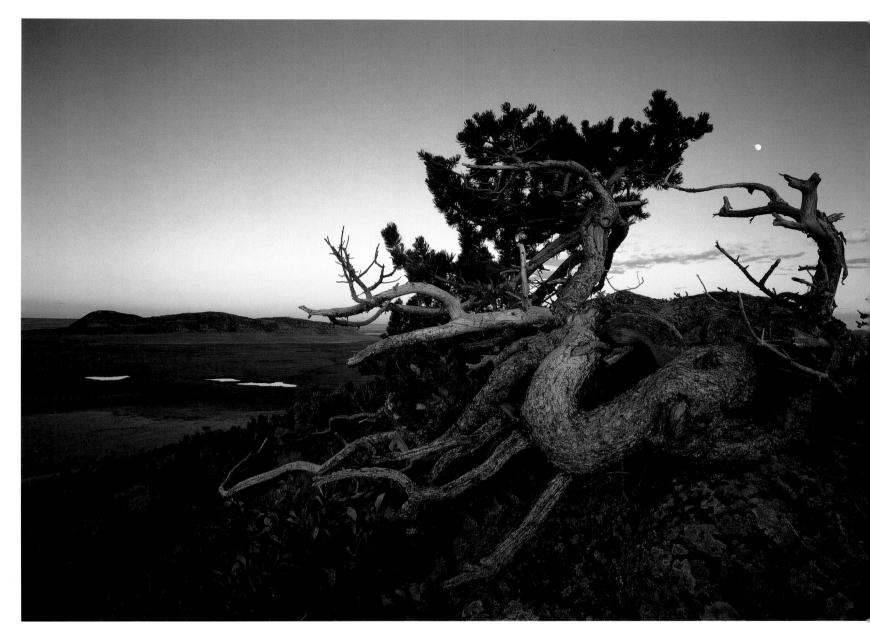

◁ Eroded formations of sandstone near Egg Mountain resemble prehistoric monsters. Egg Mountain is the site of recent remarkable archeological excavations revealing the remains of dinosaurs and their life stories.
△ A limber pine ties itself into knots to withstand wind and weather along the A. B. Guthrie Trail in the Pine Butte Swamp Preserve. Guthrie's literary works included *The Big Sky, These Thousand Hills,* and *The Way West.*

△ Great Falls, from its beginning with the first house in 1883, continues as a Montana center that serves agriculture, America's military defense, and transportation. Lewis and Clark arrived at the Great Falls of the Missouri River on June 13, 1805. It took them seven days to portage around them.

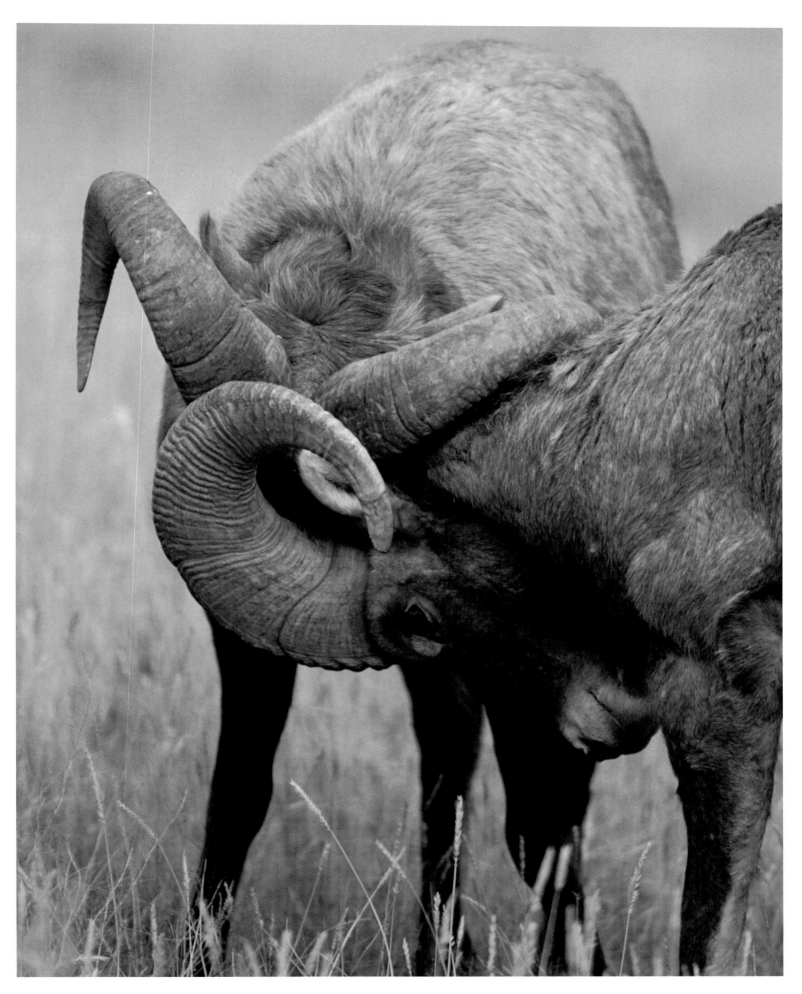

△ Trophy bighorn sheep prepare to determine dominance within the herd.
▷ ▷ Announcing the eastern front of the Rocky Mountains is a southern portion of the Chinese Wall on the perimeter of the Bob Marshall Wilderness—America's first designated Wilderness Area.

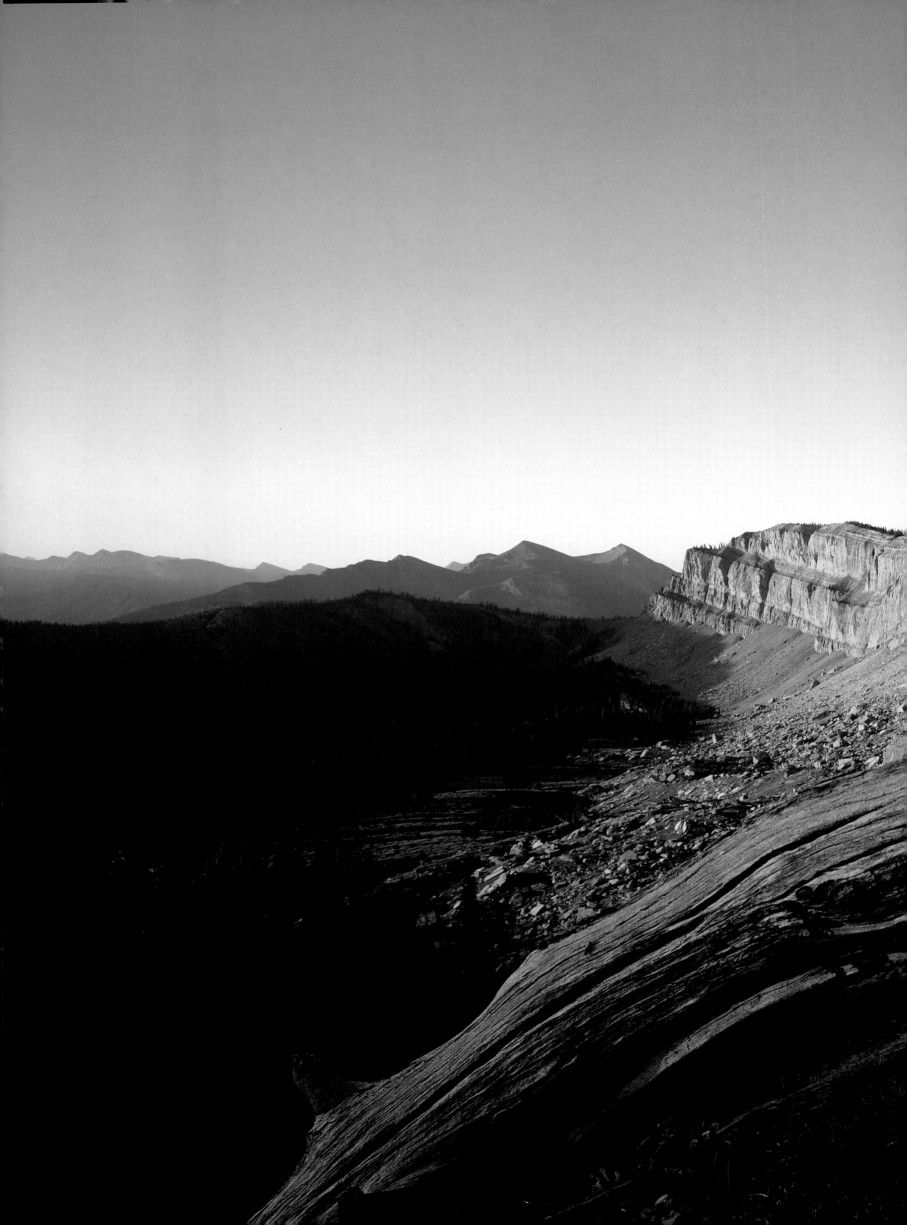

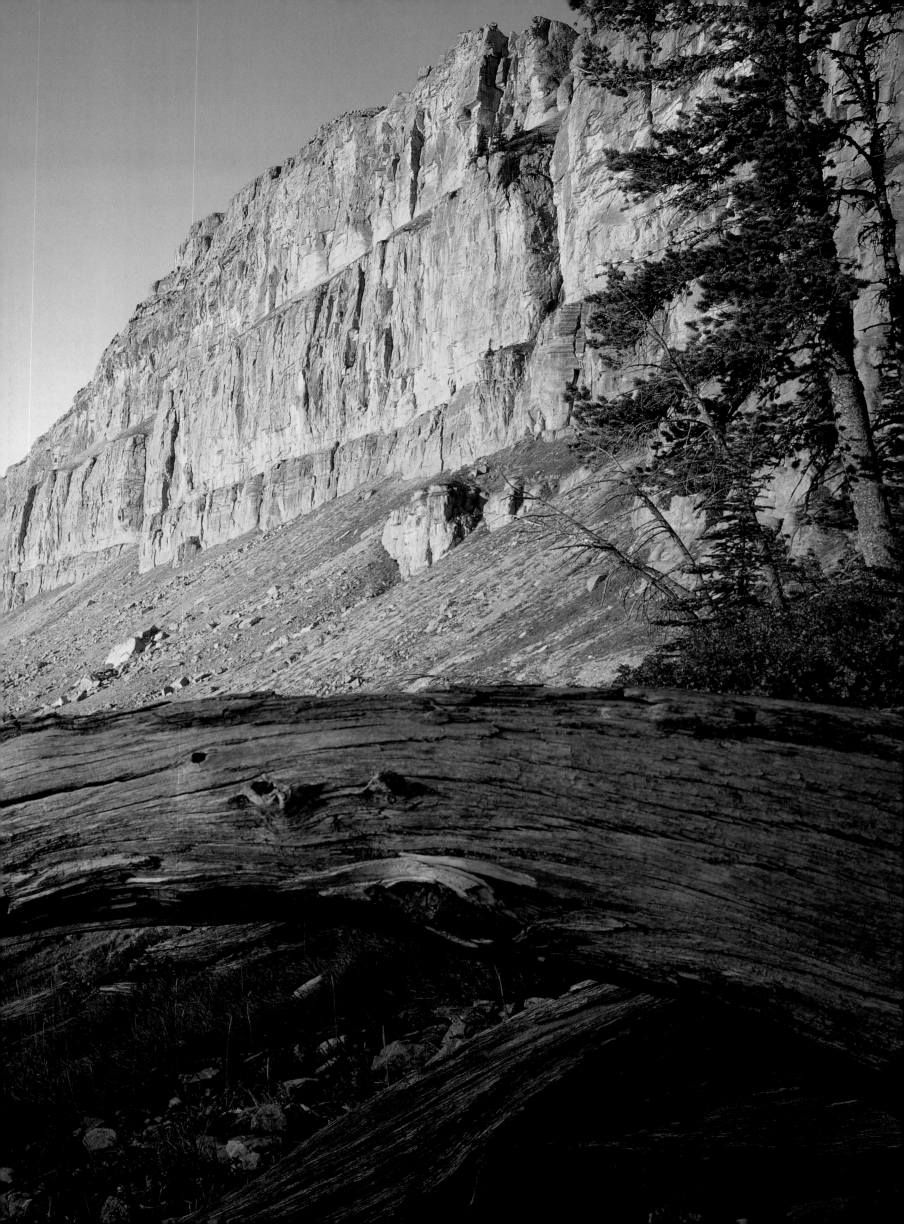

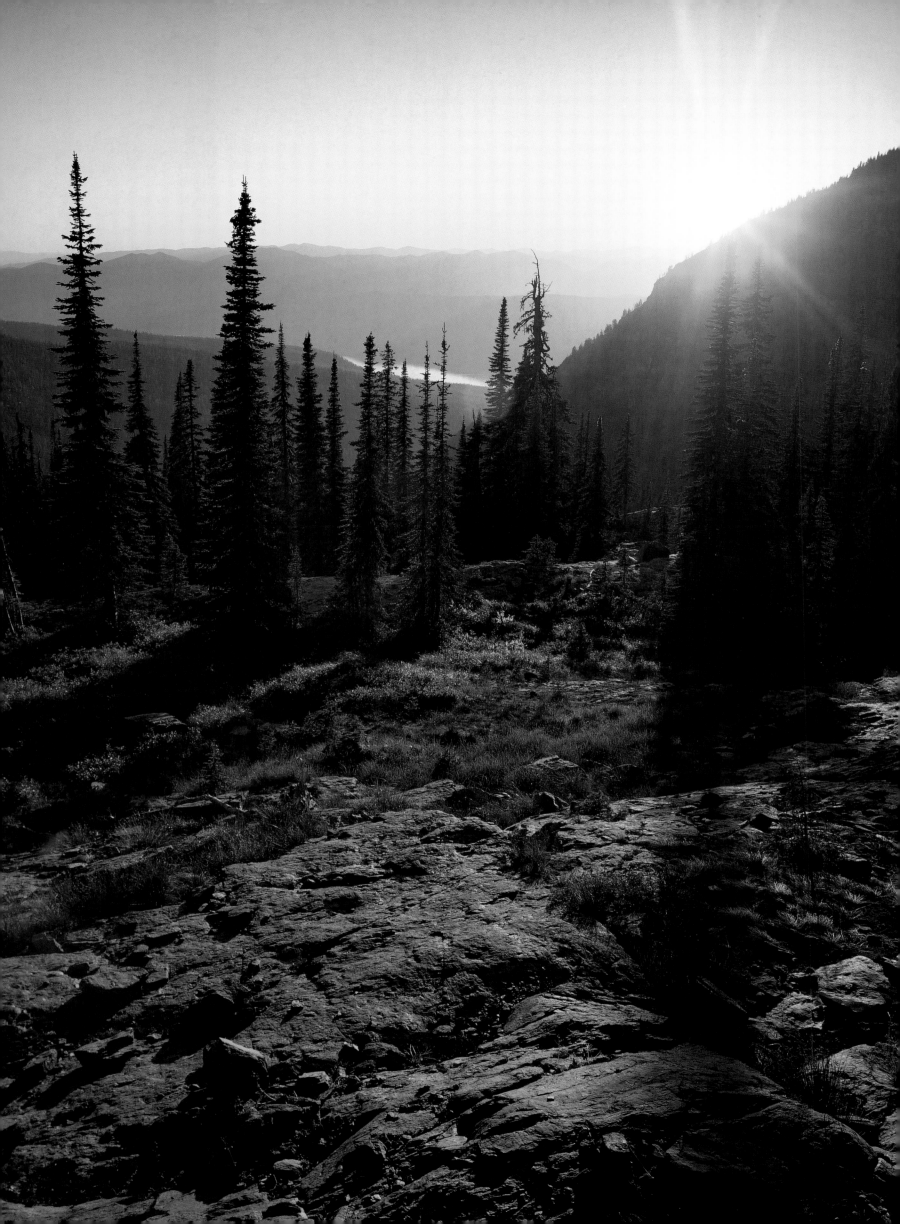

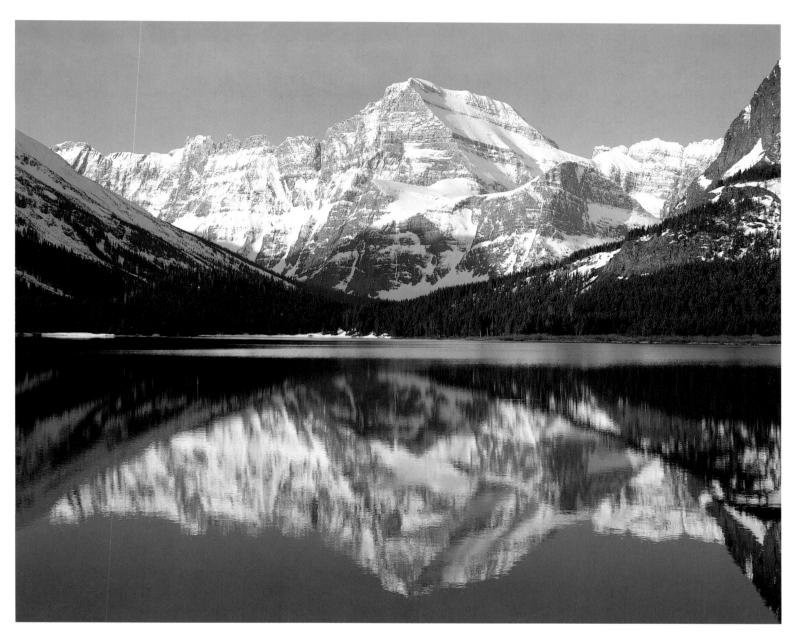

◁ A setting sun throws shadows atop Sprague Creek Canyon and glistens off the waters of Lake McDonald in Glacier National Park. Mountain ranges, glacial valleys, icy lakes, and wildflowers and wildlife that flourish in the meadows and grasslands—these make up Waterton Lakes National Park in Canada and adjoining Glacier National Park in the U.S. Waterton and Glacier have been designated the Waterton/Glacier International Peace Park.
△ The startling clear waters of Swiftcurrent Lake on Glacier's east side hold a mirrorlike reflection of 13,005-foot Mount Gould.

AUTHOR'S ACKNOWLEDGMENTS

I acknowledge and thank you, the browser and reader, as the inducement for this book.

The process of rounding up and corralling the words for the essay and photo captions of this book took some hard riding; however, the mental journey across Montana's landscape and history was a delight.

Along the way I often dismounted to revisit the thoughts and writings of others, most of them friends and colleagues: K. Ross Toole, Mark Meloy, Charles Kuralt, Harry Fritz, Dayton Duncan, Bill Farr, Andrea Merrill, Judy Jacobson, Pets Cote, Roberta Donavan, Pat Monday, Roberta Cheney, Jeff Gritzner, Bill Bevis, Norma Tirrel, Dan Baum, and Margaret Knox. A thank you to Jeannie Thompson for her sharp eyes and efficient work. And, of course, we are all grateful to Meriwether Lewis and William Clark for those first written descriptions of Montana.

My gratitude to my wife, Carol, for knowing what words had been left out and needed to be put in. This book, a love letter, is for our grandchildren.

—PAT WILLIAMS

PHOTOGRAPHIC STATEMENT

As you view the artwork within these pages it is my hope that you will see more than just good photography of this beautiful state, but also a thematic statement of fine art that utilizes many different compositional approaches of which some are pure and simple in a graphical sense. Some incorporate a multifaceted assortment of dynamic compositional elements found within nature—all captured in one image.

Hopefully, the images will draw you into them, transcendentally transporting you to that place. Perhaps motivating you to visit that area and explore with the wonder captured in that image. If you do find yourself visiting, please tread lightly for some of these areas are as fragile as they are fantastically beautiful. Give thanks to those who deserve it for working to conserve these lands, perhaps giving their lives to preserve the lands you now enjoy.

PHOTOGRAPHER'S ACKNOWLEDGMENTS

I wish to give special thanks to several people who were so influential in my life: To my father, Salvatore Vaspol, a hardworking stone and brick mason who supported five children. He passed away in 1992 as I had just completed one of my first photographic milestones, a poster that would be the first of a lifetime of professional achievements. To my mother, who knew that someday I would amount to something, though she would always ponder on what that might be from a young boy who started his first business at the age of seven shining shoes on the streets of Passaic, New Jersey. To my Aunt Ann Vaspol-Sangis for encouraging my parents to enroll me in the Boys Club of Garfield, New Jersey, where I would develop my first roll of photographic film at the age of nine, leading me to a professional career as a photographer. To Diane and Ralph Copolla, Roseann Precopio, Angela and Patrick Salmon, for their unwavering support. To Bill Tullis and Rosa Eastep for being faithful and mostly uncomplaining sherpas, carrying those necessary items that I couldn't add on to my sometimes fifty-pound-plus backpack on those long, dusty, hot trails over some of the greatest country in the world.

I also want to express my thanks to the Montanan, sometimes native, sometimes immigrant, but always friendly, supporting, and caring. There are not many places in our country where people wave to you as they drive by on what may seem like a lonely highway. Or where a total stranger will tow your stranded vehicle, buy your auto part if you could not, and trust that you will mail them a check once you get home. I have been in every state in the Lower 48 and could not think of any state where such an event can happen as it has happened to me. Therefore, I give heartfelt thanks to the people who have helped protect and preserve the state of Montana from those who would strip it of all its wealth and beauty. Always willing to help someone in need no matter what color, race, nationality, or religion—and as Montana grows, may you never lose those attributes that make you unique in a world of self-centered, me-first citizens.

—SALVATORE VASAPOLLI